THE COMPLETE GUIDE TO
SCRAPBOOKING

100 techniques with 25 projects plus a swipefile of motifs and mottoes

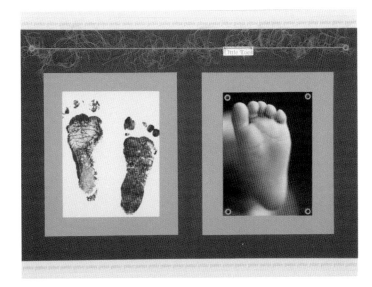

SARAH BEAMAN

COLLINS & BROWN

To my family, for love and inspiration X

First published in Great Britain in 2005
by Collins & Brown Limited
The Chrysalis Building
Bramley Road
London W10 6SP

An imprint of **Chrysalis** Books Group plc

1 3 5 7 9 8 6 4 2

British Library Cataloguing-in-Publication Data:
A catalogue record for this book
is available from the British Library.

ISBN 1 84340 158 4

Conceived, edited and designed by Collins & Brown Limited

Editor: Kate Haxell
Designer: Roger Daniels
Photography: Dan Towers
Illustrations: Luise Roberts

Reproduction by Anorax
Printed and bound in China by SNP Leefung

contents

Cherish

to treasure, adore, value and love

introduction

Scrapbooking is the art and craft of preserving and presenting memories by combining photographs, memorabilia and journaling. Though this is a relatively new craft to be recognized, I realize that I have been making my own embellished photograph albums and scrapbooks for longer than I can remember, and it appears that I am not alone in this endeavor. Many of us are already familiar with the process of making memory albums — which incorporate photographs along with memorabilia and notes — to serve as lasting reminders of people, events, places and objects. At last there is a name for this absorbing and satisfying pursuit.

The wonderful thing about scrapbooking is that, by definition, your album will be a unique and personal document — your own place to express thoughts and ideas, and record images and events. These will have meaning to others in years to come; even though a scrapbook is personal while you are working on it, in the future it will be an important and informative account of your family history. Facing this responsibility can be daunting. You probably have a large collection of family photographs already and today's technology makes it even simpler to capture and reproduce more images; it's easy to be overwhelmed by the amount of work involved in collating these into a memory book. But, don't worry, you don't need to scrapbook every photograph ever taken. Be selective: pick highlights of your family life and start with these. Be sure to record the details of your images as soon as possible after each event; it's amazing how quickly such information is lost or forgotten. Try to work on the principle that every page layout should tell a story through a combination of words and images. As with everything, your scrapbooking skills will improve with practice. Start by creating layouts for some of your less valuable items, then move on to tackle bigger events, using cherished memorabilia, as you become more confident. Remember that creating your album should be enjoyable.

Whether you are making one large album or a smaller one that relates to a specific theme or will be given as a gift, the presentation of your scrapbook is very important. Plan your layouts carefully, making sure you cut squarely and use adhesive with care so that it doesn't spoil the look of your pages. Keep potentially damaging products and items away from precious photographs. Learn to use your camera properly, develop an eye for framing a shot and shoot the best image by using light and composition to enhance the quality of your snapshots. Get into the habit of collecting things (such as tickets and maps) that may be useful when you create your pages. Allow yourself to express your thoughts and emotions in the pages you produce.

The joy of this craft is that there are no rules, no absolute rights and wrongs; a few basic skills and a good eye are all you need to get started. I hope the techniques and projects in this book will inspire you to explore and develop your own ideas in the creation of your scrapbook.

SARAH BEAMAN

Tools and equipment

The tools and equipment needed for scrapbooking will vary depending on the techniques you use. There are some special tools, such as a paper trimmer and a heat tool, which are worth the investment if scrapbooking becomes a long-term interest. You may even have some tools and supplies purchased for other hobbies that will suddenly become useful again. Scrapbooking can be a very sociable activity; some stores offer classes and there are many clubs that meet regularly to crop and scrap together. These provide ideal opportunities to try out, share and swap equipment such as stamps and punches. You will soon start to discover your favorite techniques. Here are a few basic items that will be very useful and get you off to a good start. Buy good quality tools and supplies whenever possible.

◁ **Steel ruler:** This is essential for cutting straight edges with a craft knife.

△ **Kneadable eraser:** A soft, moldable eraser is good for removing pencil marks and cleaning up backgrounds.

▷ **Pencil:** You will need a sharp pencil for accurate marking. Choose a soft B pencil so marks can be removed easily.

△ **Bone folder:** This special tool for scoring card stock is also useful for burnishing and flattening folds.

△ **Little scissors:** These are helpful for cutting fine details and trimming fibers and threads.

◁ **Craft knife:** A decent craft knife with a supply of replacement blades is essential. Choose one with a lid or retractable blade for safety.

△ **Big scissors:** Use these for cutting paper, thin card stock and all kinds of trimmings. Cutting paper can dull scissor blades, so if you like working with fabric, keep a special pair of scissors for this purpose.

▷ **White craft glue:** This is a good, general-purpose, glue.

◁ **Adhesive pen:** This is handy for sticking on small or detailed embellishments, such as punched shapes or letters.

◁ **Spray adhesive:** This is useful for fixing delicate items or finely cut motifs, and bonding layers of paper together. There are different types available including a type for gluing vellum.

▷ **Punch:** *Often used in conjunction with the eyelet setter, this little single-hole punch comes with a selection of interchangeable heads for punching holes of different sizes. You can make a hole anywhere on a page with this punch.*

◁ **Eyelet setter:** *Use this tool to set an eyelet into a hole made with the punch. This tool also has interchangeable heads for setting various eyelets.*

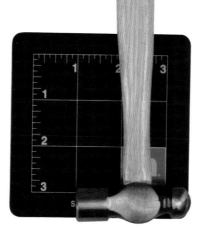

◁ **Setting mat:** *This small mat is used to protect your work surface when you are punching and setting eyelets.*

◁ **Weighted hammer:** *This small, heavy hammer makes it easy to punch holes and set eyelets. Tap it once for each layer of card you are punching through.*

▷ **Leather punch:** *Although it's designed for use on leather, this is a great tool for making several sizes of holes close to the edges of card stock or mount board.*

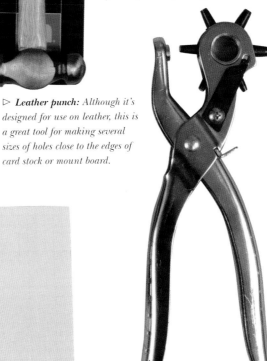

◁ **Foam pads:** *These raise the item you are attaching off the surface, giving a three-dimensional quality.*

△ **Double-sided tape:** *This is useful for all kinds of sticking jobs on many different surfaces.*

△ **Adhesive dots:** *These are a quick, convenient way to apply adhesive.*

▽ **Cutting mat:** *A self-healing cutting mat is the best surface to cut on; it protects your work surface and lasts for years. They are available in a range of sizes and many are printed with measurements which help you cut quickly and accurately and keep things square. Choose one with the measurement system you prefer.*

Using acid-free products

It is likely that your scrapbook will represent many hours and much creative energy. It may also contain irreplaceable photographs and memorabilia. You will therefore want the contents to be preserved for as long as possible and enjoyed far into the future. Many papers and materials contain chemicals that can damage or destroy photographs, or they can be unstable and discolor or fade with time. To avoid this, try to buy products that are specifically designed for archival use. These may be referred to as "acid-free," "PVC-free," "lignin-free," or "archival quality" and indicate that efforts have been made to stabilize a surface or reduce the harmful chemicals that can cause irreversible damage.

It really is up to you to decide how important the long-term preservation of your work is. It is possible to get so caught up in the mission to create enduring work that the fun and pleasure of creating it is, at best, compromised and, at worst, completely lost. Be sensible. Take no risks with precious and unique photographs; either work with specially designed products or work with a copied image and store the original away somewhere safe (in the dark at an even temperature and away from damp). The best solution may be to keep treasured archival works separate from fun, day-to-day albums that may contain various kinds of materials from unknown sources.

TECHNIQUES

The first part of this book illustrates a variety of techniques that can be used for decorating both the outside and the inside of your album. From the thousands of decorative techniques possible, I have selected a range that I think will provide simple and effective methods of drawing attention to the photographs and memorabilia to be displayed.

Almost all of the techniques have been incorporated into a project in the second part of the book. These are cross-referenced so you can see how each technique is used in the context of a finished page. These techniques are intended to provide starting points: They are flexible and can be adapted and interpreted to suit your own particular project. Make sure that the materials and techniques you choose are appropriate for, and support, the subject you are dealing with.

I hope you will develop and apply these techniques in your own unique and individual way. Use your imagination and creativity and — above all — enjoy the process.

covers and pages

It is perfectly possible to make a scrapbook album from scratch and the experienced crafter may decide to do so. Many books are available on the subject of bookbinding, the principles of which can quite easily be adapted. However, it is more likely you will be using an album chosen from the wide range available commercially. In this chapter there are ideas for customizing and personalizing a purchased album, along with techniques for protecting and preserving it. You may wish to incorporate pages within your album, interspersed with the commonly used plastic sleeves, and instructions for making these are given. There are also instructions for a minibook to make that you can use as both a journal and an embellishment for a scrapbook page.

1 paper jacket

This simple idea will give your precious album an extra layer of protection from dust and handling. Easy to make, a paper jacket is best viewed as disposable, to be replaced when it becomes tired and worn.

1 Cut a length of paper measuring exactly the height of the album you are covering by three times the width of the album plus the width of the spine.

2 Fold over one end to half the width of the album. Slide the back cover of the album into the fold.

3 Wrap the rest of the paper around the spine and over the front cover. Turn the album over and, keeping the paper taut, fold the remaining paper around the front cover.

△ *See* **Forever**, *page 112, for an alternative example of a paper dust jacket.*

1

2

3

2 fabric jacket

A fabric jacket offers more lasting protection for your album. This technique requires minimal stitching to form the flaps. The fabric's natural tension keeps the long top and bottom edges in place as the book is closed. It is important to measure your album accurately to achieve a snug fit.

△ *A fabric jacket offers great scope for decoration and embellishment. Turn to **Family album**, page 124, to see how a plain fabric dust jacket can be personalized.*

1

2

3

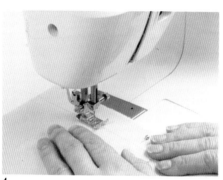
4

6

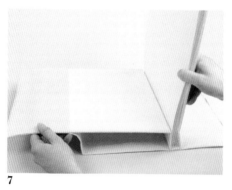
7

Getting it right
For this jacket choose fabric that is close-woven and strong; the lightweight canvas used here is ideal. The fabric should not be too thick (bulky seams will make it difficult for the cover to fit smoothly over the album). If you do not want the album cover to show through, check that the fabric is opaque before you start.

1 Following the diagram on page 138, measure the album and cut an appropriately sized piece of fabric. Trim the two short ends with pinking shears.

2 Fold over the flaps to the right side and pin them in place along the top and bottom edges.

3 Place one edge of a set square against one fold and position it so that the

perpendicular edge is 1¼ in (3 cm) from one raw fabric edge. Use a fabric marker to draw a line against the edge of the set square. Repeat the process on the top and bottom edges of both flaps.

4 Thread a sewing machine with thread to match the fabric. Set the machine to a medium-length straight stitch, then stitch along the drawn lines, backstitching at the beginning and end to secure the thread.

5 Trim the top and bottom edges with pinking shears.

6 Turn the flaps right side out and push out the corners to square them up.

7 Slip one flap over the front cover of the album. Wrap the jacket around the album and slip the other flap over the back cover.

3 embroidering a title

An obvious embellishment to the fabric jacket, a stitched title could also be used to decorate a paper dust jacket. Minimize bulky turned edges by using medium-weight fabric or bond fusible interfacing onto light-weight fabric to provide stability and prevent any show-through. Alternatively, avoid the need to turn under the edges by using a non-fraying fabric like felt.

◁ *Turn to* **Family album**, *page 124, to see how an embroidered title can be used in a project.*

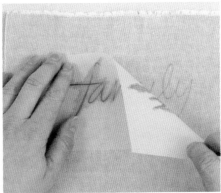

1 Iron fusible interfacing onto the wrong side of a piece of fabric.

2 Write the word you want to embroider on a piece of tracing paper. Lay the paper facedown on scrap paper and scribble over the back of the letters with the side of a pencil.

3 Lay the tracing paper scribbled-side down on the right side of the fabric. Firmly redraw the letters with the pencil. Lift the tracing paper to reveal the transferred word.

4 Thread an embroidery needle with embroidery floss and knot one end. Starting at the beginning, backstitch the word.

5 Cut the fabric to the required size plus ½ in (1 cm) all around.

6 Using an iron, press under ¼ in (0.5 cm) along the edges. Stitch (see *45 Stitching*, page 46), or glue (see *38 Adhesives*, page 42), the title straight onto a jacket or page, or mat it, instead (see *59 Felt*, page 56).

Getting it right

If you do not want to use your own handwriting, the word "family" used here is given as a template on page 139. Alternatively, you can print a word in a computer font, then scribble over the back and transfer it following the instructions above.

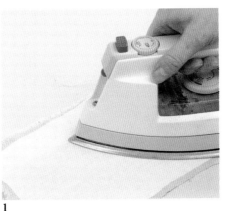

1

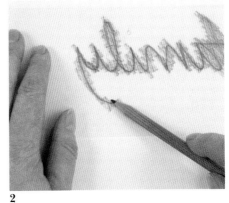

2

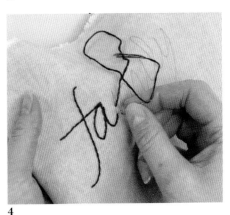

3

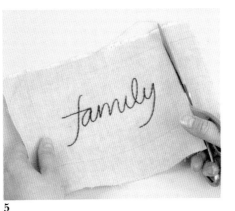

5

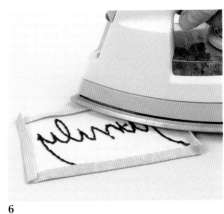

6

4 embossing a title motif

Whether the jacket is paper or fabric, it's good to provide a title or signal the theme of your album on the front. This can be done in many ways and using endless different techniques. Here, a dry-embossed heart motif has been used as a stylish method of identifying the album and providing some clue as to its contents.

1 Punch a row of hearts into medium-weight card stock.

2 Lay the punched card on a light box and lay the paper to be embossed facedown over it. Using a round-nosed embossing tool, draw around the inside of the punched hearts, gently pushing the paper down into the shape. Repeat several times for maximum effect, but do not press too hard or you may tear the paper.

3 Turn the paper faceup so the hearts stand out in relief on the front. Using a craft knife and steel ruler on a cutting mat, cut the embossed paper to size.

4 Stick a piece of double-sided tape (see *42 Double-sided tape*, page 44) onto the back of the embossed paper. The paper won't be flat, so make sure that enough of the tape sticks to form a good bond.

5 Mat the embossed paper on a piece of complementary or contrasting thin card stock. Stick it onto a jacket or page with double-sided tape.

△ *For an alternative method of embossing see* **14 Embossing with powder**, *page 20.*

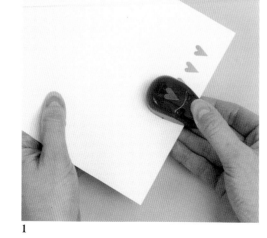

1

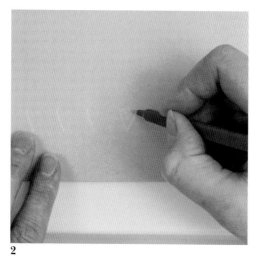

2

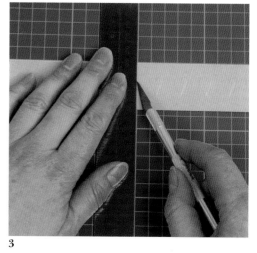

3

4

5

Getting it right

If you don't have a light box, you can tape the card stock and paper to a window. The daylight will allow you to see the shapes punched into the card.

5 page and interleaf

There are times when storing a page in a plastic sleeve is inappropriate: when layers need to be lifted (see **In the snow**, page 78) or when the material is protected another way (see **A walk in the country**, page 98). To accommodate special layouts, you can easily make pages to bind between the plastic sleeves and add variety to your memory book. A vellum interleaf can provide protection for the page facing, and offers another surface to decorate.

Getting it right

Use one of the plastic sleeves or an existing page from your album as a template and adjust the measurements given accordingly to determine the position of the holes before you punch them. The folded edge of each page acts as a spacer. If a page has high relief elements, cut a narrow strip of cardboard and punch it with holes that correspond to the holes in the page. In the album, place this cardboard strip on top of the folded edge to create extra space between the pages.

△ Turn to In the Snow, page 78, to see how the combination of a page and interleaf can be exploited in a project.

1 Cut a 13¾ x 12 in (34.5 x 31 cm) piece of paper.

2 With a bone folder score lines 1 in (2 cm) and 2 in (4 cm) from the inside short edge.

3 Fold the paper to the front along both scored lines.

4 Open the folds out, then re-fold the first line and burnish it with the side of the bone folder to crease it firmly.

5 Decide on the number and spacing of the holes you need and mark them on the folded section of the page. Using a leather punch, punch holes at the marked points. Once you have punched the page, use it as a jig to punch any others: Lay the punched page on another page, position the leather punch in each punched hole and punch through it to punch an identical hole in the page underneath.

6 If you want to include an interleaf, cut a 12¾ x 12 in (32.5 x 30.5 cm) piece of vellum or tracing paper. Slip it under the folded section of the page, then punch holes as in Step 5.

1

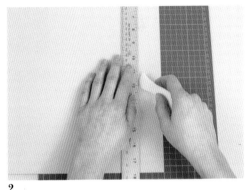
2

3

4

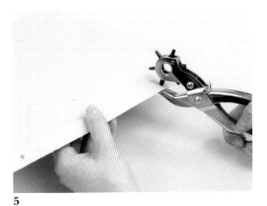
5

6

6 binding with brads

Sometimes a significant amount of journaling needs to be incorporated into a layout. A small-scale book is one way of doing so neatly and leaves much of the page free for images and other decoration. A small, transportable book is also great for on-location journaling. It is easy to make such a book which can be hand-written or assembled from printed computer text. Brads are an easy way to bind the pages and will be concealed inside the cover to give a neat finish. Use larger brads to assemble a book with more pages.

1 Cut two 5 x 3 in (13 x 8 cm) pieces of textured paper for the cover. Working on the back of one piece and using a steel ruler and a bone folder on a cutting mat, score a line ½ in (1 cm) from one long edge.

2 Fold this piece of paper to the back along the scored line. Repeat the process to score and fold the remaining piece.

3 On one piece open the folded strip. On the back, measure and mark a point ¾ in (1.5 cm) from the top edge, a point at the center and a point ¾ in (1.5 cm) from the bottom edge, all centered across the width of the strip.

4 Cut six 5 x 2½ in (13 x 7 cm) pieces of thin paper for the pages. Open out the fold on the unmarked piece of textured paper and lay it faceup on a foam mat, with the fold line to the right. Stack the sheets of thin paper with the edges aligned. Lay the left-hand edges on top of the textured paper and aligned with the fold line. Lay the remaining piece of textured paper facedown on top of the stack, aligning the edges with the first piece of textured paper and overlapping the left-hand edges of the sheets by ½ in (1 cm).

1

2

3

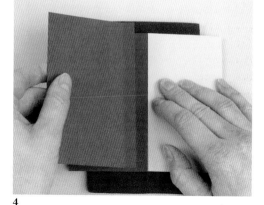

4

△ *Turn to **On the road**, page 76, to see how this minijournal can be used on a page.*

5 Hold all the pieces of paper firmly to keep them correctly aligned. Working down from the top edge and using a thick darning needle, pierce a hole through all of the layers at each marked point. Leave the needle in the lowest hole to help keep everything in position while the first two minibrads are fitted.

6 Push a brad through each pierced hole, positioning it so the opened arms will lie parallel to the edges of the paper.

7 Turn the whole book over and open out the arms of each brad.

8 Fold the textured paper covers over the pages along the fold lines. Using a craft knife and steel ruler on a cutting mat, trim the leading edges of the book to perfectly align the pages and the covers.

Getting it right

If you want a blank book to write in then bind plain pages, as shown here. If you want to bind a finished journal, print the text onto sheets of paper, using your computer to fit the text into appropriately sized blocks (so that when the paper is cut into small pages a section of text will appear on each page).

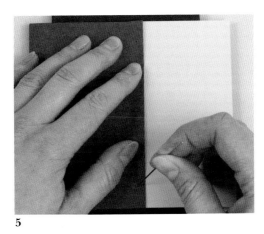
5

6

7

8

Ideas

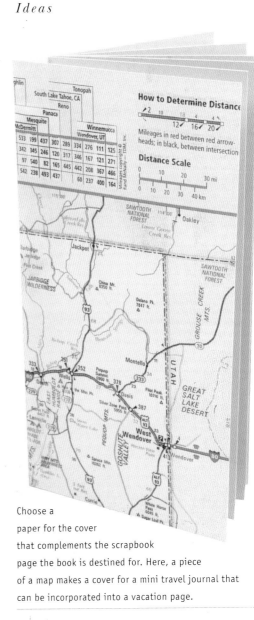

Choose a paper for the cover that complements the scrapbook page the book is destined for. Here, a piece of a map makes a cover for a mini travel journal that can be incorporated into a vacation page.

decorating backgrounds

In most instances a paper background will form the foundation for a scrapbook page. There is a huge variety of speciality papers available, trimmed to fit plastic sleeves. However, you can purchase larger sheets of paper or card stock and cut them to size. This will be necessary if you wish to make a page that can be bound into a book (*5 Page and interleaf*, page 13) or a page of a non-standard size or shape. Plain card stock provides a blank canvas on which you can create a decorated surface of your own, and some techniques for doing this are shown here. The advantage of making your own background is that colors, themes and designs can be selected and combined to set off the material used on the page and the outcome will be unique.

7 colored backgrounds

Look at art and craft papers, as well as special scrapbooking papers, when choosing colored backgrounds. There is an enormous range so you should always be able to find a color to suit a specific page.

Keen scrapbookers will keep a selection of plain colored paper and card stock on hand at all times to form the basis of many projects. A paper can be used alone, mixed with contrasting or complementary colored papers, or coordinated with patterned or textured papers. Plain colored papers can be combined to form the main decorative element in a project. See this in *Meet the family*, page 127, where careful color mixing and application gives a contemporary look. Papers can also be decorated in any number of ways to customize them for particular projects. Most of the techniques in this section are applied to plain paper: having some on hand will ensure that you are never without a starting point for a project.

▷ *As well as a variety of colors, build up a collection of papers and vellums of different weights and surfaces, such as shiny, pearl and matte finishes. This will offer you the most flexibility when you are selecting materials for a page.*

8 patterned backgrounds

There are literally thousands of patterned papers you can buy, trimmed into convenient standard-size squares and formats. Look for dollhouse wallpapers, craft papers and even real wallpapers. Some can work well as backgrounds.

You will often find a whole range of coordinating designs in card stock, paper and vellum to pick and choose from according to your needs. While patterned backgrounds add variety and interest to your layouts, care must be taken to ensure that they do not overwhelm the material you want to display. Among the least complicated and most flexible of designs are ginghams, checks, stripes and spots. In my experience, other designs and motifs are best purchased after you have collated your own images and materials. Eye-catching they may be, but fancy papers generally make unwise impulse buys to add to your stock.

▷ *As well as commercial patterned papers, consider using some of your own images as backgrounds. The photograph on the right was enlarged at a copy shop. The grainy quality of the image adds to the effect (see On the road, page 76).*

9 textured backgrounds

Textured papers fall into two main groups: those that have an abstract texture — in either a symmetrical or random pattern — and those that have an identifiable motif. The abstract textures can be used in a wide variety of projects, but the motifs should suit the theme of the page.

Used sensitively, texture can provide interest and add another dimension to a page. Again, look at art and craft papers as well as speciality scrapbooking papers when hunting for textures. A huge range — from thick handmade papers that incorporate flowers or leaves to corrugated card stock, lacy Oriental papers and embossed vellums — is easy to find. Check that the paper you choose will provide a suitable surface for applying other decorations; it can prove difficult to glue anything onto a very uneven surface.

▷ *Consider cutting out some relief elements, such as the embossed snowflakes second from the right, and applying them to a different background paper (see In the snow, page 78).*

10 collage

The strip collage technique can be used to create a background that draws together a theme and color scheme. In this one there are medium- and lightweight papers; some become almost translucent when the glue is applied. Arrange the strips carefully for best results.

1 Select patterned and plain papers that complement one another or reflect the theme of your page. These papers may include photocopies and found images (see *7 Colored backgrounds*, page 16; *8 Patterned backgrounds*, page 17; and *9 Textured backgrounds*, page 17).

2 Using a steel ruler, tear the papers into strips of random widths (see *20 Tearing*, page 25). The strips will overlap each other when they are stuck down, so ensure that you have plenty.

3 When tearing paper with long fibers in it, such as mulberry paper, tear down to a group of fibers, then gently pull the paper sideways to pull the fibers free. Carry on tearing as normal.

4 Using a wide, flat artist's paintbrush, brush a thin layer of white craft glue along the left-hand edge of the background paper.

5 Lay a torn strip vertically onto the glue. Squeeze a little more glue along the strip and brush it over the paper.

6 Lay on the next strip, just overlapping the edge of the first strip. Brush on glue as before. Repeat the process until you have covered the background.

◁ *To see how this collage can be used in a project, turn to* **Home from home**, *page 84.*

Getting it right

Have fun experimenting with this technique. The torn strips can be as wide or as narrow as you wish. Wider strips may allow any incorporated words or images to be viewed more clearly. Try incorporating cutout words, letters or images as you work.

1

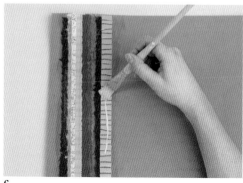

2

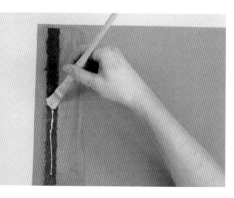

3

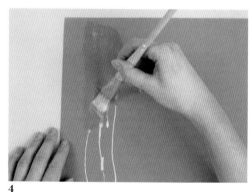

4

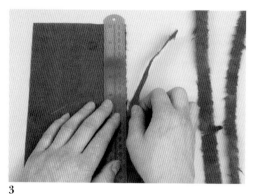

5

6

11 painting stripes and gingham

This simple technique turns plain paper into a pretty background suitable for different themes. Here, medium-weight watercolor paper (available in many sizes and finishes) has been used. Try using different-colored inks for a multicolored stripe or check. Don't worry if the lines are a little wobbly, they will add character to the finished result. It is best to work on a large sheet of paper, then trim it to size when it is dry.

△ *You can achieve a rippled stripe effect by moving the brush up and down slightly as you stroke it across the page.*

△ *Turn to* **Friends***, page 88, to see how gingham and stripes can be combined in a background for a scrapbook page.*

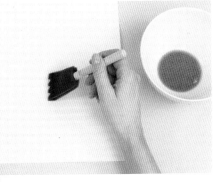

1 Dilute some ink half-and-half or more with water, depending on the saturation of color you want. Dip a notched foam brush into the ink and paint a row of stripes across the paper in one even stroke. Repeat the process, spacing each new brush stroke carefully to produce an even all-over striped pattern.

Using the same process, paint stripes perpendicular to the first stripes to make a gingham pattern.

Getting it right

A notched foam brush is easy to make. Just use scissors to snip notches in the end of a standard foam brush.

12 piercing

Piercing is a lovely technique that produces subtle and sophisticated results. Here, an individual motif has been pierced to make a mat for a photograph, but you could pierce an allover design into a background. This technique can be time-consuming but is quite therapeutic! Try using piercing tools or needles of different diameters for variety. Be sure to protect your work surface.

△ *See how the pierced mat is used in* **Happily ever after***, page 117.*

1 Enlarge the template on page 139 to the appropriate size. Trace the motif onto tracing paper. Lay the tracing on the background paper and, if necessary, hold it in place with small pieces of low-tack masking tape. Place both layers on a foam mat and, using a piercing tool or a needle, pierce evenly spaced holes along all the lines of the motif.

2 Remove any tape and lift the tracing paper to reveal the pierced motif.

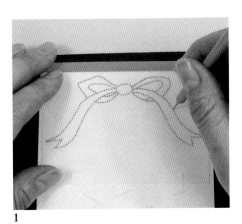

13 stamping

This technique uses a rubber stamp to repeat a motif all over a background paper. Literally thousands of stamps are available, with words and images covering all kinds of themes. It would be expensive to purchase stamps specific to each project, but a few basic motifs — such as a heart, a star and a flower — can be wise investments since you can use them to create backgrounds for many pages.

◁ *A stamped background always looks more convincing if the motif is allowed to run off the edges of the page. Work on scrap paper to protect your work surface.*

1 Press a stamp onto an ink pad to pick up some color. Here, a rainbow ink pad is being used and the stamp is pressed on straddling two colors.

2 Lay the background on a piece of scrap paper. Press the stamp down onto the background, then lift it off cleanly. Repeat the process, pressing the stamp onto the ink pad in the same position each time to avoid blurring the colors.

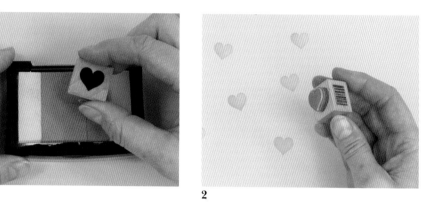

1

2

14 embossing with powder

This technique combines stamping with embossing. Here, a rainbow ink pad has been used with clear embossing powder. There is a limit to how long the ink will stay damp enough for the embossing powder to cling to it. If you have a large area to decorate, stamp and then emboss a few motifs at a time. Alternatively, you could use a clear embossing pad, designed to remain sticky longer, with a colored embossing powder.

▷ *Turn to* **Forever***, page 112, to see how an embossed background can work in a project.*

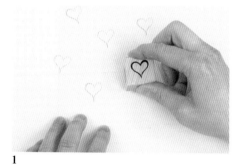

1

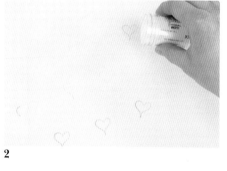

2

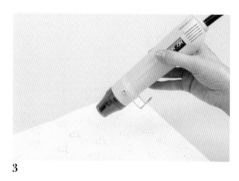

3

1 Lay the background on a piece of scrap paper. Using a pigment ink pad, stamp motifs across the paper (see *13 Stamping,* page 20).

2 Working quickly before the ink dries, sprinkle clear embossing powder over the stamped motifs. Pick up the background and tip the excess powder onto the scrap paper (later put it back in the jar to reuse).

3 Use a soft artist's paintbrush to brush off any stray flecks of powder clinging to the background or they will fuse on when they are heated. Heat the powder with a heat gun until it melts and fuses.

15 making a simple stamp

A craft punch can be used to make a simple rubber stamp. You could combine this stamped motif with a punched one to give a coordinated look to a page. There are lots of different punches available, small and large. Take a careful look at what you already have and, if you intend to purchase a new one, remember the dual function these useful items have.

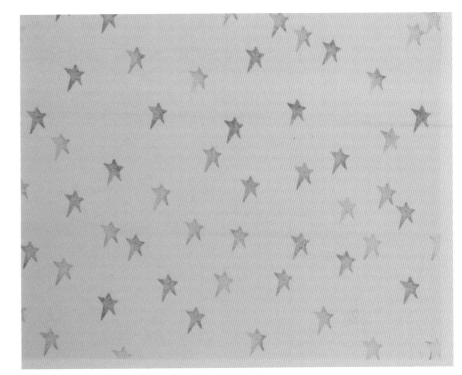

▷ *Make a wish, page 109, shows how this stamp can be used to make a patterned background for a page.*

1 Wrap a piece of waxed paper around a piece of self-adhesive rubber sheet. The waxed paper allows the rubber to slide more easily into the punch.

2 Punch out the shape.

3 Peel the backing off the rubber shape and stick it to a mount, such as the plastic bottle cap used here, which is ideal for a small stamp.

4 Press the stamp onto an ink pad and stamp onto the background (see *13 Stamping*, page 20).

Getting it right

You can use this technique to make larger stamps, including allover designs, frames and borders. Punch out a number of shapes and arrange them on a block of wood. When you are happy with the arrangement, stick the shapes onto the wooden mount.

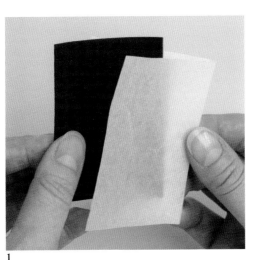
1

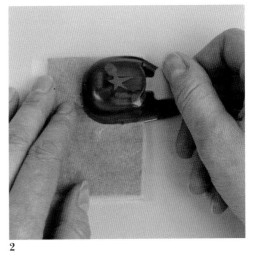
2

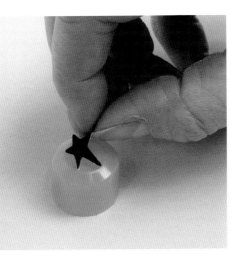
3

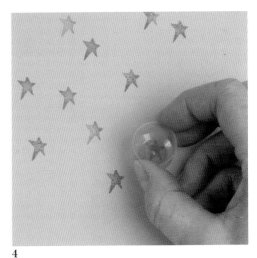
4

16 paper cutting

This is a traditional technique that usually involves paper being folded and then cut into a single motif with sections still attached at the folds. The paper is unfolded to reveal repeated motifs joined together — remember those paper chains of people holding hands? This variation has been used to make a trellis that will be laid over a contrasting background. A pair of sharp, pointed scissors is essential for cutting the fine details. You can also try using scissors with blades designed to cut decorative edges, such as scallops or zigzags, to create paper cuts.

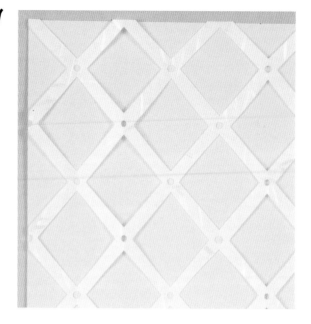

◁ *Turn to **Happily ever after**, page 117, to see this paper cut in use.*

1

2

3

4

5

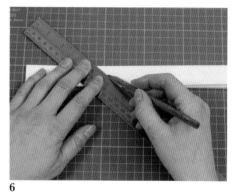

6

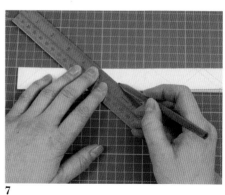

7

1 Fold a sheet of thin paper in half lengthwise so the wrong sides are together.

2 Fold it in half again, aligning this fold with the two long edges.

3 Fold over the folded edge so it aligns with the fold made in Step 2.

4 Turn the paper over. Fold over the two long edges (from Step 1) so they align with the fold made in Step 2.

5 The result should be a double-layer "M" shape.

6 Using the grid on a cutting mat and a ruler, draw a zigzag along one side of the folded paper, spacing the points of the zigzag 2¼ in (6 cm) apart on each side.

7 Draw another zigzag, parallel to the first and ½ in (1 cm) away from it.

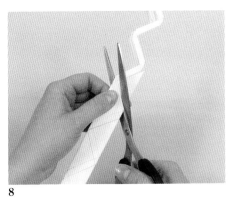

8

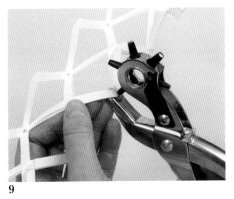

9

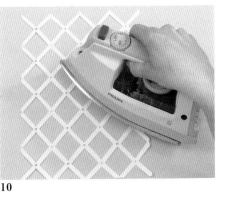

10

8 Using scissors, cut out the zigzag, being careful not to cut through the folded edges of the paper. Cut into the inside of each point from one direction, then turn the paper and cut into the point from the other direction. Make sure the insides of the points are neatly cut.

9 Open out the cut-out paper along the central fold. Using a small punch of a leather punch, punch half a hole through the fold at each diamond point. Unfold the paper along the side folds and repeat the process until every point has a hole punched in it.

10 Carefully unfold the paper completely to reveal the trellis. Using an iron set to warm, carefully press the paper flat.

17 spraying

Spraying color through materials such as lace and metal mesh can make interesting patterns on paper. You can also spray over objects such as pressed leaves, metal washers, or keys, but remember that these objects will end up covered in paint.

1 Lay the lace rightside down on scrap paper, then spray it with repositionable spray adhesive (see *39 Spray adhesive,* page 43).

2 Lay the lace sticky-side down on the background paper so the edges overlap the edges of the paper all around (try to position the lace pattern sensitively in relation to the edges of the paper). Roll over the lace with a brayer to ensure that it is firmly stuck down.

3 Following the manufacturer's instructions, spray-paint through the lace.

4 Before the paint is fully dry, carefully peel off the lace, then allow the paper to dry completely.

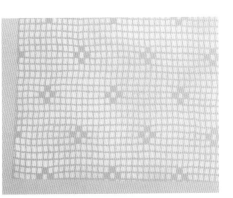

◁ *Turn to* **True love** *page 122, to see this sprayed background used in a project.*

Getting it right
Always paint in a well-ventilated room and carefully read and follow any instructions on the can. Acrylic paints are usually more environmentally friendly than oil-based ones.

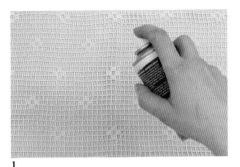

1

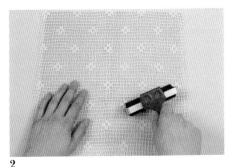

2

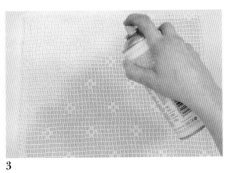

3

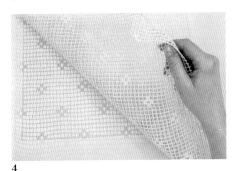

4

decorating edges

The edges of pages and mats are often overlooked as areas for decoration, but fancy edging can add to the overall look of a scrapbook page — setting it off, subtly framing and drawing attention to the images or the other materials displayed. Some of these techniques, such as coloring and hand stitching, simply add decoration to the existing edges of a page. Other techniques, such as tearing and cutting, create whole new edges. This should be taken into account from the start since your newly treated page will be smaller than the original. If you wish to work to a standard format, start with a bigger piece of card stock than usual or mount your treated page onto standard-sized card stock.

18 punching

There are different types of punches available; some are especially designed with alignment guides to help you create an even, continuous pattern. Some punch out single motifs that you can use for applied decoration (the positive and negative shapes adding interest to a page). Most punches have a limited reach, which makes them perfect for working near the edges of a page or mat. Although this punch has no alignment guides, the technique allows a continuous border to be created easily.

◁ *This punched border is decorative in its own right, but it can be taken further; see* **65 Ribbon***, page 61. Turn to* **Ellie and Kelly***, page 114, to see how it can be used in a project.*

1 Start punching from the bottom of the page: Slide the punch over the paper and align the edge of punch with the bottom of the page.

2 To let you see what you are doing, turn the punch upside down to punch the next section: To keep the pattern continuous, align part of the punch pattern with the holes already punched. Repeat the process until the whole edge is punched.

1

2

Ideas

Speciality border punches usually remove a strip of paper from the page edge as the motifs are punched. If you are making a mat, try the border on some scrap paper to ensure that the finished mat will not be too small. Use a single punch to create a random pattern along the edge of a page. Alternatively, evenly space the punched motifs by aligning the edge of the punch with the same point on each previously punched shape.

19 cutting

Paper edgers — scissors with shaped blades — are inexpensive and come in many designs. Best used on paper and thin card stock, they provide a quick method of decorating the edges of pages or mats.

1 Using paper edgers, cut the decorative edge close to the original edge of the paper. Open the scissors fully and cut, but do not close the blades completely. Realign the pattern on the shaped blades and cut again. Repeat the process until the whole edge has been cut.

1

△ *To see how paper edgers can be used on a page, turn to **Evelyn Alice Price**, page 86, and **A day in my life**, page 93.*

△ *To see how paper edgers can be used on a page, turn to **Evelyn Alice Price**, page 86, and **A day in my life**, page 93.*

Ideas

As well as speciality edgers, you can use pinking shears to create a decorative edge, as shown on the paper at left, above.

20 tearing

*These tearing techniques produce edges that resemble the distinctive deckle edges of many high-quality handmade papers. The direction of the paper grain will influence the way it tears; the result is more ragged if the paper is torn across the grain. A torn edge can look quite dramatic if colored card stock with a white core is torn (see **Sand castles and shells**, page 73).*

◁ *Turn to **Cherish**, page 130, to see how torn edges can be used in a project.*

tearing edges against a ruler

This simple technique works well with most standard papers and lightweight to medium-weight card stock.

1 Lay a steel ruler ½ in (1 cm) from the existing edge of the page. Hold the ruler firmly in place with one hand and tear the edge off the paper with the other. Tear short sections at a time, moving your hands down the ruler and paper as you work.

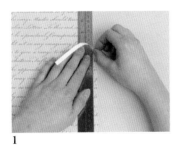

1

Getting it right

Like fabric, paper and card stock have a grain. They will crease more neatly if the fold runs along the grain line rather than across it. You can determine the direction of the grain in a number of ways: One of the easiest is to tear a scrap of the paper in one direction, then in the other. The straightest tear will indicate the direction of the grain. If you need to score paper, score a test strip to find out if the scoring works best on the front or the back of the paper. This can vary depending on the type and finish.

tearing edges with water

This is an alternative technique for producing a torn edge. It works well on thicker, less supple papers or on papers with long, uneven fibers.

1 Lay a steel ruler ½ in (1 cm) from the existing edge of the page. Dip a fine-tip artist's paintbrush in clean water and paint a line of water along the edge of the ruler. Make the paper quite wet so the line soaks through to the back.

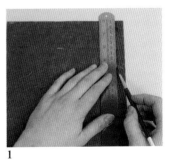

1

2 Gently tear the paper along the wet line, pulling the edge away sideways. Tear a short section at a time, moving your hands down the ruler and pulling any fibers out of the paper as you work.

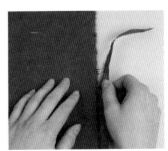

2

CORNWALL COLLEGE
LEARNING CENTRE

21 coloring

Coloring the edge of a page or mat must be one of the simplest and quickest methods of decoration. The results can look naive or sophisticated depending on the subject matter of the page. A good effect can be achieved by using these techniques on torn edges as well as straight ones.

▷ *Edges decorated with colored pencils appear in* **True love**, *page 122.*

with an ink pad

This is a clean and neat method of using an ink pad to color an edge. Ink pads are available in a huge selection of colors, even pearlized ones. The sponge applicator makes it easy to achieve lovely, soft, blended shades. If stamps form part of the decoration on the page there is the advantage that the edge color will match the stamp exactly.

▷ *Edges colored with an ink pad appear in* **A day in my life**, *page 93, and* **Cherish**, *page 130.*

1 Dab a makeup sponge onto an ink pad. Gently stroke the color down the edge of the page.

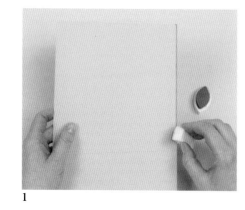

Getting it right

Apply the color sparingly, dabbing a little at a time onto the makeup sponge and wiping it onto the paper before re-inking the sponge. It is always possible to add more color, but once the ink is on the page you cannot remove it.

with a colored pencil

Many of us will have a few colored pencils around the house. Choose a color to complement the materials that will be used on the page.

1 Lay the edge of the page on scrap paper. Using the pencil point, color along the edge. Build up the color so it is deepest at the edge and fades to a lighter shade across the paper.

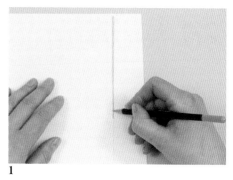

with a watercolor pencil

These can be used like ordinary colored pencils or the color on the paper can be moistened with a paintbrush for a soft watercolor appearance.

1 Lay the edge of the page on a piece of scrap paper. Using the point of the pencil, color along the edge. Build up the color so that it is deepest right at the edge and fades to a lighter shade across the paper.

2 Gently brush over the colored edge with an artist's fine-tip paintbrush dipped in clean water to soften and blend the color.

22 perforating

A sewing machine without any thread can be used to create very pretty edges that are both delicate and sophisticated. All but the most basic sewing machines can produce a variety of embroidery stitches, many of which will be effective. It's perfectly ok and great fun to use a sewing machine to perforate paper, though you may find that the needles dull more quickly than they do with cloth.

1 Set the sewing machine to the required stitch but do not thread it. Lay the paper under the presser foot, with the edge of the paper at the edge of the foot. Keeping these edges aligned, stitch along the edge of the paper.

1

◁ *You can leave the line of perforations as it is, but make sure the holes are not too close together or the strip will simply tear away. Alternatively, you can remove the narrow strip of paper outside the perforations by gently pulling it away from the paper. This will leave a pretty, lacy edge. Turn to **Happily ever after**, page 117, to see how this technique can work in a project.*

Ideas
Explore the different stitches your sewing machine can produce. You can alter the stitches by adjusting the stitch length and width. Spend some time experimenting to discover your favorite combinations.

23 machine stitching

Attractive edges can be made with machine stitching. Most machines can produce many different stitches and it's well worth experimenting with the various options. Be sure you choose the best combination of stitch length and width before you start sewing, as you won't be able to conceal any errors.

1 Thread the sewing machine and set it to your chosen stitch. Lay the paper under the presser foot, with the edge of the paper at the edge of the foot. Keeping these edges aligned, stitch along the edge of the paper. Knot the ends of the thread neatly on the back.

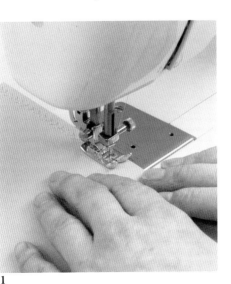

1

△ *See an embroidered edge in* **Make a wish**, *page 109.*

Ideas

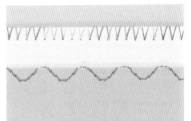

Some stitches look best placed close to the edge of a page (left), while others are better when worked over the edge (above). To stitch over the edge, position the needle carefully before you start. Ensure that it will stitch just off the edge of the card as you sew along, stitching through the card on the left-hand side of the stitch only. Try combining stitches to create more complex borders. For added interest, use metallic or multicolored threads that subtly change shade as you sew along.

24 hand stitching

Thread, embroidery floss or yarn can add an unusual dimension to the edge of a page or mat, and many different hand stitches can be used. Achieve a rustic or sophisticated effect by selecting your materials carefully. Choose from smooth, textured or multicolored threads. A basic whipstitch is one of the simplest ways to decorate an edge.

1 Measure and mark a row of dots parallel to the leading edge of the page. They should all be evenly spaced and the same distance from the edge.

2 Using a pin, pierce a hole at every dot.

3 Thread a needle with a long length of embroidery floss and knot one end. Stitching from the back to the front, pull the needle and floss through the first hole to the knot.

4 Take the needle around the edge and push it up through the next hole. Continue making stitches in the same way, keeping them all at the same angle, until the stitching is completed.

5 Knot the floss on the back.

Getting it right
Start from the bottom or the top of the page, depending on which way you want the stitches to slant.

1

2

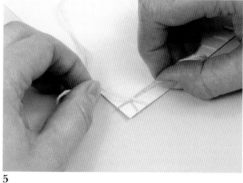
3

4

5

△ *Turn to* **Friends**, *page 88, to see another way of using whipstitch in a project.*

Ideas
Simple hand stitches can be used in different ways to enhance scrapbook pages with diverse themes. Running stitches are used in *On the road*, page 76, and *4th July*, page 104, while straight stitches decorate a panel on *A day in my life*, page 93. Try a blanket stitch on a baby page or embellish your stitches by stringing small beads or sequins onto the thread as you sew along. Consult an embroidery book to find instructions for more complex stitches.

preparing photographs

Photographs play a key role in any scrapbook, so presentation techniques and treatments are particularly important if your photographs are to be displayed to best effect. A photograph should almost always take center stage on a page, the other materials selected to complement it, not overpower it. If you are using precious photographs that cannot easily be reproduced, it is important to plan your page carefully and ensure that the techniques you choose will not damage the images. This chapter illustrates a variety of techniques for treating and preparing images. The majority of photographs will be candid snapshots that were not staged, so assess the strengths and qualities of your images and choose the method that most enhances them.

25 sepia tinting

If you want to feature an old photograph on a scrapbook page but don't want to use the original, a good quality photocopy is the answer. A color copy will pick up the sepia color that makes old photographs so attractive. However, if you do not have access to a color copier, you can tint a black-and-white photocopy with good results.

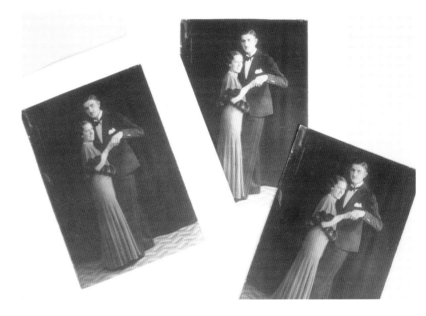

▷ *Left to right: This shows a black-and-white photocopy, a color photocopy, and the original photograph.*

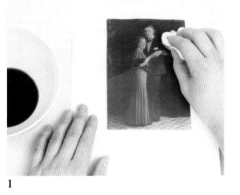

1

1 Mix a strong solution of instant coffee and hot water and allow it to cool. Dampen a cotton pad with the solution and wipe it onto a black-and-white photocopy. Allow the tinted photocopy to dry completely before cropping it. If it wrinkles, place it under a heavy book overnight to flatten it. Mat the photocopy (see *27 Single matting, page 31*) and stick it to a page (see *42 Double-sided tape, page 44*).

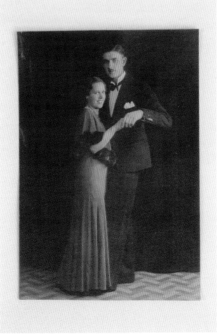

△ *Turn to **Cherish**, page 130, to see how a tinted photocopy can be used in a scrapbook.*

Ideas

Sepia tinting is also a good way of aging contemporary items so that they will fit into a heritage themed page. This color photocopy of a map originally had a bright white background that has been toned down to suit the other papers used in a collage background for *Home from home*, page 84. (See also *10 Collage*, page 18).

26 cropping

Sensitive cropping can transform a rather ordinary or poorly composed photograph into a strong and interesting image. It can help to focus the eye on the main point. Cropping can also remove, or at least disguise, unwanted or unnecessary items in the background. L-crops allow you to view your image cropped in a variety of ways and choose the optimum composition before you proceed to trim or frame the photograph. Be bold with your experimentation: An unusual cropping can be very effective.

△ *These photographs have been cropped to draw attention to the main focal point of the image and remove extraneous background. See how the cropped images are used in* **Home from home**, *page 84;* **Evelyn Alice Price**, *page 86; and* **A walk in the country**, *page 98.*

1 Draw two 2¼-in (6-cm) wide right-angled shapes on a sheet of card stock. Interlock them as shown to make them as large as possible on the sheet.

2 Using a craft knife and steel ruler on a cutting mat, cut out the L-crops.

3 To crop a photograph, hold the L-crops over it and slide them in and out to frame the picture in different ways.

4 Once you have decided how you want to crop it, measure the framed image carefully. Pick an obvious point in the photograph and measure from it to the outside edges of the framed image, then note the measurements.

5 Using the craft knife and steel ruler on the cutting mat, carefully cut the photograph to the measured size. If you are cutting a square or rectangle, you can use the grid on a cutting mat to ensure that the corners are perpendicular. Mat the photograph (see *27 Single matting*, page 31) and stick it onto a page (see *42 Double-sided tape*, page 44).

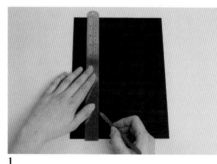

1

2

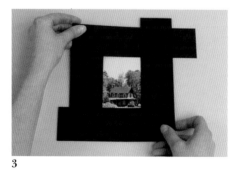

3

4

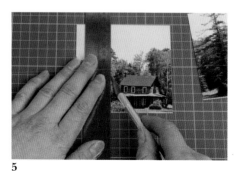

5

Getting it right

L-crops are traditionally made from black card stock, though white or a neutral gray will work just as well. Avoid strong colors, however, as they will influence the colors in the picture you are working on.

27 single matting

Attention can be drawn to a photograph if it is given a frame just as a painting might be. This is the simplest of techniques: The image is matted onto a piece of thin card stock that is slightly larger than the photograph. On a page, the mat will prevent the image from being lost against the background. The width of the border is your choice, but try to keep the scale of the mat sympathetic to the image.

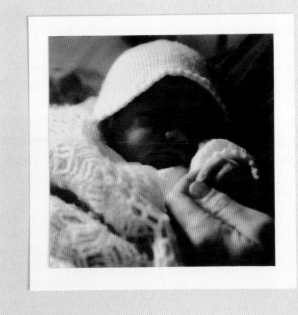

▷ *Here a classic ivory card stock is used to complement the subject matter and connect the various elements. Turn to* **Evelyn Alice Price***, page 86, to see how the matted photograph is used in a project.*

1 Lay the cropped image (see *26 Cropping*, page 30) on a larger sheet of thin card stock, positioning it in one corner to help you choose a suitable border width for the photograph.

2 Measure the border, then measure across the photograph and add the width of the border again, to determine the width of the mat you need. If the photograph is not square, repeat the process to determine the height.

3 Using a craft knife and steel ruler on a cutting mat, cut out the mat. Use the markings on the cutting mat to ensure that the corners are perpendicular.

4 Stick pieces of double-sided tape or invisible photo mounts onto the back of the photograph (see *42 Double-sided tape*, page 44).

5 Stick the photograph onto the mat, ensuring that you center it.

1

2

3

4

5

Getting it right

You can make tiny pencil marks on the mat to help you stick the image in the right position if you are not confident that you can center it by eye.

28 multimatting

This is an extension of the single-matting technique. Colored card stocks should be carefully selected to complement the image. The borders do not have to be the same width; try variations in widths and alternative ways of layering the colors before you make a decision.

1 Lay two or more pieces of colored card stock on top of each other so that at one corner all of the layers are visible. Lay the cropped photograph (see *26 Cropping*, page 30) on top of the stack and adjust the widths of the borders and the order of the colors to determine the best combination. Measure and cut each mat (see *27 Single matting*, page 31).

2 Stick the photograph onto the top mat.

3 Stick the matted photograph onto the remaining mats. Stick the multi-matted photograph onto a page with double-sided tape (see *42 Double-sided tape*, page 44).

Getting it right

Choose mat colors that complement the photograph. Here a silver metallic inner mat has been chosen to reflect the dress, while a taupe outer mat picks up the shades in the hair.

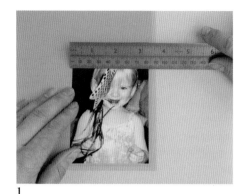

1

2

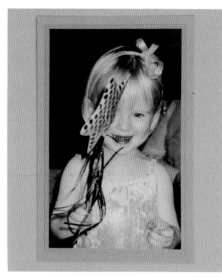

△ Turn to **Make a wish**, *page 109, to see how this mat has been used in a project.*

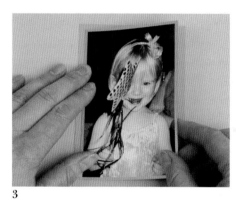

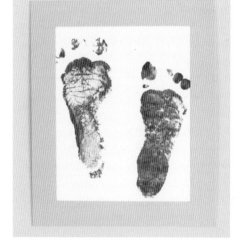

3

29 window matting

With this alternative matting technique, a photograph or artwork is framed by a piece of card stock, with a window cut out of it, that is laid on top. The window can be cut by hand or with a punch. The photograph must be bigger than the opening so that the edges of the image are covered when the mat is in place. It is often neatest to trim the edges of the window mat and photograph to size after they have been stuck together.

by hand

The advantage of this technique over using a punch is that the opening can be cut to any size. The drawback is that unless it is well cut, the opening can look rough and spoil the overall impression of a page. Use a new blade and a steel ruler and be careful to keep the opening totally square, with neatly cut corners, clean edges and no overcuts where the knife has cut too far.

1

△ *This window-matted image was prepared for* **Little toes**, *page 96.*

1 Do not crop the artwork or photograph before matting it. Measure the area of the artwork you want to display to determine what size the opening in the window mat needs to be.

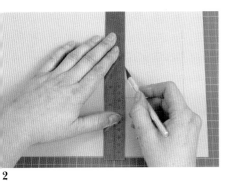

2

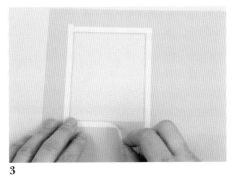

3

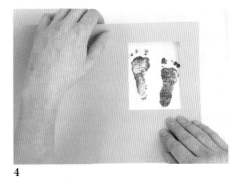

4

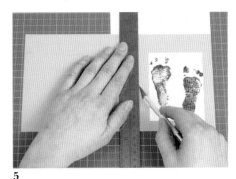

5

2 Draw an appropriately sized opening on the back of a piece of card stock. Use the grid on a cutting mat or a set square to ensure that the corners are perpendicular. Using a craft knife and steel ruler on a cutting mat, cut out the aperture.

3 With the mat facedown, stick lengths of double-sided tape around the edges of the opening (see *42 Double-sided tape*, page 44). If the frame is going to be wider than the tape, stick on more lengths of tape beside the first ones, so that both the inner and outer edges of the window mat will be stuck down.

4 Peel the backing off the tape. Positioning it carefully, stick the window mat to the artwork. Smooth the mat down with your fingers to ensure it is firmly stuck in place.

5 Decide how wide you want the frame of the window mat to be. Using the craft knife and steel ruler on the cutting mat, cut through the card and the artwork. Stick the matted artwork onto a page with double-sided tape.

Getting it right

When you are cutting out the window, do not pull away the cutout if it remains attached at a corner. Carefully cut a little farther to release it, instead.

with a punch

A punch can be used to make a neat and accurate opening for a window mat. You are, of course, limited to working with the punches you have and these may be small. Nevertheless, tiny openings can be used to pick out details in poorer quality photographs that otherwise would not be used.

1 Punch an opening in a piece of card stock.

2 Stick lengths of double-sided tape around the opening (see *42 Double-sided tape*, page 44). Peel the backing off the tape and stick the window mat onto the photograph.

3 Using a craft knife and steel ruler on a cutting mat, cut the mat to size. Stick the matted photograph to a page.

Getting it right

The opening must be large enough to contain the desired portion of the photograph, so punch a piece of scrap paper and test it first.

▷ *Try using shaped punches such as circles, hearts and stars for a different look.*

1

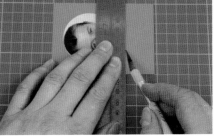

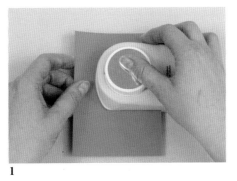

2

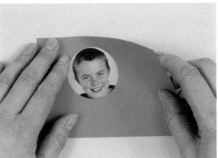

3

30 relief matting

An image can be subtly emphasized when relief matted. It gives a contemporary, frameless look and can avoid the need for any additional mat. The photograph is applied to self-adhesive mount board or thick card stock. This lifts it slightly above the background and creates a shadow line.

◁ *Turn to* **True love**, *page 122, to see this relief-matted image used on a page.*

1 Cut a piece of self-adhesive mount board that is a little larger than the photograph to be matted. Peel the backing off the mount board.

2 Center the photograph and stick it onto the mount board.

3 Use L-crops (see *26 Cropping*, page 30) to decide on how you will crop the photograph.

4 Using a craft knife and steel ruler on a cutting mat, cut through the photograph and the mount board.

5 Stick lengths of double-sided tape around the edges on the back of the mount board, then peel off the backing.

6 Stick the photograph onto a page.

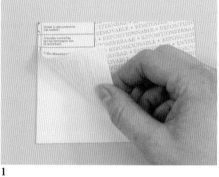

1

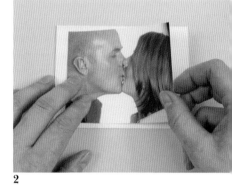

2

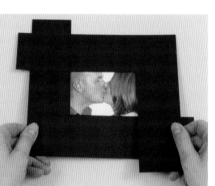

3

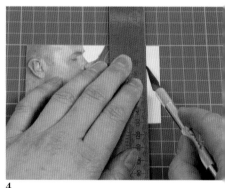

4

Getting it right

Self-adhesive mount board has a thin and even layer of adhesive that ensures perfect contact with the photograph and a smooth finish. Use spray adhesive on card stock for a similar effect. For the neatest edge, don't crop the photograph before sticking it to the mount board; it is too difficult to align the edges.

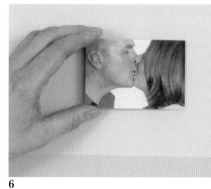

5

6

31 page template

It can be difficult and challenging to combine a group of apparently disparate photographs of random shapes and sizes on the same page and attain a pleasing result. This template provides a grid that can help you arrange and lay out the images. Decide on your main focal image and place this in the center. The template can be used either way up, so the central image can be either a landscape or portrait format. When allocating a photograph to a space, it can be helpful to be guided by the shape of the main image; a tall thin object should be matched to a long thin space, a square space filled by a square image, and so on. This will help you narrow down the possibilities.

△ The grid can be used to incorporate pieces of text, journaling and other items into the layout. To see how this can be done, turn to **Faithful friends**, page 136.

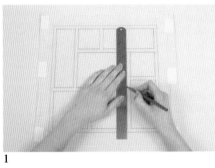

1

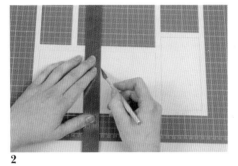

2

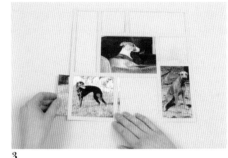

3

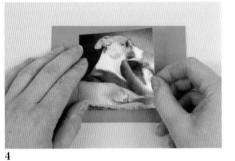

4

5

6

1 Enlarge the template on page 140 by 300 per cent. Using a pencil, trace it onto a sheet of tracing paper. Lay the tracing paper facedown on a piece of thin card stock and, using a pencil and steel ruler, redraw the lines to transfer them onto the card. This will transfer the mirror image of the template, but as you can use the template any way up, this does not matter.

2 Using a craft knife and steel ruler on a cutting mat, cut out the template. It is important to cut as accurately as possible.

3 Arrange the photographs in the spaces in the template. At this stage you are not finalizing the cropping of the photographs, you are simply deciding which photograph is going into which space. Some photographs may be too large or too small for some spaces, but this doesn't matter.

4 When you are happy with their positions, decide which of the photographs need cropping. Crop them to size. If there are any photographs that are too small for their chosen spaces, mat them onto pieces of card stock that are the right sizes to fit into the spaces (see *26 Cropping*, page 30, and *27 Single matting*, page 31). The photographs and mats must be cut to exactly the same sizes as the appropriate template windows.

5 Once you have all of the photographs cut to the correct sizes, lay the template on the background page. Using a pin, pierce a tiny hole at each corner of each window in the template.

6 Remove the template and, using double-sided tape, stick the photographs into the marked positions (see *42 Double-sided tape*, page 44).

Getting it right

If you plan to use your template often, make a more lasting version from lightweight Mylar (polypropylene).

32 focal-point matting

This technique can be used if you wish to emphasize a particular area of a photograph to create a focal point. In this instance it also highlights the scale of one element in the photograph by confirming the size of it in relation to another element. Here, the width of the mat is narrow so as not to obscure too much of the background, but the mat could have been wider if the background features were less important.

1 Select a photograph that contains appropriate elements and crop it if necessary (see *26 Cropping*, page 30). Lay the photograph on a cutting mat, squaring it up on the grid lines. Using L-crops, choose the focal point to be cut out. Use the grid on the cutting mat to ensure that the edges are parallel to the adjacent edges of the photograph. Using a pin, pierce a tiny hole at each corner of the focal point.

2 Lay the photograph facedown on the cutting mat. Using a craft knife and steel ruler, cut out the focal point of the photograph, cutting carefully and accurately between the pinholes so the surrounding section of the photograph is not damaged.

3 Cut a piece of colored paper ¹⁄₁₆ in (2 mm) larger all around than the cut-out section of the photograph. Using double-sided tape (see *42 Double-sided tape*, page 44), stick the cutout to the piece of colored paper, centering it.

4 Lay the surrounding section of the photograph facedown and stick a piece of masking tape over the hole.

5 Turn the photograph faceup and stick the back of the matted focal point to the masking tape so the colored mat overlaps the edges of the hole.

Ideas

Try using vellum to frame your focal point; this will soften the border without completely obscuring the image underneath it.

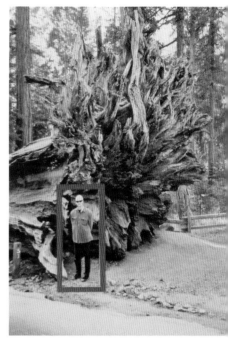

△ *This focal-point matted photograph appears in* **Yosemite**, *page 81.*

1

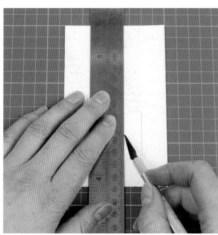

2

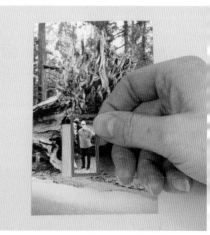

3

4

5

33 cut-out focal-point matting

It can be nice to highlight a specific detail in a photograph without completely hiding its surroundings. Vellum can be cut away to draw attention to the key feature or focal point of the picture, while the background is softened but remains visible. This technique works best with areas in the photograph that have a relatively clean edge and easy-to-cut shape.

1 Select a suitable photograph and crop it if necessary (see *26 Cropping*, page 30), then stick it onto the background. Cut a somewhat larger piece of vellum and lay it on the photograph. Using a pencil, draw accurately around the focal point.

2 Using a craft knife on a cutting mat, carefully and accurately cut out the drawn shape. Do not cut into the surrounding vellum.

3 Lay the piece of vellum over the photograph, perfectly aligning the hole with the focal point. At the corners stick the vellum onto the background paper with tiny scraps of tape.

4 Cut an opening in a piece of card stock to frame the photograph (see *29 Window matting*, page 32) and conceal the edges of the vellum. With the window mat facedown, stick lengths of double-sided tape around the edges of the opening (see *42 Double-sided tape*, page 44). Peel the backing off the tape. Positioning it carefully, stick the window mat onto the vellum and background paper.

Getting it right
Exact drawing and cutting is the key to this technique being successful.

1

2

3

4

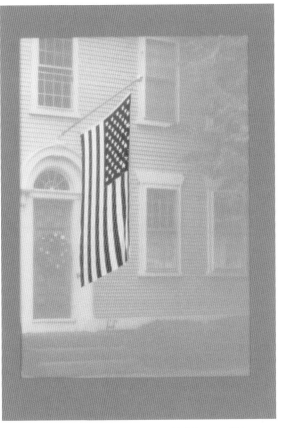

△ *See how this idea can be developed in* **4th July**, *page 104.*

34 photo mosaic

You can combine similar photographs to create a larger image. Here, strips cut from two photographs have been used to stretch a panorama, so it extends from each side of the main image. The focal points of these background photographs have been left out to create a continuous vista. The main photograph has been single matted to draw the eye.

▷ *This photo mosaic is used in* **Sand castles and shells**, *page 73.*

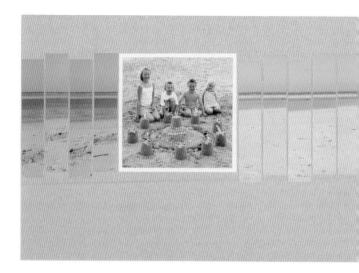

1 Stick lengths of double-sided tape across the back of the background photographs (see *42 Double-sided tape, page 44*), applying one length across the top, one across the middle and one across the bottom. Do not peel off the backing.

2 Cut the background photographs into strips for the mosaic. These can be either random or equal widths.

3 Crop and mat the main photograph (see *27 Single matting, page 31*). The mat should be the same height as the strips cut from the background photographs.

4 Arrange the main photograph and the strips on the background paper, leaving narrow gaps between them. Choose strips which work well next to each other, rather than ones from the same photograph. Make tiny pencil dots to mark the position of the main photograph. Using double-sided tape, stick the main photograph into the marked position.

5 Peel off the backing and stick one of the photograph strips next to the main photograph. Stick down the strip nearest the edge of the background, then the remaining strips in between, ensuring that they are evenly spaced (in the case of a vista, keep the horizon level for the best effect). Repeat the process to stick down the strips on the other side of the main photograph.

1

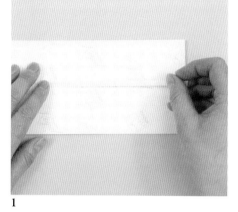

2

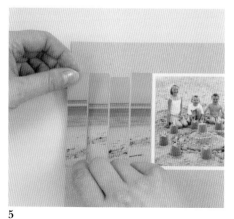

3

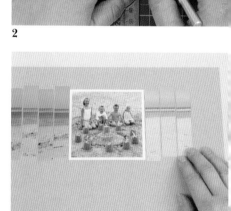

4

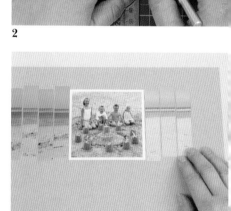

5

Getting it right

The method used in this project widens a vista, but photographs can be cut horizontally as well as vertically to create a more traditional type of mosaic. This can be a good way of combining sections of different photographs, particularly those with interesting details, but which are not very strong overall.

35 composite photographs

There are times when it is impossible to frame a complete image in a single shot: When you are trying to shoot a panorama or vista, or when you are standing close to something very tall. The answer is to take a series of photographs that capture parts of the image over a number of frames. Then you can join the prints to make one continuous picture. Be sure to overlap the frames slightly when taking the photographs to guarantee that you have captured everything.

1 Select the photographs and ensure that they overlap, ideally by about ½ in (1 cm). Lay a piece of masking tape sticky-side up on your work surface. Lay the lowest photograph on the tape, positioning it so it just overlaps the bottom edge of the tape.

2 Hold the next photograph above the first one. Look for strong, obvious vertical lines in both photographs and overlap the photographs so these lines meet as accurately as possible. (If the photograph is landscape format, strong horizontal lines may work better.) Press the photograph down onto the exposed masking tape. If you are not happy with the position, carefully peel the photograph off the tape and reposition it. Don't worry if the side edges of the photographs do not align.

3 Repeat the process to stick the remaining photographs together.

4 Go back to the first photograph and, without unpeeling the tape, fold the photographs above it to the back along the top edge of the first photograph. A narrow strip of the second photograph will protrude above the first one. Stick a length of double-sided tape onto this strip and peel off the backing (see *42 Double-sided tape*, page 44).

5 Fold the bottom edge of the second photograph over the edge of the first one again, so the double-sided tape sticks the two together. Repeat the process with the other photographs.

6 Using a craft knife and steel ruler on a cutting mat, trim the side edges of the composite photograph even.

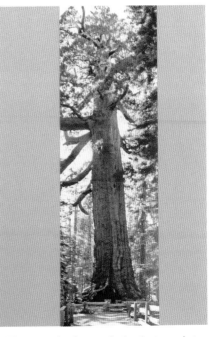

△ *This composite photograph of a giant sequoia tree appears in* **Yosemite**, *page 81.*

Getting it right

When taking photographs to make a composite, try to stand as still as possible, moving only the camera as needed. For fun, have a go at capturing a 360-degree panorama.

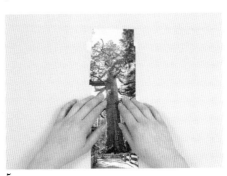

1

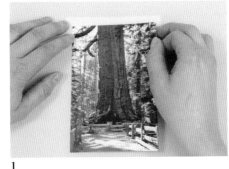

2

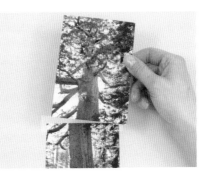

3

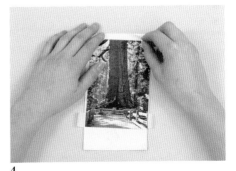

4

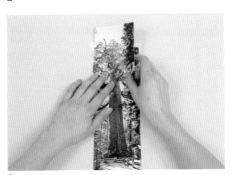

5

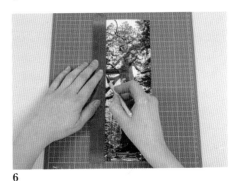

6

36 punching shapes

One of the simplest techniques to draw attention to a photograph is to change the shape into something other than the usual rectangle. This can be done with a punch by subtle shaping of corners or by punching a completely different shape out of the photograph. Choose a shape that will exclude unwanted areas of background and frame the key element of the image.

corner-rounding punch

A basic corner-rounding punch can be used to remove the sharp corners from a photograph. You can also use punches that cut more decorative corners, but beware that these do not overwhelm your photograph. They can be more effective when used to treat the corners of a mat (see **Cherish**, page 130).

1 One at a time, slide the corners of the photograph into the punch and press down to round them off. Mat the photograph (see *27 Single matting*, page 31) and stick it onto a page (see *42 Double-sided tape*, page 44).

1

△ *This shaped photograph appears in* **Things I love**, *page 106.*

shaped punch

Another neat way to use a punch is for shaping a photograph. Many fancy punches are available, but plain circles and squares are among the most useful and are especially helpful if you find it hard to keep things square or trim them neatly. The punched photograph could be matted before it is used on a page.

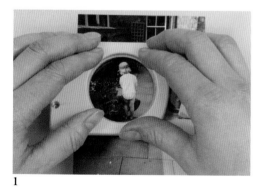

1

1 Turn the punch upside down and slide the photograph into it so that you can see exactly where you are punching. When the picture is framed as you wish, press down hard with both hands to punch it out. Using double-sided tape, stick the photograph to a page (see *42 Double-sided tape*, page 44).

△ *These square- and circle-punched photographs are components of the project* **Things I love**, *page 106.*

Getting it right
If you are nervous about punching into a photograph directly, punch the shape out of a piece of scrap paper first. Discard the cutout and hold the remaining paper over the photograph to determine the section to be punched out. A blunt punch can damage a photograph; so punch it through foil kitchen wrap a few times to sharpen the cutting edges.

37 cutting shapes

This is a useful technique, but it should be approached with a degree of caution. Using a number of shaped photographs on a single page can give a rather chaotic result: The eye finds it difficult to pick out the most important image. It is better to shape one feature photograph, then use it alone or in conjunction with other square or rectangular photographs. Obviously any shape is possible, but bear in mind that you are going to have to cut it out. Tight, rounded curves and very complex shapes can prove difficult; it really comes down to how skilled and confident you are with your scissors. In most cases, simple is best. There are also a number of commercially available gadgets to help you cut different shapes.

▷ Use sharp scissors and do not close the blades fully with each cut to achieve the smoothest edge.

1 Lay a piece of tracing paper over the photograph and draw out the shape you want, making sure it complements the composition of the photograph.

2 Cut out the tracing paper shape with scissors.

3 Lay the shape into position on the photograph. Using a pencil, draw around it.

4 Using scissors, cut out the photograph carefully, just inside the drawn line. Using double-sided tape, stick the photograph onto a page (see *42 Double-sided tape*, page 44).

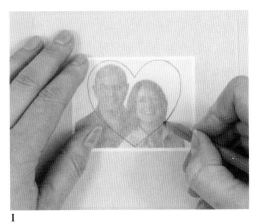

1

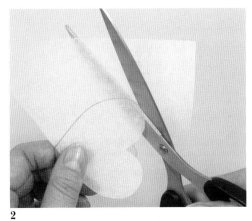

2

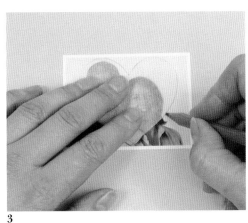

3

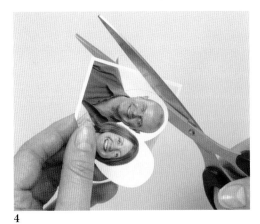

4

sticking and fixing

It is important to use suitable methods to attach different items to a page. In most instances, the fixing material should not be visible. If you are using visible fixing techniques such as eyelets, brads, stitching or photo corners, these will be part of the accents and embellishments on the finished page, and should be selected as thoughtfully as the other materials. Carefully plan the layout of the whole page before you attach anything; moving things later may be difficult to do without damaging them. Make a sketch of the layout and assemble all the components, including fixings, before you start. If necessary, lightly pencil some guidelines on the page and erase them after all of the elements are attached.

38 adhesives

There are dozens of different adhesives on the market, many of which are specially formulated for use with specific materials or groups of materials. However, you don't need to buy a whole range immediately; to suit the majority of materials and jobs, you can start with a couple of different types of adhesive.

If you are worried about the long-term effect adhesive may have on the contents of your scrapbook, choose one from the growing range of acid-free and archival-quality products (see *Using acid-free products*, page 7). One or two types of adhesive are enough to get you started, but it's surprising how many different sorts of adhesives and applicators are useful if scrapbooking becomes a serious hobby.

Take care when applying adhesive; it looks messy if it seeps out under the edges of an item and will spoil the look of the page.

Some sheer materials such as vellum will require thought and special handling. Most types of adhesive will show through sheer materials and ruin the effect. Think around the problem and try alternative fixing methods, such as brads.

△ *Choose strong, sticky, white glue that remains flexible when dry, preferably with a fine-ended applicator (left). A pen that contains two-way glue that can be used to create a permanent or temporary bond is also very useful (right).*

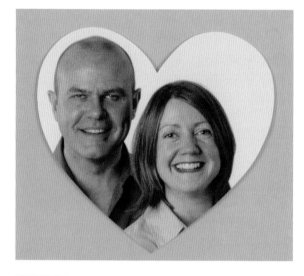

◁ *Spreading adhesive close to the edges of a photograph, but not right up to them, will help ensure that the adhesive remains where it should — on the back of the photograph and not on the front of the page.*

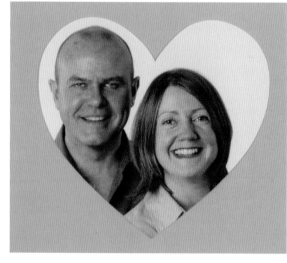

◁ *A badly stuck-down photograph with adhesive seeping out under the edges will spoil the whole look of your page. It can also cause damage. The excess adhesive can stick to the inside of a plastic sleeve, then tear the page when you try to slide it out.*

Getting it right

I find that I rarely use adhesive to stick down photographs, unless they are an irregular shape. Double-sided tape or adhesive tape are quick and clean, and usually provide more than enough sticking power.

39 spray adhesive

An acid-free, spray adhesive is invaluable for applying a sheer, allover coat of adhesive without you having to touch the surface. This is necessary if you are working with lightweight or delicate materials such as this paper cut. Spray adhesive is fast-drying and suitable for use on a variety of surfaces, and can be used to create a permanent or temporary bond. With care, it can even be used on vellum. Ensure the other items in your work area are well protected as the spray can drift, and always follow the instructions on the can.

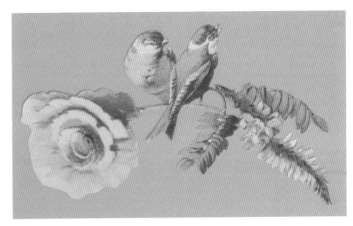

△ Turn to **Cherish**, page 130, to see this paper cut used in a project.

1 Lay the loose item facedown on a piece of scrap paper. Following the manufacturer's instructions, spray carefully to avoid disturbing the item.

2 Position the item on the page and gently press it down, ensuring that the entire surface makes contact. Rolling a brayer over a large item will ensure even contact, but cover the item with scrap paper first.

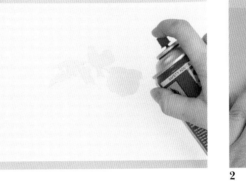

1

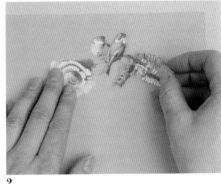

2

40 adhesive dots

These provide a quick, mess-free method of applying adhesive. They are extremely sticky and quite dry, so the adhesive will not run beyond the edges of an item, but position the dots carefully to ensure they won't show. Different sorts are available for doing different types of jobs: Three-dimensional dots are quite thick and will raise an item off a page. Thin dots are useful for most applications, except sticking lightweight papers; an impression can sometimes show on the front of the paper.

1

1 Apply the dots straight from the backing onto the back of the item you wish to stick down.

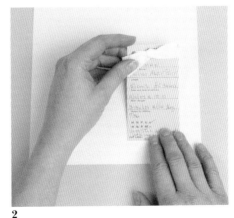

2

2 Position the item on the page and gently press it down.

△ This item has been stuck to a page using adhesive dots. It appears in **Evelyn Alice Price**, page 86.

41 adhesive tape

I find this type of adhesive particularly useful. It is quick, convenient and makes no mess. A rolling action releases dry, tacky adhesive from its backing, applying a very thin layer directly onto the surface to be stuck. It's the thinness of the adhesive that is appealing; if it is used to mat photographs there is no risk of shadow lines showing on the front. I have even used this tape to stick vellum successfully. This adhesive may not be acid-free, so seek an alternative if that is important.

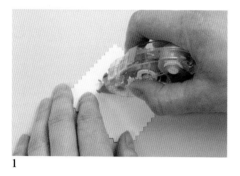

1

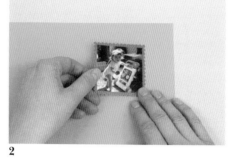

2

△ *Turn to* **A day in my life**, *page 93, to see more photographs attached using this technique.*

1 Press the tip of the dispenser onto the back of the item. Pull the dispenser along, releasing the layer of adhesive around the edges of the item.

2 Position the item over the page and firmly press it down.

42 double-sided tape

Double-sided tape is available in a range of different widths: I use widths of ½ in (12 mm) and 1 in (2.5 cm) the most. You can cut the tape to any length. On very thin or lightweight items, the thickness of the tape can create a shadow line on the front. With these, use an alternative fixing method such as adhesive tape (see **41 Adhesive tape**, *page 44) or spray adhesive (see* **39 Spray adhesive**, *page 43).*

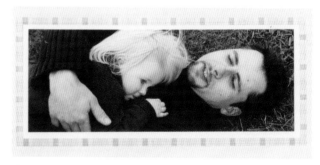

△ *Here, the same technique was used to stick the matted photograph to the page. This forms part of the project* **Dare to dream**, *page 90.*

1

2

1 Stick lengths of double-sided tape to the back of a photograph. Stick the tape close to the edges, but make sure it doesn't protrude beyond the edges. Peel off the backing.

2 Stick the photograph onto a mat (see *27 Single matting*, page 31).

Getting it right

Invisible photo mounts are also useful. These are small pieces of double-sided tape cut to a specific size. They are usually sold in a dispenser that makes it easy to peel off one photo mount at a time. The disadvantage is that they are precut. If you are taping a large area or right along an edge, you need to use more than one. However, if you are just taping the corners of a photograph, they are ideal for the job.

43 double-sided film

Sheets of this film come in a range of sizes. The layer of adhesive is protected on both sides with a backing paper, so you can easily cut it to size with scissors or a craft knife. It can even be punched to make sticky shapes that can be decorated with glitter or accent beads.

1 To make a fabric motif with a paper back, peel the backing off one side of the double-sided film and stick it onto a piece of paper.

2 Lay a piece of fabric rightside down on your work surface. Peel the remaining backing off the film and stick the paper-based film onto the fabric.

1

3 Using a pencil, draw a shape on a piece of tracing paper. Turn over the tracing paper and lay it on the paper. Firmly redraw the lines.

4 Lift the tracing paper to reveal the transferred lines.

2

5 Using scissors, cut out the shape.

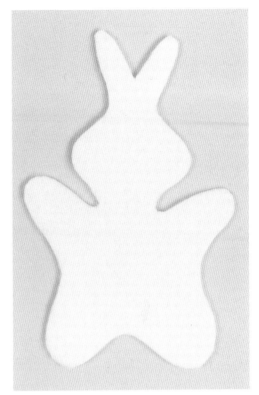

△ *This is a shaped tag that hangs on a thread in* **Friends***, page 88.*

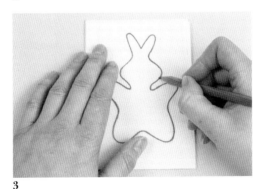

3

4

Getting it right

If you want to apply a fabric motif directly onto a page, apply the film to the wrong side of the fabric. Draw and cut out the shape as shown. Peel off the backing and stick the fabric shape directly onto the background.

5

44 foam pads

Available in different shapes and sizes, foam pads are another quick fixing method. Large pads can be cut to size if necessary. The thickness of the pads will raise the items off the background. The adhesive is quite strong and the pads are flexible; they can be good for attaching hard or rigid items onto a flexible card stock background. The foam will act as a buffer between the two surfaces.

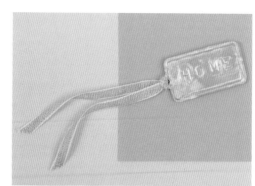

◁ *This metal tag and others are used in* **Home sweet home,** *page 132.*

1

2

3

1 Depending on the size of the item and the size of the foam pads, press one or more pads onto the back of the item.

2 Peel off the backing from each pad. Use a stack of pads if you want to create high relief.

3 Position the item over the page and gently press it down.

45 stitching

Stitching can provide an unusual fixing method for text or matted photographs, adding a naive charm to a page. Try using multicolored threads to add interest.

1 Position the item on the background. Using a pin, pierce four holes in a square through each corner of the item and background. They do not have to be perfect squares; irregularity will add to the naive look.

2 Thread a needle with two strands of embroidery floss and knot one end. From the back, push the needle through a pierced hole and make a cross-stitch over one square, stitching through the pierced holes. Take the thread to the next corner, across the back, and repeat the process until all the holes are stitched.

3 Knot the floss on the back.

1

△ *This stitched-on panel decorates* **Friends,** *page 88.*

2

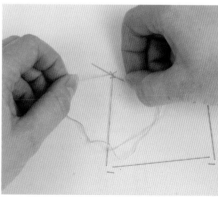

3

46 eyelets

▷ This photograph is used in **Little toes**, page 96.

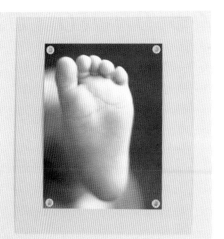

Traditionally used to thread things through, eyelets are also used to attach items to a page. This nonadhesive technique creates an understated, contemporary-looking fixing detail. Simple to apply if you have the correct tools, eyelets can hold paper, card stock or cloth together. They come in many colors and finishes, most commonly in 1/16 in (2 mm) and 1/8 in (4 mm) sizes (the smaller size can be tricky to handle).

1 Mat a photograph with double-sided tape (see *27 Single matting*, page 31). Lay the matted photograph on a setting mat. Using an eyelet punch and weighted hammer, and carefully following the manufacturer's instructions, punch a hole in each corner of the photograph, punching through the photograph and the mat.

2 Drop a colored eyelet into one of the punched holes.

3 Holding the eyelet in place, turn over the matted photograph and lay it on the setting mat. Using an eyelet setter and weighted hammer, and following the manufacturer's instructions, set the eyelet in place.

Getting it right
The holes should be positioned an equal distance from each corner. To make it easy, mark their positions with a pencil dot before punching.

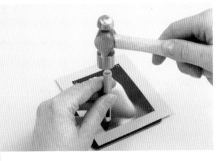

1

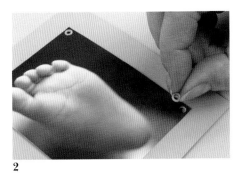

2

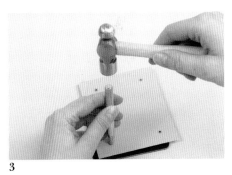

3

47 brads

Also known as paper fasteners, brads — like eyelets — are an adhesive-free fixing method which makes them useful when dealing with problem materials such as vellum. Different sizes, colors, shapes and finishes are available.

▷ Here, the brads have been chosen to match the color of the mat. See how this feature is used in **A day in my life**, page 93.

1 Using adhesive tape, stick a matted photograph onto the page. Lay the page on a cutting mat and push just the tip of a craft knife into each corner to cut a tiny slot.

2 Push the arms of a brad through each corner slot.

3 Turn the page over and open out the arms of the brads flat against the back.

1

2

3

48 photo corners

These are small corner pieces used to attach photographs onto album pages in a traditional way. They are usually made of paper with a gummed back. The craft of scrapbooking has made photo corners popular again.

▷ *Top left: These are traditional black purchased photo corners. Bottom left: These photo corners are homemade from brown paper. Right: These vellum photo corners are discreet fixings. Photo corners are used in* **Cherish**, *page 130, and* **Happily ever after**, *page 117.*

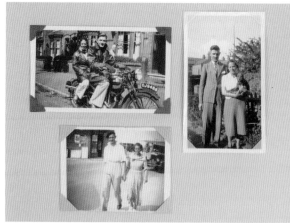

purchased photo corners

These now come in decorative shapes and a range of colors plus clear vinyl, self-adhesive types.

1 Slide a photo corner over each corner of a photograph.

2 Moisten the gummed backs or, if they are self-adhesive, peel them off the backing. Position the photograph on the page and gently press down the corners.

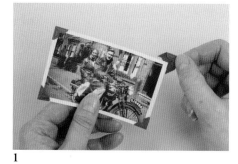

1

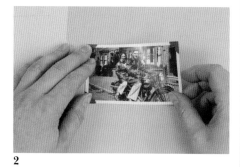

2

homemade photo corners

Have a go at making your own photograph corners to perfectly complement a nostalgic page. They are tiny, and so a bit fiddly to make, but the results are worth the trouble.

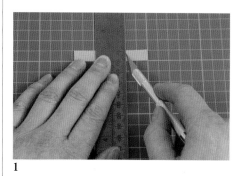

1

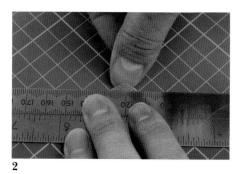

2

3

4

1 Using a craft knife and steel ruler on a cutting mat that has a ½ in (1 cm) grid, cut a strip of paper ½ x 1 in (1 x 2 cm).

2 Lay the strip on the mat so that it fits into the grid. Lay the ruler across it, from the midpoint of the top edge to one bottom corner. Fold up the triangle of paper.

3 Repeat the process in the opposite direction to make a folded corner. Press down the folds.

4 Cut a triangle of double-sided tape and stick it to the folded paper triangle, spanning the central gap.

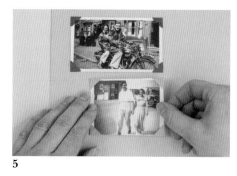

5

5 Make as many photo corners as you need. Slide one over each corner of a photograph and peel off the backing from the tape. Position and stick the photograph onto the page.

creating text

Most scrapbook pages will incorporate words as well as images and other materials. These might range from a title to a motto, a caption or a more extensive piece of journaling. Neat handwriting can be used to render words and can add a personal touch to personal subject matter. However, there are many other ways of incorporating text if you are nervous about the quality or style of your handwriting — including convenient, computer-generated fonts that have the look and feel of handwriting. It can be nice to incorporate more than one method and one font on a page, but avoid using too many techniques or the result can end up looking untidy and ill-considered.

49 choosing fonts

Fonts fall into two main categories: Serif fonts have fine cross-lines that finish off the strokes of each letter; sans-serif fonts don't. Individual fonts may have subdivisions of styles within them, such as bold and italic. These allow you to introduce variety within a single typeface. Computers make it possible to reproduce fonts easily, and you can download fonts for free from Internet sites. You can also use letter stickers, rub-down lettering and found letters. So how do you select a font for a project? Fashions come and go with fonts as with anything else, and it is mostly down to personal taste. Aim to pick a font that suits the subject matter. For example, a script such as copperplate will suit a heritage project, whereas a sans-serif font is appropriate for a contemporary project. Position text carefully and avoid combining too many fonts on one page; it takes great skill and a good eye to pull this off successfully.

▷ **On the road**, page 76. In this project, letter stickers in an uncomplicated, contemporary-looking sans-serif font have been chosen to harmonize with the clean, graphic lines of the image. The shape of the letters seems appropriate for the subject matter, while the thickness of the letters matches the width of the white markings on the road. The title is positioned so the eye scans it before being drawn off toward the strong vanishing point.

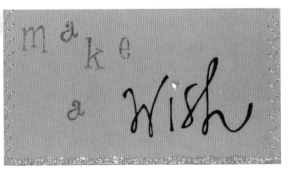

△ **Make a wish**, page 109. Two fonts from different sources have been combined to create a title for this page. Mixing techniques can be effective if careful selections are made. "Wish," the dominant word, is a rub-down transfer. Embellished with a rhinestone, it is strong enough to stand out against the bold background. The words "make a" are more muted as they are of secondary importance. They are stamped using lowercase letter stamps from an informal alphabet.

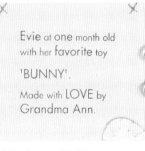

△ **Friends**, page 88. Here, a computer-generated, simple sans-serif font has been chosen to reflect the innocence and naive charm of the subject matter. Attention is drawn to key words by using capital letters, which is a good way of adding interest and variety to text without introducing different fonts. The deliberate play with the rules of written English adds an informal, childlike quality.

△ **Forever**, page 112. Names on this contemporary wedding album have been created using an informal font that mimics handwriting. For contrast, letter stickers that are more formal in shape make up part of the title which is completed with a rub-down word. Though three different fonts and types of lettering are used in a small space, they are united by their color.

50 printing

If you use a computer to generate titles and journaling, there are endless things you can do to enhance and personalize your text. Advancing technology has made color printers affordable. These can really extend your creativity if you spend a little time planning and experimenting. A computer with a reasonable-quality printer is by far the quickest and most adaptable way to record and produce words. It will help you create attractive, interesting and grammatically correct text in next to no time. Having selected your font and arranged it in a pleasing way, you need to consider its color and the material it can be printed on. A home printer should easily cope with medium-weight papers, although I have used heavier ones. I am happy to put unconventional paper through my printer, hoping that not too much can go wrong! If you are a bit more cautious, check your printer manual and look for specifically designed printer papers. There is a huge range available and all kinds of finishes and inclusions. Computer-generated text doesn't need to be dull.

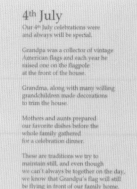

△ *4th July*, page 104. This text is printed on vellum, which will be laid over an image without concealing it. The color of the text relates to the blue of the American flag in the image this text supports.

△ *Three good friends*, page 120. This title and the striped background are all printed on plain white paper. The colors were selected to blend with tones that appear in the accompanying photograph.

◁ *Forever*, page 112. In this example, reversing a handwriting font out of the background has made a title. In other words, the lettering is the color of the original card, while the gray-green is the printed area.

51 journaling

Journaling is recording in words the events and emotions associated with photographs and other memorabilia. It can be as brief or as detailed as you wish. Some people are more comfortable and confident with this means of expression than others, but remember that journaling offers you a personal way of sharing stories, feelings and thoughts with future generations. If you find it difficult to make a start, begin with the five Ws: who, when, what, where and why; add to and embellish these as you like. With practice, you should find that writing down these things comes more naturally. If you plan to use handwriting for your journaling, avoid the possibility of making mistakes you cannot erase by writing on a separate piece of card stock that can then be matted onto the page.

△ *On the road*, page 76. Here, journaling is contained in a small-scale notebook neatly tucked into a pocket attached to the page. This mini-journal could be produced in advance and taken on a trip to record details such as routes, landmarks, accommodations. Or it could be made afterwards with the relevant information transcribed using a computer and printed on the loose pages before the book is assembled.

△ *Home from home*, page 84. The journaling here includes lists that serve as aide-mémoires. For several generations this "home" has been visited by family members throughout the year. The tags list some of the key seasonal activities that are annual events and traditions. More tags could be made and added to the pockets using this flexible journaling technique.

52 transferring text

You can transfer black-and-white printed text or images straight onto a page or a photograph mat using cellulose thinners. The text or image must be photocopied, and the quality of the copy will affect the end result. This is a quick and easy way to transfer even the most complicated words or images.

1

2

3

4

5

△ *This technique offers a neat way of adding a name to a photograph mat. The texture of the paper you transfer the photocopy onto will also affect the result. Textured paper, like the paper used here, will give an antique effect, whereas smooth paper will allow a more solid, crisper transfer.*

1 Dip a cotton swab into the thinners and wipe it over the back of a photocopy. Do not flood the photocopy, but make sure all of the image is wet. If you are transferring text, read *Getting it right* first.

2 Position the photocopy facedown on the page.

3 Firmly rub down the photocopy with the back of a teaspoon. Make sure you rub over the whole image, but do not allow the paper to move or the image will be blurred.

4 Carefully peel off the photocopy to reveal the transferred image.

5 A motif can be transferred in exactly the same way.

Getting it right

Though the word in the step photographs looks the right way around, the thinners are actually being applied to the back of the paper. Everything you transfer will be reversed on the page. This does not matter with most motifs, but text needs special treatment. You must reverse the text on a photocopy so it won't be backward on the page. Most photocopiers can do this — ask at your local copy store.

53 letter stickers

There are many types of letter stickers available in many different fonts, from flat paper stickers to thicker foam cutouts. It is helpful to position the stickers on the background before you apply them. This is easy with individual letters. If they are on a backing sheet, it may be possible to cut each one out so you can arrange them before sticking them down.

in a straight line

Carefully consider the position and arrangement of the letters. Placing them in a straight line will give a formal effect.

1

1 Before removing the backing, arrange the stickers on the page. Butt the bottoms of the stickers against a ruler so they are all in a straight line. Peel off the backing from the stickers one by one, and stick them down.

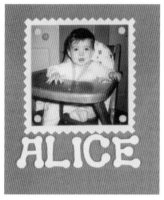

△ *The letter stickers used are the same color as the mat to give continuity.*

in an uneven line

In some cases, deliberately mis-aligning the individual letters can be effective. Easy to do, it is still worth positioning the letters before you go ahead and stick any down.

1

1 Arrange the stickers by eye on the page. It is best to space them evenly apart, even though the baseline is not straight. When you are happy with the arrangement, stick the letters down, one by one.

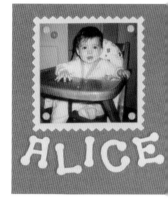

△ *A fun, informal mood is established in this example. A similar treatment appears in **A day in my life**, page 93.*

54 rub-downs

Not so many years ago rub-down letters were in the domain of graphic designers. With the advent of computers, rub-down lettering almost disappeared. Today scrapbookers love them. Rub-downs can be applied directly onto the background of a project. They generally come on a sheet of backing paper for protection.

1

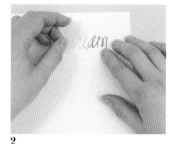

2

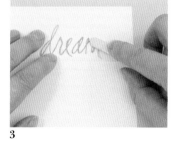

3

1 From the paper-backed sheet, carefully cut out the word or phrase you want to use. Peel off the backing and position the word on the page. Following the

manufacturer's instructions, rub it down. If a tool didn't come with the lettering, use a wooden Popsicle stick or an embossing tool with a scoop-shaped tip.

2 Peel off the covering paper.

3 Put the piece of backing paper over the rub-down and lightly burnish it with the tool.

△ *If you are going to use a ready-made rub-down motto, ensure that it truly reflects the subject matter you are dealing with. It can be better to use single words or sections of mottoes then add words of your own to them as in **Make a wish**, page 109.*

55 letter stamps

Alphabet stamps offer a flexible method of applying words to different materials and different areas of a page. You can use them with ink pads and embossing powders. Alphabets are relatively expensive, so avoid purchasing fonts that are too trendy or distinctive. Don't overuse them or you will get bored with their appearance. Consider buying two alphabets that can be used singly or mixed for variety.

in a straight line

If you are stamping a short word it is possible to simply hold the stamps together in a straight line. If the word is longer, it is better to tape the letters together, as long as no letters are repeated.

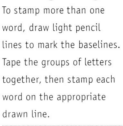

Getting it right
To stamp more than one word, draw light pencil lines to mark the baselines. Tape the groups of letters together, then stamp each word on the appropriate drawn line.

1 Lay the selected letter stamps on their sides and push the rubber faces up against a ruler so that they are all level.

2 Without moving the letters, set the ruler aside. Lay a piece of masking tape over the wooden handles and wrap it right around the letters to hold them together in a block.

3 Stamp the paper. You can use ink pads of different colors for different words.

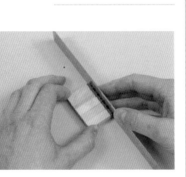

1

2

3

in an uneven line

It can be difficult to position stamped letters, especially if you are trying to center them on a specific piece of paper. This technique will help you get it right.

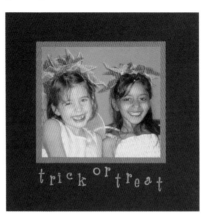

◁ *This slightly quirky, lowercase alphabet and relaxed image are used in* **Trick or treat**, *page 101.*

Getting it right
Many types of ink pads are available, even ones that enable you to print light-colored words that show up against dark backgrounds.

1 To stamp below a photograph, position the photograph on the page, but don't stick it down until you have completed the stamping to your satisfaction. Use a ruler to determine the center. Start stamping from this point, picking the middle letter (or letters) and stamping it first.

2 Work out in one direction, stamping each letter in turn, spacing them by eye. Work out in the other direction to complete the lettering. Using double-sided tape (see *42 Double-sided tape*, page 44), stick the photograph onto the page.

1

2

56 found letters

Letters torn out of magazines can be used to make a decorative heading. They can be stuck straight onto the page, as with "true," or onto a separate piece of paper that is then applied to the page. Here, "love" was stuck onto a card, which was fixed at an angle in a tiny envelope.

1 Carefully tear out the individual letters you need to make up your chosen word or phrase.

2 Position the letters on the page and stick them down with a paper adhesive (see *38 Adhesives*, page 42).

▷ *This title is used in **True love**, page 122.*

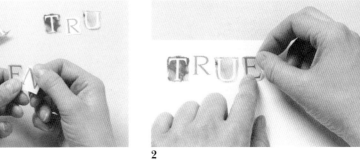

1

2

57 embossing foil

Thin metal foil can be embossed with letters using either of two simple techniques — one requires nothing more than a dried-up ballpoint pen. The foil can be cut with regular scissors and used to make tags to hang from a page or nameplates that can be attached in several ways.

▷ *Top: Attach the tags to a page using eyelets (see **46 Eyelets**, page 47). Alternatively use sticky mounting pads (see **44 Foam pads**, page 46). This nameplate has also been decorated with coiled wire (see **Home sweet home**, page 132). Create a tag by drawing around the edge of the cutout with a dried-up ballpoint pen. Punch a hole in one end and loop a piece of ribbon through it. Give foil a verdigris finish by rubbing on a little verdigris antiquing wax (see **Home sweet home**, page 132).*

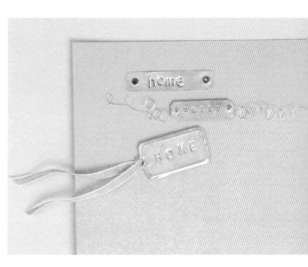

1

2

3

1 Letter stamps are available from good craft stores and are easy to use. Choose a letter, position the stamp on the foil, then firmly tap it with a small hammer.

2 Another way to emboss letters is to write them on the foil with a dried-up ballpoint pen. Lay the foil on a cutting mat or layers of paper, and write the letters, pressing firmly with the pen.

3 Once you have completed the lettering, using either or both techniques, cut the foil to the size and shape you want using scissors.

threads, ribbons and fabrics

Threads (or fibers), ribbons and fabrics come in endless types and varieties. There is something to suit every taste and theme — smooth, shiny, textured, matte, multicolored — which can add interest and a tactile dimension to any scrapbook page. Choose materials that pick up a theme or a color in your photographs or memorabilia. Bring a touch of nostalgia to a project by incorporating bits of fabric and trimming that relate directly to the subject matter, such as the swatch of fabric used from the child's dress in *Ellie and Kelly*, page 114; the white felt used to make the rabbit in *Friends*, page 88; or the piece of tartan fabric left over from a soft furnishing project in *Home sweet home*, page 132.

58 fabric pockets

Pockets made from fabric can provide an attractive and alternative presentation technique for a variety of items. Anything that is relatively flat can be enclosed (if the item is too thick you will encounter problems when sewing along the final pocket edge). Although a pocket could be stitched directly onto a page, it's a good idea to safeguard against accidents by making it up separately and then matting it.

◁ *Turn to* **Ellie and Kelly**, *page 114, to see how fabric pockets can be used on a scrapbook page.* **A walk in the country**, *page 98, shows how the technique can be developed to make a whole pocket page.*

1 Cut a piece of sheer fabric, such as organza, for the pocket. Lay it on a larger piece of paper. Thread a sewing machine with thread to match the fabric and set the machine to a medium length straight stitch. Stitch around three sides of the fabric, holding it square and flat against the paper and keeping the edge of the presser foot aligned with the edge of the fabric.

2 Tuck a small item, such as a feather, inside.

3 Stitch the open edge closed, stitching over a few of the original stitches at each corner to secure the threads. Trim the thread ends.

4 Using the grid on a cutting mat to guide you, tear the edges of the paper against a steel ruler so the paper is ½ in (1 cm) larger all around than the fabric.

1

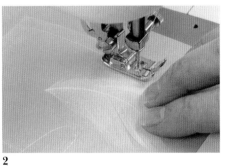

2

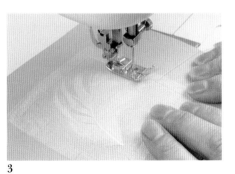

3

4

Getting it right

Not all materials are as transparent as they appear, so lay the item you want to contain in a pocket under different materials before choosing one for the job.

59 felt

Felt is an easy and versatile fabric to work with as it doesn't fray when it's cut. Available in a range of colors, it can be cut or punched into shapes to be stuck or stitched onto a page. Try cutting out letters to make titles; use a printed font to make a template.

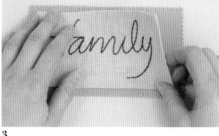

◁ *Here, felt has been used to mount the title that was embroidered on page 11. Turn to* **Family album***, page 124, to see how a mounted title can be embellished in a project.*

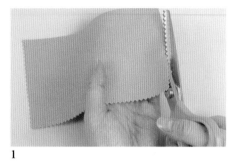

1

2

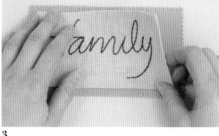

3

1 Cut a piece of felt ½ in (1 cm) larger all around than the fabric you want to mount onto it. Trim the edges closely with pinking shears.

2 Using a leather punch set to make a tiny hole, punch a hole within each point of the pinked edge.

3 Using fabric adhesive, stick the centered fabric onto the felt (see *38 Adhesives*, page 42).

60 woven fabric

In contrast to felt, many fabrics will fray when cut. Instead of seeing this as a problem, exploit it by using frayed edges to provide decorative details. For the most dramatic effect, choose fabrics where the warp and weft threads are different colors. Carefully trim the edges along the fabric grain before you fray them; keeping them straight avoids a naive, rustic look. Remember, fabric will only fray on the straight grains; you can't fray around a curve.

△ *Here, the silk fabric reflects a suitable sense of occasion and was carefully selected to pick up the rich colors in the photograph. See this developed in a project in* **Three good friends***, page 120.*

1 Using dressmaker's chalk, mark a piece of fabric the size of the photograph plus the width you want the frayed fabric edges to be all around, marking along the fabric grain. Cut out the piece of fabric, cutting carefully along the grain.

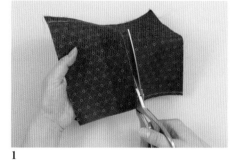

1

2 Pull out threads along the edges to fray the fabric to the right depth.

3 Relief mat the photograph (see *30 Relief matting*, page 34). Stick lengths of double-sided tape (see *42 Double-sided tape*, page 44), to the back, sticking a length along each edge. Stick the photograph onto the fabric, centering it between the frayed edges.

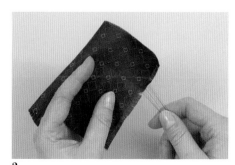

2

3

61 image transfer

For a change and to add variety to your pages, try applying images directly onto the surface of fabric. This can be done using a computer to print images onto transfer paper, but these can look a little too regular and smooth. Here is an alternative method of transferring images. It can achieve a more characterful result, particularly well suited to nostalgic images. Do not attempt this technique using an original photograph; you must use a photocopied image.

1 Photocopy the photograph (see *Getting it right*). Following the manufacturer's instructions, brush the transfer paste over the front of the photocopy, applying the paste quite thickly.

2 Lay the photocopy facedown onto a piece of fabric that is larger than the final size required. Pat the back of the photocopy with your hands to flatten it against the fabric.

3 Lay a clean piece of paper towel over the photocopy and firmly roll over it with a rolling pin or a round canister. Wipe away any excess paste that has squeezed out around the edges of the photocopy. Allow the fabric and photocopy to dry following the manufacturer's instructions.

4 Soak a sponge in water and place it on the back of the photocopy, allowing the water to soak into the paper.

5 When the paper is thoroughly wet, start gently rubbing it off the fabric with the sponge, working from the center of the paper out, to avoid lifting the image off the fabric. Rub until all the paper is removed, then allow it to dry. When the fabric is dry, some paper residue will be left on the image. Repeat the soaking and rubbing procedure to remove it.

6 Seal the image by squeezing a small amount of the transfer paste onto the picture and brushing it onto the surface with a flat artist's paintbrush. If you want to fray the edges of the fabric (see *60 Woven fabric*, page 56), ensure that you don't spread the paste beyond the edges of the picture.

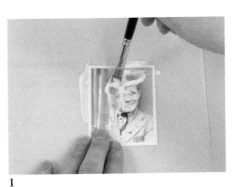

1

2

4

6

△ *Turn to* **Family album**, *page 124, to see how transferred images can be used.*

3

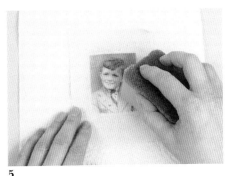

5

Getting it right

You can use a color or a black-and-white photocopy with this technique. If you are using an old black-and-white photograph, as shown here, use a color photocopy. It will make a better reproduction than a black-and-white one because it will pick up more tonal variations in the image.

62 fabric pennants

This variation on the popular technique of using tags makes a whimsical addition to a page. Use felt or a close-woven fabric to avoid frayed edges. The pennants could also be made from paper. Variegated cotton thread can add further interest.

◁ *Pennants can be embellished with letters or applied decorations such as stickers, see how in* **4th July**, *page 104.*

1 Trace the pennant template on page 139 and cut it out to make a paper pattern. Pin the pattern to your fabric and cut around it.

2 Fold under the seam allowance along the top edge and press the fold with your fingers to crease it.

3 Thread a needle with variegated crochet cotton and knot one end. Sew running stitch along the center of the seam allowance, stitching evenly to make a casing.

4 Knot the cotton at the end of the stitching and trim the end. Repeat the process to make as many pennants as you need.

5 Thread the needle with a long length of the cotton. Thread it through the stitched casings to make a string of pennants.

6 Fasten the string of pennants to a page by twisting each end around a brad, then fixing the brad to the page (see *47 Brads,* page 47).

Getting it right

If you want to use a loose-woven fabric that may fray, you can iron fusible interfacing onto the back before cutting out the pennants, but this will make them thicker and stiffer. Try pennants in different colors or patterned fabrics.

1

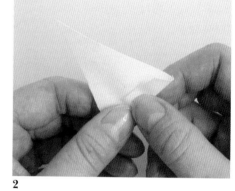
2

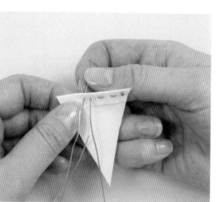
3

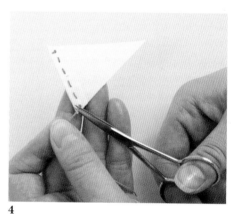
4

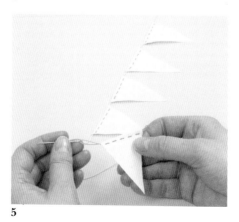
5

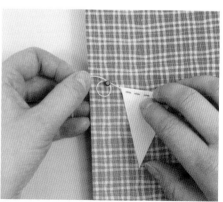
6

63 cords

The great thing about making your own cords is that colors can be selected to blend with other elements on a page. Embroidery floss is ideal for making cords. It comes in an extensive array of colors and you can easily separate the strands and combine different shades to create multicolored cords. Make cords by twisting or braiding lengths of floss.

twisted cords

These are most easily made with the help of a friend who holds the ends together as you twist. The finished cord will end up shorter than the original strands, depending on how tightly you twist them. Make a thicker cord by twisting together a greater number of strands.

△ This cord made in muted shades, is used to fasten the **Family album**, page 124.

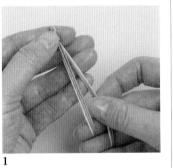

1

1 Cut lengths of embroidery floss approximately 30 percent longer than you want the finished cord to be. Knot them together at one end. Separate the strands into two groups; for an even twist there should be approximately the same number of strands in each group.

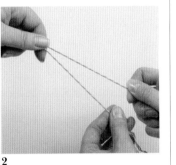

2

2 Ask a friend to hold the knotted end, or tie it to something steady to anchor it. Holding one group of strands in each hand, start to twist them, twisting both groups in the same direction.

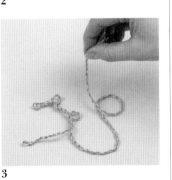

3

3 Continue twisting along the whole length until the twisted cord starts to kink. Bring the ends together and, holding them firmly, ask your friend to let go of the knot, or untie it from its anchor. Allow the strands to coil up and twist around one another. When they have stopped moving, pull the cord straight, then knot the loose ends. Trim and fluff the floss ends.

braided cords

Braided cords are another good way of combining colors to reflect a particular scheme. Again, embroidery floss is ideal. Small objects can be threaded onto the strands of the braid as you work. If floss is used, items with even tiny holes can be attached by threading them through one or two fibers. The items will be held in place as you continue braiding (see **Sand castles and shells**, page 73).

▷ Here, a shell has been worked in so that it is suspended at the bottom of the braided cord. A pale, multicolored embroidery floss was used to create the color changes.

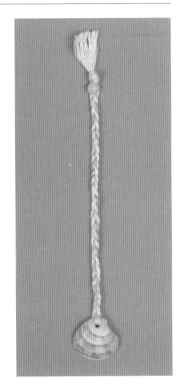

1

2

1 Cut three lengths of embroidery floss that are a little longer than twice the length you want the finished cord to be. Holding them together, thread one end through an item you want to hang. A shell with a hole in it has been used here, but you can use anything with a large enough hole. Push the item halfway down the floss.

2 Fold the floss in half around the item, bringing the two ends together. Using each doubled group of strands as one, tightly braid them together. When you have finished the braid, knot the loose ends together. The cord can be hung from a page by pushing the arms of a brad through the braid, then through a hole in the page (see *47 Brads*, page 47).

64 tassels

Tassels, which make a natural companion to cords, are easy and satisfying to make. Again, the advantage in doing this yourself is that colors can be specially selected to coordinate with the other materials being used. Using this method to make them ensures that the ends of the wrap are neatly secured.

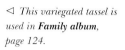

◁ *This variegated tassel is used in **Family album**, page 124.*

1 Cut a piece of stiff card stock as long as you want the finished tassel to be. Begin winding embroidery floss around the card.

2 You can use more than one color of floss to create a variegated tassel. Wind the floss around the card approximately 20 times or to make a very full-skirted tassel, wind more times.

3 Slide a length of floss under the wound loops and pull it up to the top edge. Firmly double knot the ends. Slide off the loops.

4 To wrap the neck of the tassel, cut a length of floss, then lay one end along the skirt. Tightly wrap the floss around the top of the tassel a few times over the end so it is secured.

5 Hold a tapestry needle across the wrap with the eye toward the skirt. Working from the top down, wrap floss around the tassel and needle, ensuring that each wrap is neat and tight. Make the wrap as long as you like.

6 To secure the wrap, thread the needle with the working end of the floss, then gently pull the needle underneath the wrap and out at the top.

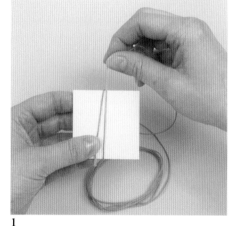

1

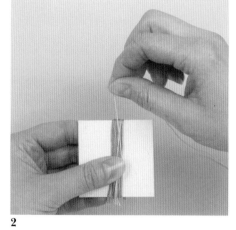

2

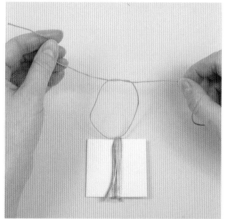

3

4

Getting it right

You can hang a tassel from a twisted or braided cord by leaving floss ends below the knot in the cord. Use these ends in Step 3 to tie the top of the tassel, then hide the ends inside the tassel.

5

6

7 Carefully trim the floss ends as close to the wrap as possible.

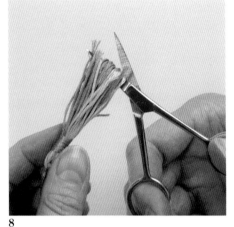

8 Cut through the loops of the tassel skirt. If necessary, trim them even.

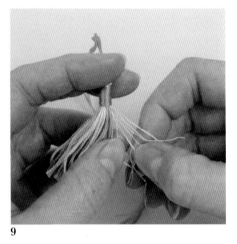

9 Unravel the floss of the skirt to make the tassel as full as possible.

65 ribbon

Ribbon has many decorative uses in scrapbooking and is available in a vast array of colors, designs and widths: There will always be a suitable ribbon to enhance and embellish a project. Think about less obvious ways of using it than the customary bow. Here, narrow ribbon has been woven through slots made by a craft punch, to make a pretty edging.

◁ *A version of this ribbon border is used in **Ellie and Kelly**, page 114.*

1 Punch a continuous border up the side of a page (see *18 Punching*, page 24). Thread a tapestry needle with ribbon that fits the punched holes. Leaving an end at the back, weave the ribbon in and out through the punched holes.

2 Trim the ends of the ribbon close to the top and bottom holes, then glue them onto the back with dabs of all-purpose gel adhesive (see *38 Adhesives*, page 42).

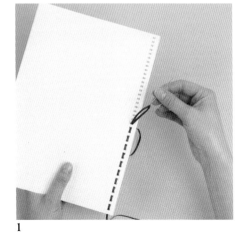

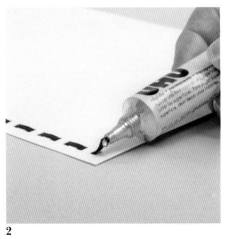

accents and embellishments

There is an ever-increasing range of decorative items available. Some are interesting and beautiful and a few are irresistible, but they are by no means personal. Use them only if they are truly relevant to the subject matter; after all, the history you are recording is entirely yours. Where possible, look for ways to incorporate your own items within a project. Though their use requires a little forethought, found objects, such as feathers, shells or pressed flowers can be far more evocative and have much greater meaning than purchased embellishments. The range of decorative accents is almost limitless; this chapter proposes just a few easily obtainable embellishments and suggests suitable methods of presenting them.

66 botanicals

Botanicals — items of plant-based origin — are abundant, unique, beautiful and often free. Please have proper respect for the environment, however, and never collect protected flowers, or damage plants and trees.

Fresh-picked leaves and flowers should be pressed prior to use. You can use a simple flower press or place them between layers of absorbent paper underneath a pile of heavy books.

Seeds and particles can be contained in fabric pockets

(see *58 Fabric pockets*, page 55), or applied to a page using double-sided tape (see *True love*, page 122).

Flowers and leaves are usually quite fragile, so choose an adhesive that will not drag their surfaces as it is applied or discolor them over time. The acid-free adhesives you are likely to use will be suitable.

Flowers can often be pressed more easily if the head and the stem are separate. Stick them back together on a background.

Pressed botanicals are now readily available at craft stores and can be an alternative to home-collected ones, depending on the nature of your project and your sense of authenticity.

To preserve your botanicals longer, it might be best to consider some additional way of protecting them, even if the page will be stored in a

plastic sleeve. They could be laminated to a background to seal them into their own permanent pocket. Do this by applying white craft glue to an area of the background slightly larger than the item. Stick on the item to and allow it to dry. Apply another layer of glue on top, completely covering the item. This technique would work well in conjunction with *10 Collage*, page 18.

△ *The panels on this page are elements used in **A walk in the country**, page 98.*

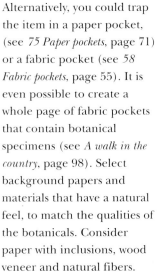

Alternatively, you could trap the item in a paper pocket, (see *75 Paper pockets*, page 71) or a fabric pocket (see *58 Fabric pockets*, page 55). It is even possible to create a whole page of fabric pockets that contain botanical specimens (see *A walk in the country*, page 98). Select background papers and materials that have a natural feel, to match the qualities of the botanicals. Consider paper with inclusions, wood veneer and natural fibers.

67 shells

Collected from Nature's treasure trove, shells are souvenirs of many seaside vacations. Flat shells are easy to accommodate, and tiny rounded ones can be used to decorate cords. Shells are often fragile; this framing technique creates a protective box around a shell. Choose materials that reflect and emphasize the color and texture of the shell. Consider hanging small shells from the bottom of the frame which will still offer them some protection.

◁ See how this technique can be used in a scrapbook page in **Sand castles and shells**, page 73.

1 Cut a paper rectangle or square. Using a craft knife and steel ruler on a cutting mat, cut a centered opening that is large enough to hold your chosen shell.

2 Cut a piece of thick card stock that is slightly smaller than the paper. Cut a centered opening that is ½ in (1 cm) larger all around than the opening in the paper.

3 Using double-sided tape (see *42 Double-sided tape*, page 44), stick the paper onto the card stock.

4 Using double-sided tape, stick the frame onto your page. Using adhesive dots (see *40 Adhesive dots*, page 43), stick the shell inside the frame.

Getting it right
You may have to stack several adhesive dots to make them thick enough to stick on a curved shell.

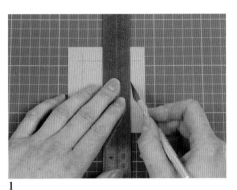

1

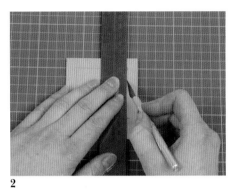

2

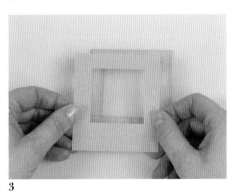

3

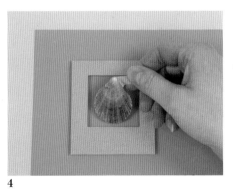

4

68 stickers

Stickers are one of the quickest ways to decorate a scrapbook page and can be chosen to reflect almost any theme imaginable. They may be flat, like the round vellum stickers in **A day in my life**, page 93, or have a raised surface like the diamanté hearts in **Things I love**, page 106. They may even be made of materials such as fabric or metal. Try making a sticker into a tag; stick it onto paper, then cut it out.

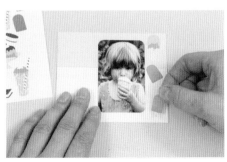

1 Peel a sticker off the backing. Position it carefully over the background before sticking it down (once stuck, it will be very difficult to remove or reposition without damaging the sticker or the background).

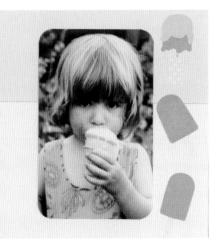

△ Only stickers that pick up the colors in the image have been used here. Use stickers sparingly; less can definitely be more. This is a component from **Things I love**, page 106.

69 paper tags

Displaying images, memorabilia and journaling on tags is very fashionable. This has given rise to a whole new technique known as tag art. Perhaps the appeal of tags lies in their scale; small and neat, they can provide an interesting, sometimes interactive way to display information. Despite the range of tags available, it is sometimes better to make your own. Then you can use materials and colors that are unique. Two methods of making basic tags are illustrated.

◁ There are many types of tags available and now they come in lovely shapes, colors and card stocks — even vellum — as well as the more traditional brown and white varieties.

cut by hand

This technique uses punches for the detailing and the finishing touches. These make the tag look very professional, but they are not vital; your tag will be fine left plain.

◁ See how tags can be used in **Home from home**, page 84.

1 Cut a rectangle of thin card stock that is the size you want the tag to be.

2 Using a craft knife and steel ruler on a cutting mat, diagonally trim each corner of one end. Use the grid on the cutting mat to help cut the angles correctly.

3 Using a corner-rounding punch, round off the bottom two corners.

4 Using a small circle punch, punch a circle out of colored paper. Stick the circle onto the tag with a dab of paper adhesive (see *38 Adhesives*, page 42), centering it along the top end.

5 Using a leather punch, punch a hole through the center of the circle.

6 Loop ribbon or embroidery floss through the hole, thread the ends through the loop and pull.

1

2

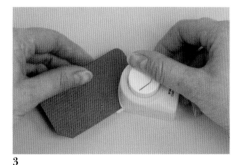
3

4

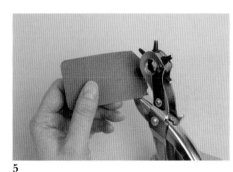
5

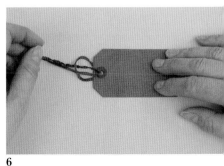
6

ut with a punch

ag-shaped punches can be used
make the process very quick. You
re, of course, limited to making
gs the same size and shape as the
unches. The circular hole-
einforcement could be added
r detail.

> If you have punches of
her shapes, try using them
make tags in the same way.

Using a tag punch, punch a tag out of
hin card stock.

Using a leather punch, punch a hole
hrough the angled end.

Loop ribbon or embroidery floss
hrough the hole, thread the ends
hrough the loop and pull.

Since tags are such a popular way to display information, it seems important to consider the different ways they can be attached to a page. There are more interesting techniques for doing this than simply gluing the tag onto the background. Consider the different options when planning the page. In this example, a number of methods are illustrated. It will be necessary to consult **Sticking and fixing** (see pages 42 to 48) for more detailed instructions on using some of the different fixing materials.

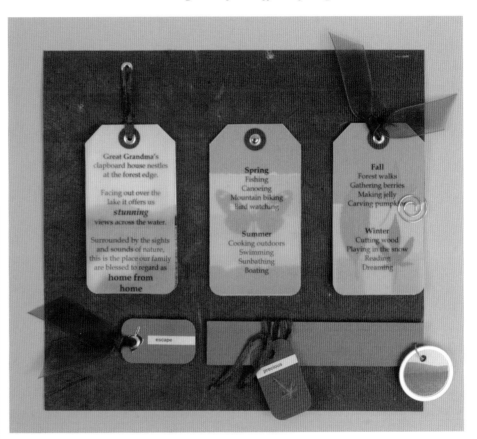

Top left: A tag can be hung from an eyelet (see 46 Eyelets, page 47). Make sure a hanging tag won't get damaged when the page is turned. If the tag is decorated on one side only, apply an adhesive dot or foam pad to the back of the tag and stick it onto the page (see 40 Adhesive dots, page 43, and 44 Foam pads, page 46). If the tag is double-sided, make a paper pocket to hold it (see 75 Paper pockets, page 71).

Top center: A single-sided tag can be fixed to a page using a brad (see 47 Brads, page 47). Ensure that the brad is larger than the hole in the tag. If your tag is round or perhaps flower shaped, try making the hole in the center of the tag and fixing the brad through it.

Top right: A tag that needs to be removable can be held against the background using a paper clip. These now come in many attractive shapes, sizes and different finishes.

Bottom left: Foam pads can be used to stick a tag onto the background (see 44 Foam pads, page 46). These raise the tag off the surface, adding an attractive shadow line around the tag.

Bottom center: Tie a tag around an item using interesting fibers. Fibers are increasingly popular in scrapbooking and can be chosen to coordinate with the color theme of your page.

Bottom right: Attach a tag with a jump ring. These come in a variety of sizes; choose one to suit the scale of the tag.

71 faux metal tags

Though it is possible to buy metal tags in different shapes and sizes, it is easy to make your own metal-look tags from thin card stock. The results are surprisingly convincing, especially when letters or words are stamped to give the appearance of engraving. Take your time, allowing the fused embossing powder to cool before you press the strip of card stock onto the embossing pad again. The decorated card stock can be cut to the desired shape using a punch or scissors.

◁ *Faux meta tags of various shapes and siz are used in* **Faithful frien** *page 136.*

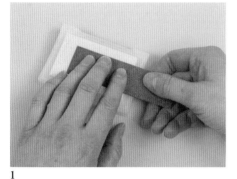

1

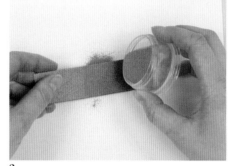

2

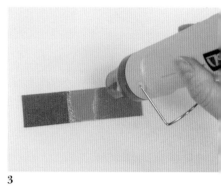

3

4

5

6

1 Cut a strip of thin card stock that is the width you want the tag to be by twice the length. Rub it across a clear embossing ink pad, inking enough card stock for the tag.

2 Lay the inked card stock faceup on scrap paper and sprinkle it with silver embossing powder, then pick it up and tip the excess powder onto the scrap paper.

3 Using a heat gun, heat the powder until it melts and fuses. Repeat the inking and embossing process three more times to build up a thick layer of embossing powder.

4 Choose the letter stamps you want to use. Line them up and tape or firmly

hold them together. Gently reheat the embossing powder and, as soon as it starts to melt, firmly push the letters into it. Hold them in place for a minute until the surface cools, then lift them to reveal the stamped letters. Allow the embossing powder to cool.

5 Turn a tag punch upside down and slide the embossed card stock into it face-up, so you can see exactly where to punch. Punch out a tag with the lettering centered toward the bottom.

6 Using a leather punch, punch a hole through the tag and thread it with a fine key chain. Fix a brad into a page (see *47 Brads*, page 47), but before you push it through, hang the key chain from it.

Getting it right

The finished tag will look more convincing if you apply the powder to thin metallic card. Select a color that matches the color of the embossing powder. The back of the tag will not be decorated and may show depending on the technique used t attach it.

Ideas

This technique can also give an engraved look to a real metal tag. Be careful when handling the tag during the embossing process; the heat gun will make it very hot.

72 wire

Craft wire is readily available in different colors and thicknesses. It can be used in many ways to add decorative touches to a page. Use it instead of thread for beadwork and stitching, or shape it into motifs. Or use it to make your own paper clips to hold materials together. It is easy to thread small beads and sequins onto wire as done in this technique, but use your imagination and creativity to take the idea further.

▷ *This method of attaching the beaded wire gives a neat finish. See it used to decorate a page in* **Make a wish**, *page 109.*

1 Decide where you want the wire decoration to start and finish on the page. Using all-purpose adhesive, stick on a sequin at the start and finish points (see *38 Adhesives*, page 42).

1

2 Using a pin, pierce a hole in the paper through the middle of each sequin.

2

3 From the front, push one end of a long length of fine wire through one of the holes. Bend it flat against the back of the page and tape it in place with masking tape.

3

4 Thread an arrangement of beads and sequins onto the loose end of the wire.

4

5 Thread the end of the wire through the other sequin and the paper. Gently pull it taut and tape it in place on the back.

5

Ideas
A flattened coil of wire can have tiny notes or photographs pushed between the circles, or small items like this key threaded onto it. See this used in *Home sweet home*, page 132.

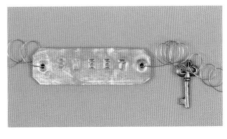

73 buttons

Buttons are among my favorite accents and embellishments; they are often miniature decorative works of art in their own right. Available in endless variations to suit all sorts of themes, buttons can add a sophisticated or casual charm to a page, and they are a natural choice for baby pages. Using buttons from a garment that belonged to someone special or selections from the family button box is a nice way to enhance a nostalgic theme. The following techniques illustrate a number of ways that buttons can be used and attached onto a page.

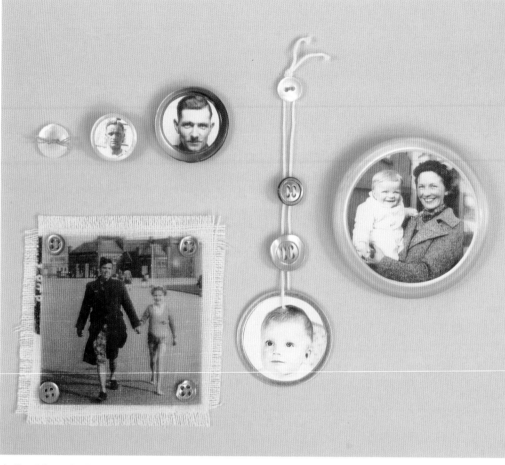

△ Top, left to right: Buttons are stitched to a page and used to carry an image.
Bottom, left to right: Buttons are used to attach an image, to decorate and attach a tag and to carry an image.
Some of these buttons decorate the **Family album**, page 124.

stitched to a page

This technique works equally well on paper and fabric. If you don't want the tuft of thread on top, work the other way around and tie the knot on the back.

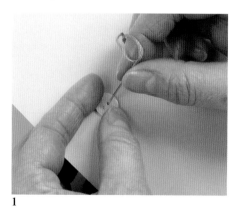

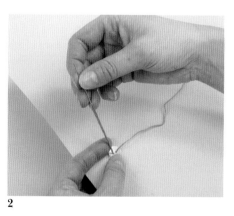

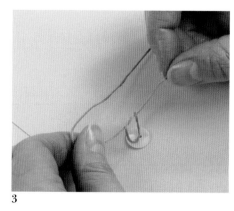

1 Lay a two-hole button in position on the page. Push a needle through the holes and pierce the paper.

2 Thread the needle. Push it down through one hole and up through the other.

3 Knot the ends of the thread on top of the button. Trim the thread ends short.

to attach an image

As well as holding an image in place, the buttons act as a frame for it, too.

1 Position the image on the page and use an invisible photo mount to hold it in place while you attach the buttons. One at a time, place a four-hole button just inside each corner of the image, then push a needle through the holes and pierce the paper.

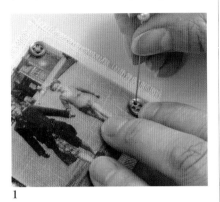
1

2 Thread the needle and push it up through one hole in a button, leaving a long thread end at the back. Push the needle back down through the diagonally opposite hole. Repeat the process with the other two holes to make a cross-stitch. Knot the thread ends on the back. Repeat the process to stitch on all the buttons.

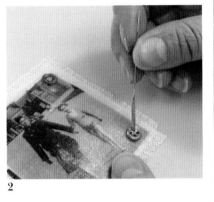
2

Getting it right

The photograph used here had been transferred onto fabric, see *61 Image transfer*, page 57, but the same technique can be used to attach an image on paper onto a page.

to decorate and attach a tag

Choose buttons that are not too heavy and are the right scale for your tag.

1 Thread the strings of a tag in and out of parallel holes in a four-hole button, then slide the button down the string until it is where you want it. When you have threaded on as many buttons as you want, knot the ends of the string.

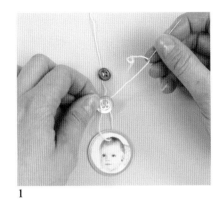
1

2 Stitch a button to the page. Hang the loop of the tag over the stitched-on button.

2

Getting it right

The button-threading technique can also be used to decorate plain string or thread (see *Friends*, page 88).

to carry an image

A flat button makes a perfect miniature photo frame.

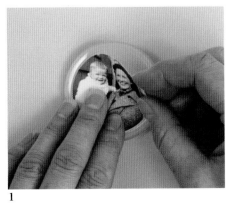
1

2

3

1 Cut a circle out of a photocopied image to fit inside the rim of a button. Using tacky glue, stick the circle onto the button.

2 If the button has a shank on the back, push the shank into a thick adhesive dot.

3 If the button is flat, use a thin adhesive dot. Stick the button onto the page.

loose memorabilia

You may not always want to attach your memorabilia directly to a page. This raises the question of how to safely and attractively store it in your scrapbook. Envelopes and pockets can provide a good solution. Use ready-made versions or make your own, choosing colors and materials to match your page. Try opaque papers to conceal the sentiments expressed by special letters or personal items, and show off other treasures under vellum or other translucent materials. Adapt the shape and size of the pockets to suit the project and the item you are storing. Whichever storage technique you use, loose items add lovely, interactive elements to your scrapbook.

74 purchased pockets

Stationery stores sell items, such as envelopes and files, that make good storage pockets and a huge selection of these are readily available. There are also scrapbook-friendly pockets available from craft supply stores. These self-adhesive pockets make good alternatives to the homemade variety.

1 Peel the pocket off the backing. Position it on the page and stick it down.

2 Tuck the item into the pocket.

1

2

△ *This looks like an ordinary vellum envelope, but it comes with a self-adhesive back specially designed for sticking onto a scrapbook page. See it used in* **Evelyn Alice Price***, page 86.*

Ideas

Use an ordinary plastic storage file to protect a journal. Plastic storage files are available in a range of sizes and can be bound into a scrapbook if corresponding holes are punched into the file. Use a page from your scrapbook to help you correctly position the holes.

75 paper pockets

These pockets are stitched flat against the page and so they will hold only reasonably slim items. The items need to be put in and taken out of such pockets with some care to avoid tearing the pockets. If an item fits snugly inside a pocket it can be easier to remove if you cut or punch a centered half-circle notch on the open edge of the pocket.

▷ Turn to **On the road**, page 76, to see how paper pockets can be used on a scrapbook page.

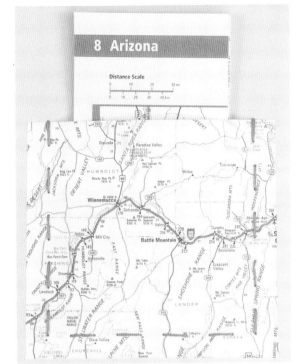

1 Cut a 4½ x 4 in (11 x 10 cm) piece of paper. Along both short sides and one long side mark points ½ in (1 cm) from each edge, ½ in (1 cm) apart. Use the grid on a cutting mat to help you position the marks accurately.

1

2 Position the pocket on the page, so the appropriate long edge is at the bottom, and secure it with pieces of low-tack tape. Lay the page on a foam mat. Using a pin, pierce a hole through both layers at each marked point. On each short side, pierce a hole — through the page only — just above the top edge of the pocket, aligned with the existing holes.

2

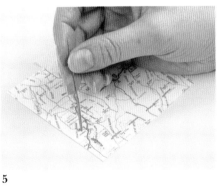

3

3 Thread an embroidery needle with embroidery floss and knot the end. Push the needle up through the top hole in the pocket on one side. Push the needle down through the hole above the pocket.

4 Push the needle up through the second hole down in the pocket.

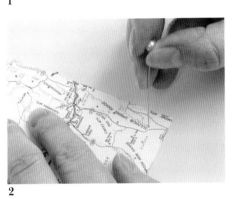

4

5

5 Sew running stitches along the three pierced edges, ending at the remaining hole just above the top edge of the pocket.

6 Knot the thread on the back.

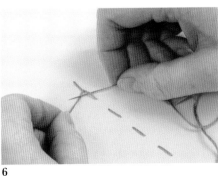

6

Getting it right

When you have worked out the size of the pocket you want for a particular project, cut a piece of scrap paper to these dimensions before cutting the project piece. Work out the stitching pattern on this test scrap to ensure that the stitches will stop and start in the right places.

PROJECTS

A scrapbook is — and should be — a uniquely personal item that is impossible to duplicate. We all have our own cherished memories, along with the photographs and memorabilia that remind us of them.

The following projects illustrate a range of themes and possible outcomes. Each project combines a number of techniques selected to enhance the subject matter.

Balance and proportion are important factors in the success of a page; dimensions are provided to help you understand the size relationship between items. You will inevitably have to adapt sizes and formats to suit your own photographs, so do not feel that you have to follow these measurements. Remember that the steps are meant as a guide and a source of inspiration for the development of your own unique pages.

My golden rules are measure twice and cut once. And never start work on a page until you have planned every detail — it's helpful to make a rough sketch of the layout before you begin.

vacation memories

For most of us a vacation is a precious time-out from our everyday activities. Vacations are quality time spent with family or friends. Most of us try a bit harder to take photographs and record places visited and sights seen, in case we don't get back there again. In addition to a collection of pictures, you will usually gather bits of interesting ephemera. Carefully stow away items, such as leaflets, tickets, found objects, postcards, timetables, menus and so on, then use them to enrich your scrapbook pages by marrying them up to your photographs when you get home. Making a scrapbook can help prolong the memories of these happy days, and allow you to enjoy your vacation experiences many times over.

sand castles and shells

Techniques that use and enhance the natural qualities of the carefully selected materials give this project strong impact and appeal. To serve as a lasting reminder of a special vacation, some of the found objects on the sand castle were retrieved before the ocean could reclaim them.

MATERIALS AND TECHNIQUES

Photo mosaic on background measuring 12 x 7⅞ in (30.5 x 20 cm)
34 Photo mosaic, page 38

Craft knife; steel ruler; cutting mat

Thick card stock measuring 12 x 6¾ in (30.5 x 17 cm)
67 Shells, page 63

Double-sided tape
42 Double-sided tape, page 44

One sheet of bright blue background paper and one sheet of pale blue background paper, each measuring 12-in (30.5-cm) square
7 Colored backgrounds, page 16
20 Tearing, page 25

Spray adhesive
39 Spray adhesive, page 43

Four small shells; four adhesive dots
67 Shells, page 63
40 Adhesive dots, page 43

Embroidery floss; found beach objects with holes
63 Cords, page 59

Two blue eyelets; eyelet kit; masking tape
46 Eyelets, page 47

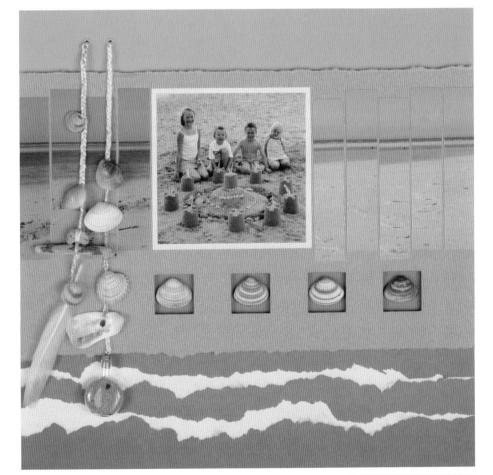

△ *Beach-combing can yield some real treasures for decorating your scrapbook, so always take a bag with you to stash them in. You can match the objects up to appropriate images when you get back home and plan out your pages.*

Choosing the pictures

The photographs that are to be cut up and used to make the mosaic on each side of the main image must contain large areas of background that are uninterrupted by people or things.

1

2

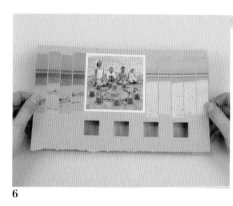

3

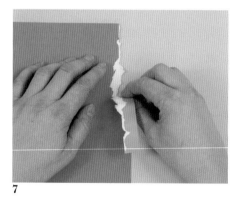

4

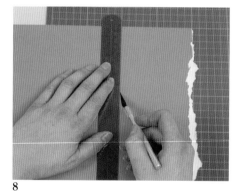

5

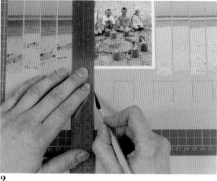

6

7

8

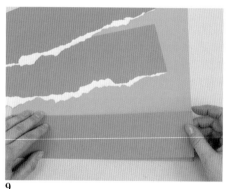

9

1 Mark four 1-in (2.5-cm) square openings (or openings that fit your shells) along the bottom of the photo mosaic. Space them 1 in (2.5 cm) apart.

2 Using the craft knife and steel ruler on the cutting mat, cut out the openings.

3 Draw four openings on the card stock. Position them so that they will sit immediately behind those in the photo mosaic, but make them ¼ in (0.5 cm) larger: These openings here are 1¼-in (3-cm) square and ¾ in (2 cm) apart.

4 Using the craft knife and steel ruler on the cutting mat, cut out these openings.

5 Tear the top and bottom edges of the photo mosaic so that it measures 7 in (18 cm) high.

6 Using double-sided tape, stick the photo mosaic onto the card stock, aligning the left- and right-hand edges and centering it vertically.

7 Tear one edge off the bright blue paper, tearing freehand toward you, to create an uneven, white-feathered edge.

8 Using the craft knife and steel ruler on the cutting mat, cut the strip approximately 3½ in (9 cm) above the torn edge, cutting perpendicular to the

straight side edges. Repeat the process to produce one more bright blue strip with a torn edge. The remaining piece of paper will have four straight edges.

9 Using double-sided tape, stick the straight-edge piece to the pale blue paper, aligning the side and bottom edges.

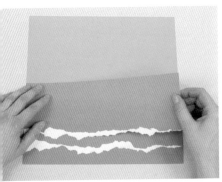

10

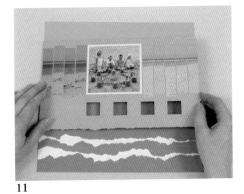

11

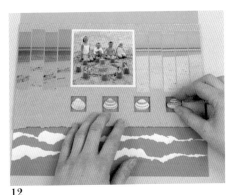

12

13

14

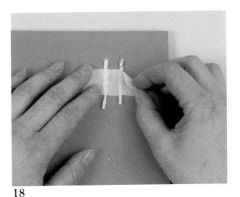

15

16

17

18

10 Stick lengths of double-sided tape onto the back of the torn strips, along the straight edges. Stick a length of tape above the highest point of the torn edge, ensuring that it does not show on the front of the paper. Peel off the backing and stick one torn strip above the straight-edged piece, overlapping the torn edge. Repeat the process to stick on the second torn strip. Approximately half of the pale blue paper should be covered.

11 Using double-sided tape, stick the photo mosaic onto the blue background, positioning it so that the openings reveal the bright blue paper.

12 Stick one or more large adhesive dots onto the back of each shell and stick one shell inside each opening.

13 Using the embroidery floss, make two braided cords incorporating the found objects: slide an object onto the floss and start braiding. Braid a short length, then slide another object onto one strand of the braid.

14 Push the object against the braided section of the cord.

15 Continue tightly braiding out from the object. Repeat the process until you have made two cords measuring approximately

8 in (20 cm) and 10 in (25 cm), leaving the last 4 in (10 cm) of each cord free of any objects.

16 Using the eyelet kit, set two blue eyelets 1 in (2.5 cm) from the top of the page. Position the first one 1¾ in (4.5 cm) in from the left-hand edge, then the second one ⅝ in (1.5 cm) from the first.

17 From the front, thread a cord through each eyelet. Pull them up until they hang down the page attractively.

18 Using masking tape, tape the ends of the cords to the back of the page.

on the road

Driving from destination to destination proved to be one of the most exhilarating and memorable aspects of this vacation. The main image really captures the big sky, wide landscape and the empty highway that we remember.

MATERIALS AND TECHNIQUES

Spray adhesive

39 Spray adhesive, page 43

Photograph enlarged on a color photocopier to 11 in (28 cm) square

8 Patterned backgrounds, page 17

12-in (30.5-cm) square white background card stock

Two landscape-format photographs, one color photograph cropped to 5 x 4 in (12.5 x 10 cm), and one photocopied, black-and-white, onto vellum and cropped to 5 x 4 in (12.5 x 10 cm)

26 Cropping, page 30

75 Paper pockets, page 71

White and yellow embroidery floss; embroidery needle

75 Paper pockets, page 71

5¼ x 1 in (13 x 2.5 cm) strip of road-map legend; 5¼ x 2¾ in (13 x 7 cm) mini-journal

6 Binding with brads, page 14

Folded road map

White letter stickers; blank aluminum key fob and chain; craft knife; silver letter and number stickers

53 Letter stickers, page 52

Large, circular silver paper clip

70 Attaching tags, page 65

1 Spray adhesive onto the back of the large photocopy. Carefully stick it to the background, positioning it so there is an equal border all around.

2 Position the two cropped images on the background, ¾ in (2 cm) from each side edge and 3 in (8 cm) from the top of the page. Make pockets by stitching the photograph to the background with yellow floss and the vellum photocopy to the page with white floss.

3 Spray adhesive onto the back of the map-legend strip and stick it onto the front cover of the journal, ¼ in (0.5 cm) from the leading edge.

4 Slide the folded road map into the photograph pocket and the journal into the vellum pocket.

5 Using the letter stickers, stick the title onto the bottom left-hand corner of the large photocopy. You may find it easiest to use the craft knife to lift the letters off the backing sheet to position them.

6 Using the silver letters and numbers, stick the route number to the key fob.

7 Slip the fob chain onto the circular paper clip. Slide the clip over the top edge of the vellum pocket.

Choosing the pictures

The background picture needs to be a clean, graphic image with simple, strong lines and plenty of space to accommodate the pockets and title. Consider the scale of the images on the pockets, reducing or enlarging them if necessary to achieve the best fit. There needs to be enough space around the edges of the pocket photographs to ensure that the stitching will not interfere with the image.

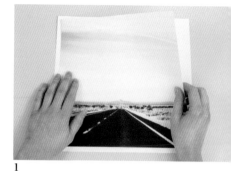

1

2

3

4

5

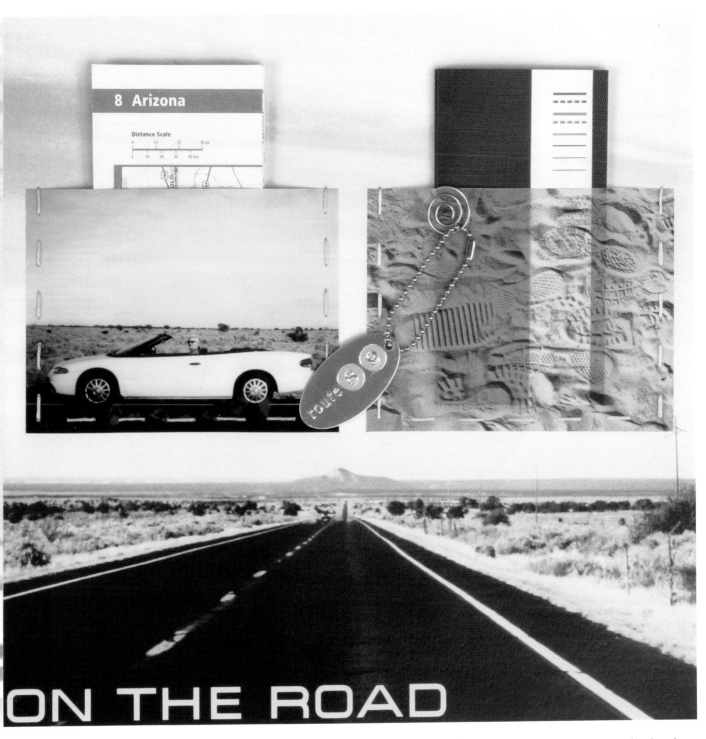

ON THE ROAD

△ Notes kept of all the highway numbers form the content of the mini-journal and help to remember the route on the map. If you don't wish to keep a full journal on your vacation, even notes in point form can prove invaluable later on in helping you recall the details. The tag bears the number of the highway in the main photograph.

6

7

in the snow

The first snowfall of winter is always exciting. What started as an opportunity to photograph the family building a snowman turned into a more extended photographic session, an attempt to capture the beauty of the snow on twigs and branches. The strong contrast between the various elements was wonderful, particularly against the azure sky.

MATERIALS AND TECHNIQUES

13 x 12 in (32 x 30.5 cm) white page with vellum interleaf (the interleaf should not be stuck onto the page)
5 Page and interleaf, page 13

Template on page 138; selection of snow photographs
31 Page template, page 35
26 Cropping, page 30

Adhesive tape
41 Adhesive tape, page 44

Silver letter stickers
53 Letter stickers, page 52

Selection of 4 to 6-in (10 to 15-cm) squares of different lightweight patterned and textured white papers; snowflake templates on page 138; small, sharp scissors; pencil; iron
16 Paper cutting, page 22

Sheet of pearlescent embossed snowflake paper

Spray adhesive; scrap paper; brayer
39 Spray adhesive, page 43

White snowflake stickers
68 Stickers, page 63

Double-sided tape
42 Double-sided tape, page 44

1

2

3

4

5

6

1 Arrange the photographs inside the spaces on the template, cropping them if necessary. Leave the edge of the page under the folded section blank. Stick lengths of adhesive tape to the back of each photograph, sticking one length along each edge. Stick the photographs onto the page in the planned arrangement.

2 Lay the vellum interleaf over the page, but do not stick it down. Using the silver letter stickers, stick on the title, aligning the letters with an edge of one of the photographs underneath.

3 Fold a square of patterned or textured paper in half diagonally, to make a triangle.

4 Fold the paper in half again, to make a smaller triangle.

5 Accordion-fold the triangle into three sections, aligning the long straight edges perfectly.

6 Enlarge one of the snowflake templates so it fits over the folded paper. Trace the outline onto the paper. Using the scissors, cut it out.

IN THE SNOW

△ Strong contrast in the images and careful positioning of the cut out snowflakes allows you to see enough of the background through the vellum to know what the page is about. This technique could be adapted to suit other themes using lacy heart cutouts over a valentine or wedding page, or leaves for a fall theme.

Choosing the pictures

A project of this type works best when you have a selection of images that show the subject matter in various ways. Contrast makes this example work, in combination with variety of scale and proportion. Close-ups and tight crops are best balanced with midrange and long-distance shots, so that it is possible to tell what it is you are looking at and have some context for the subject matter.

7 Unfold the paper to reveal the paper cut snowflake.

8 Set the iron to warm and press the snowflake flat. Repeat the process, using the remaining squares and different snowflake templates, until you have enough snowflakes to cover the vellum.

9 Using the scissors, carefully cut some snowflakes out of the embossed paper.

10 Arrange the snowflakes on the vellum, sensitively positioning them over and around the photographs. Position some so they overlap the edges of the vellum and others so they overlap each other.

11 Lift the vellum off the page of photographs, being careful not to disturb the arrangement of snowflakes. Leaving the others in position on the vellum, place one snowflake face-down on scrap paper, then spray adhesive onto the back of it.

12 Stick the snowflake into position on the vellum.

13 Lay a clean piece of scrap paper over the snowflake and roll over it with a brayer to ensure that it is firmly stuck down. Repeat the process until all of the snowflakes are stuck into position. You need to work methodically so that you stick down the overlapping snowflakes in the right order.

14 Stick some snowflake stickers onto the decorated vellum, allowing some of them to overlap the edges of the vellum and others to overlap the snowflake cutouts.

15 Using the scissors, trim off the snowflakes even with the edges of the vellum, being careful not to cut the vellum.

16 Stick a length of double-sided tape along the blank edge of the page under the folded section. Stick the vellum to the tape, aligning the edges of the vellum with the edges of the page all around.

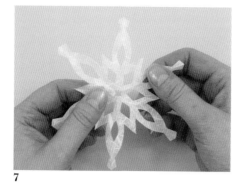

7

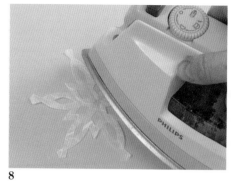

8

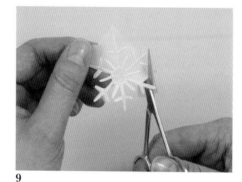

9

10

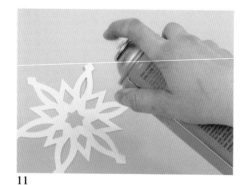

11

12

13

14

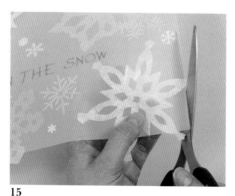

15

16

yosemite

These photographs record a visit to the home of the towering and majestic giant sequoia trees, and are taken from almost identical spots to those used by family members of a previous generation when they visited the area many years before.

Choosing the pictures

Using different photographs of the same subject matter can reinforce the atmosphere of an interesting location or event. Here, the composite photograph really gives some sense of the scale of the trees, and the supporting photographs serve to emphasize this.

MATERIALS AND TECHNIQUES

12-in (30.5-cm) square of white background card stock; 12 x 8¼ in (30.5 x 21 cm) piece of leaf-patterned paper; spray adhesive

8 Patterned backgrounds, page 17

39 Spray adhesive, page 43

Composite photograph measuring 12 x 3¾ in (30.5 x 9.5 cm)

35 Composite photographs, page 39

Double-sided tape

42 Double-sided tape, page 44

12 x 5 in (30.5 x 13 cm) piece of light-colored wood veneer

Craft knife; steel ruler; cutting mat

Wood-burning tool or soldering iron; protective gloves

12 x 5 in (30.5 x 13 cm) piece of self-adhesive mount board

Two focal-point matted photographs, one measuring 3-in (8-cm) square, the other measuring 5½ x 3½ in (14 x 9 cm)

32 Focal-point matting, page 36

29 Window matting, page 32

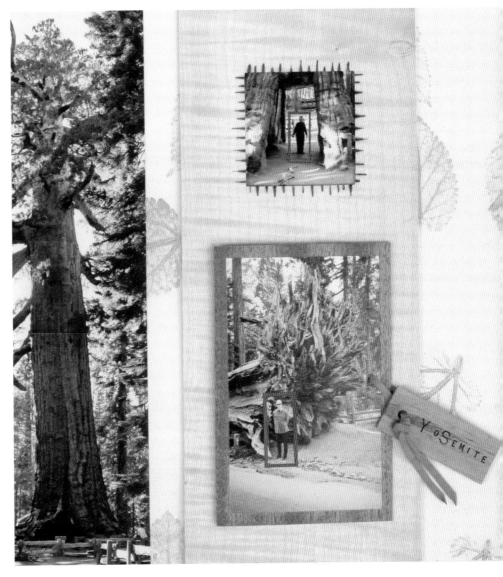

Two 5¼ x 3⅜ in (13.5 x 8.5 cm) pieces of leaf-patterned paper, one with journaling

51 Journaling, page 50

6 x 4 in (15 x 10 cm) piece of dark-colored wood veneer

6 x 1 in (15 x 2.5 cm) strip of suede, pinked along both long edges

2½ x 1 in (6.5 x 2.5 cm) wooden tag; metal letter stamps; hammer; fine-tip brown marker

57 Embossing foil, page 54

Leather punch

10 x ⅛ in (25 x 0.25 cm) strip of suede

△ *Concealed journaling adds an interactive element of surprise and discovery to your scrapbook pages that future generations will enjoy. Remember the excitement when you look at a pop-up book and be inventive when you incorporate your text.*

1 Spray adhesive onto the back of the large piece of leaf-patterned paper and stick it to the background, aligning the top, bottom and right-hand edges.

2 On the back of the composite photograph, stick lengths of double-sided tape around the edges. Stick the photograph onto the background, aligning the top, bottom and left-hand edges and overlapping the left-hand edge of the leaf-patterned paper.

3 Mark a 2⅜-in (6-cm) square opening on the back of the light-colored veneer, 1⅜ in (3.5 cm) from the top edge and centered between the side edges. Using the craft knife and steel ruler on the cutting mat, cut out the opening.

4 Wearing the protective gloves and following all the manufacturer's safety instructions, use the wood-burning tool to burn a pattern of long and short lines around the inner edge of the opening.

5 Using the measurements from Step 3, cut a slightly larger opening in the self-adhesive mount board, then peel off the backing and stick the veneer on top, carefully aligning all the edges.

6 Stick lengths of double-sided tape to the back of the mount board around the opening. Peel off the backing and stick the mount board over the focal-matted photograph.

7 Stick more lengths of double-sided tape to the back of the mount board around the outer edges. Peel off the backing and stick the matted veneer on to the leaf-patterned paper, 2 in (5 cm) from the right-hand edge.

8 Using double-sided tape, stick the piece of leaf-patterned paper with journaling onto the veneer, 1½ in (4 cm) below the opening and centered between the side edges.

1

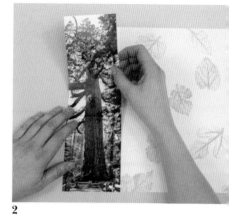
2

3

4

5

6

7

8

9 Using double-sided tape, stick the other piece of leaf-patterned paper to the back of the dark-colored veneer, centering it. Using double-sided tape, stick the remaining focal-matted photograph to the front of the veneer, centering it.

10 Stick lengths of double-sided tape along each long edge of the pinked suede.

11 Fold the suede in half lengthwise so the tape is on the outside. Peel the backing off one length of tape and stick it onto the back of the dark-colored veneer, with the fold just overlapping the right-hand edge.

12 Keeping the suede folded, peel the backing off the remaining length of tape. Lay it on the light-colored wood veneer, overlapping the left-hand edge of the leaf-patterned paper with journaling. Position the suede hinge so that, when folded closed, the dark-colored veneer is centered over the light-colored veneer and covers the journaling completely all around.

13 Using the metal stamps and hammer, emboss letters onto the wooden tag, working the word backwards and starting from the end of the tag without the hole.

14 Color in each letter with the fine-tip, brown marker.

15 Using the leather punch, punch a hole in the dark-colored veneer, centered along the right-hand side. Thread the remaining strip of suede through the hole, then thread both ends through the hole in the tag and knot them to attach the tag.

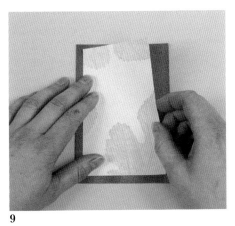
9

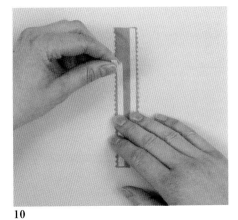
10

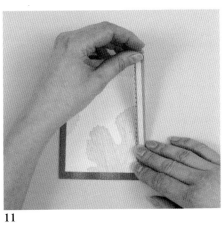
11

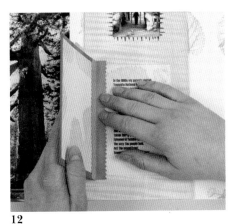
12

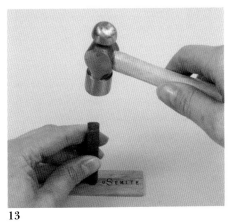
13

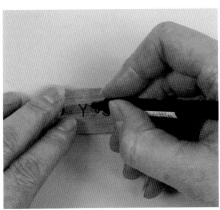
14

15

home from home

This project records some of the flora and fauna around our vacation home, and some of the activities that link us to this beautiful place. It will be interesting to note if and how family traditions change and develop through the years.

MATERIALS AND TECHNIQUES

Four 3½ x 2 in (9 x 5 cm) rust-colored card-stock tag shapes, one decorated with a section of map, one a photocopied photograph, one with botanicals and one with a cut-out butterfly; four 3½ x 2 in (9 x 5 cm) vellum tag shapes with different printed and stamped journaling on each one; four circles of red card stock; four silver eyelets; eyelet kit; green organza ribbon

69 Paper tags, page 64

51 Journaling, page 50

46 Eyelets, page 47

8⅝ x 7 in (22 x 18 cm) piece of collage

10 Collage, page 18

Craft knife; steel ruler; cutting mat

12 x 8⅝ in (30.5 x 22 cm) sheet of red background card stock

7 Colored backgrounds, page 16

Sewing machine; red thread

23 Machine stitching, page 27

Masking tape

Photograph single-matted onto rust paper then relief-matted

27 Single matting, page 31

30 Relief matting, page 34

Double-sided tape

42 Double-sided tape, page 44

Four silver brads

47 Brads, page 47

Pressed leaves; all-purpose gel adhesive

66 Botanicals, page 62

Bugs and butterflies découpage paper; sharp scissors; spray adhesive

39 Spray adhesive, page 43

1 To make up the tags: Lay a printed and stamped vellum tag over a card-stock tag, aligning all edges. Place the circle of red card stock into position and punch a centered hole through the circle and the tag. Set a silver eyelet into the hole.

2 Thread a length of green ribbon through each eyelet, knot it and diagonally trim the ends.

3 Mark four horizontal slots on the back of the collage, each 2⅜ in (6 cm) long. Position two slots 2⅜ in (6 cm) from the short, top edge of the collage and ⅝ in (1.5 cm) from each side. Position one more slot 4¼ in (10.5 cm) below each of the first two. Using the craft knife and steel ruler on the cutting mat, cut all the slots.

4 Lay the collage on the background, aligning the top, bottom and right-hand edges. Thread the sewing machine with the thread and set it to straight stitch. With the edge of the presser foot aligned with the edge of the collage, stitch along all four sides of the collage to attach it to the background. To keep the collage in place as you sew, you can use a small piece of adhesive putty at each corner to hold it and take them out as you sew.

5 To sew down the middle of the collage: Lay one short edge under the presser foot so the needle is exactly on the center point of the edge. Ensure that the edge is perpendicular to the presser foot and stick a length of masking tape on the machine bed, aligning it with the long side of the collage. Stitch right down the collage, keeping the edge aligned with the edge of the masking tape. Repeat the process in the other direction to divide the collage into four sections, each with a slot in it.

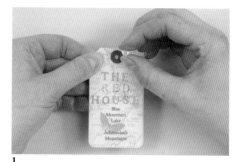
1

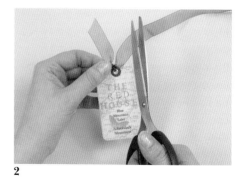
2

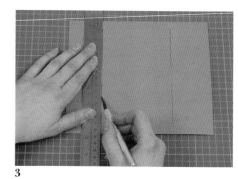
3

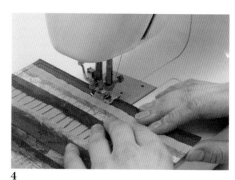
4

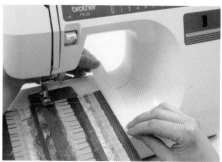
5

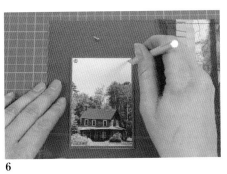

6

7

8

6 Using double-sided tape, stick the matted photograph to the plain left-hand section of the background, positioning it 2¾ in (4.5 cm) from the top edge and centered between the side edges. Use the tip of a craft knife to cut a tiny slot in each corner of the matted photograph. Push the arms of a silver brad through each slot and open them flat against the back.

7 Arrange a selection of pressed leaves and cut-out bugs and butterflies around the photograph and on the collage, leaving room for the tags. You may find it easiest to slide the tags into the slots now, but do remove them before sticking the

other items into place. Stick the leaves down with all-purpose gel adhesive and the cutouts down with spray adhesive.

8 Slide each tag into its slot.

▽ *Adapt the pocket idea to suit all kinds of projects and subject matter. Several items can be stored in each pocket, so this is a useful technique when more extensive journaling or memorabilia is involved.*

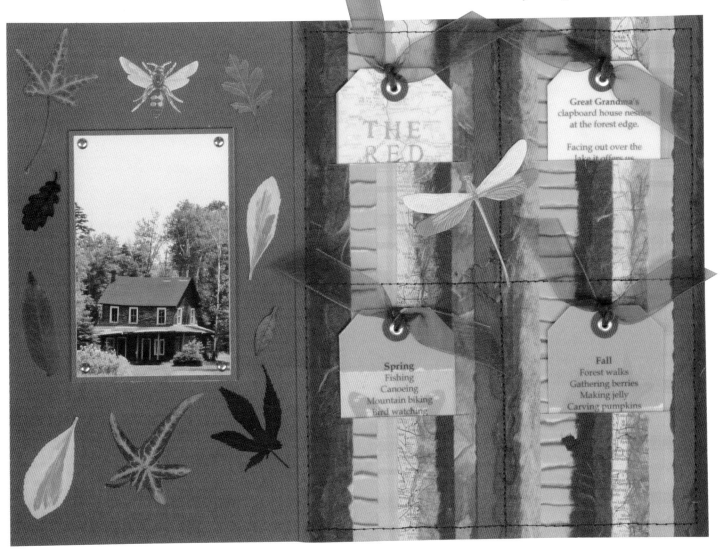

baby memories

The birth of a baby is one of the most momentous and life-changing events that can happen to any family. Their constantly evolving growth and development is something that many of us are keen to record, and it provides us with endless opportunities to fill our scrapbooks. So many changes occur in the first year alone that it is easy to be intimidated by the prospect of capturing them all, but remember that there is no time limit on completing your pages; scrapbooking should be enjoyable. Try to address everyday activities along with the more obvious milestones — these will provide interest and sometimes amusement when the child is old enough to appreciate your work.

Evelyn Alice Price

Celebrate the arrival of a new baby with a scrapbook page using his or her first photograph along with other personal identification items issued at birth. Here, the lovely announcement card replaces the need for any additional title or journaling on the page.

MATERIALS AND TECHNIQUES

12-in (30.5-cm) square of pink gingham background paper
8 Patterned backgrounds, page 17

Self-adhesive pink vellum envelope; Baby's hospital bracelet
74 Purchased pockets, page 70

Birth-announcement card and Baby's hospital card

Double-sided tape
42 Double-sided tape, page 44

Adhesive dots
40 Adhesive dots, page 43

Photograph of Baby, single-matted onto ivory paper measuring 4-in (10-cm) square and scalloped around the edges
27 Single matting, page 31
19 Cutting, page 25

Three ceramic buttons with a pink heart motif; white embroidery floss; sewing needle
73 Buttons, page 68

Purchased baby-and-stork self-adhesive charm

1

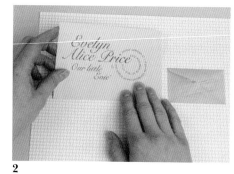

2

3

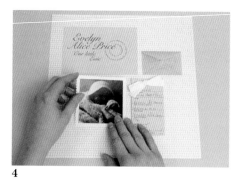

4

1 Peel off the backing from the vellum envelope and stick it onto the right-hand side of the background. Slip the bracelet into the envelope.

2 Using double-sided tape, stick the birth-announcement card onto the background to the left of the envelope.

3 Using adhesive dots, stick the hospital card onto the background, positioning it below the card and envelope.

4 Using double-sided tape, stick the matted photograph to the left of the hospital card.

Choosing the pictures
This page will depend enormously on the memorabilia you have. Choose a color scheme that unites all the elements to give a cohesive look.

◁ Start scrapbooks as
special gifts to give to
new parents or
maintain them for
the children. Give the
scrapbooks to the
children when they
are old enough to
appreciate them.

5

6

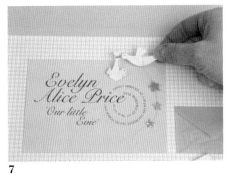

7

5 One at a time, lay the buttons below the photograph; using the needle, pierce holes in the background through the buttonholes. Thread the needle with embroidery floss. From the back, stitch through the holes in one button.

6 Turn the page over, knot the ends of the floss and trim them short. Repeat the process to stitch on the other two buttons.

7 Stick the baby-and-stork charm to the birth-announcement card.

friends

Three-dimensional elements can add a lot to a memory-book page: texture, shape and, with hanging decorations, movement. Here, a piece of the fabric used to make a favorite toy is combined with a naive stitched heart and tiny buttons to produce a decoration — reminiscent of a baby's mobile — which complements this baby page.

MATERIALS AND TECHNIQUES

12-in (30.5-cm) square of white background card stock, painted in a gingham pattern with a 4-in (10-cm) wide border on the left-hand side painted in stripes only

11 Painting stripes and gingham, page 19

Two matted photographs, one with a torn edge and one with a pinked edge and title made with rub-down letters

27 Single matting, page 31
20 Tearing, page 25
19 Cutting, page 25
54 Rub-downs, page 52

Double-sided tape

42 Double-sided tape, page 44

12 x 4 in (30.5 x 10 cm) strip of vellum with torn edges

20 Tearing, page 25

Journaling on 3-in (8-cm) square of cream paper

51 Journaling, page 50

Two strands of variegated pink embroidery floss; embroidery needle

45 Stitching, page 46

Four cream eyelets; eyelet kit

46 Eyelets, page 47

Rabbit motif; tracing paper; pencil; fine-tip gray pen; kneadable eraser

43 Double-sided film, page 45
51 Journaling, page 50

Strong cotton thread; needle; heart cut from a leftover scrap of gingham paper, embellished with whipstitch in yellow embroidery floss

24 Hand stitching, page 28

Four small buttons.

73 Buttons, page 68

1

2

4

5

1 Position the matted photographs to best advantage on the background. Here, the larger photograph provides visual weight at the bottom. When you are happy with the arrangement, stick the photographs in place with the double-sided tape.

2 Stick the journaling to the vellum with a scrap of double-sided tape, positioning the journaling so the top edge aligns with the top edge of the smaller picture. Using the needle, pierce four holes in a square through all three layers at each corner of the journaling. Make a cross-stitch through each square.

3 Lay the strip of vellum over the striped border of the page, 1 in (2.5 cm) from the left-hand edge. Using the eyelet kit, punch a hole through the vellum ½ in (1 cm) from each corner, punching through both layers. Set an eyelet into each hole.

4 On the tracing paper, write a short piece of journaling to go on the back of the rabbit motif, turn the paper over, then scribble over the back of the words with a soft pencil. Lay the tracing paper faceup on the back of the rabbit motif and firmly redraw the words to transfer them.

5 Redraw the words again with the gray pen, then erase any pencil marks.

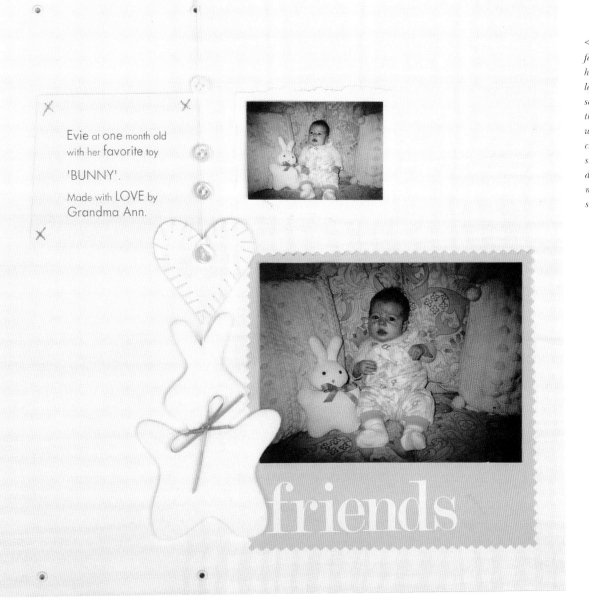

Evie at one month old
with her favorite toy
'BUNNY'.

Made with LOVE by
Grandma Ann.

friends

◁ *If your baby's
favorite toy was
homemade, use a
leftover scrap of the
same fabric to cover
the toy motif. If the toy
was store-bought,
choose a piece of
similar soft fabric and
draw your own simple
motif, based on the
shape of the toy.*

6

7

7 Thread the four buttons onto the cotton thread, positioning one button against the top of the heart, spacing out the other three along the thread and backstitching through each one to hold it in place. Cut the thread at the eye of the needle, then push one end through the top right-hand eyelet on the page. Adjust the length of the thread so the rabbit's feet hang below the bottom of the larger picture. Knot the ends together on the back.

6 Thread the needle with cotton thread and knot the ends together. From the back, push the needle through the top of the rabbit, between its ears, and pull the thread through up to the knot. Then, from the front, push the needle through the bottom of the stitched heart. Slide the heart down the thread until it hangs between the tips of the rabbit's ears. From the back, push the needle through the heart at the top.

Choosing the pictures
Customize this page to suit your own photographs by altering the color scheme to complement them.

dare to dream

Photographs don't always need to be packed with action and locations — portraits are important, too. Try to capture your subjects in a variety of moods, including tender moments such as this. Images of this type make perfect vehicles for more abstract journaling, including thoughts, hopes and dreams for the future.

MATERIALS AND TECHNIQUES

12-in (30.5-cm) square of watercolor background paper; tea bag
`7` Colored backgrounds, page 16

Large photograph single-matted onto blue-and-yellow checked paper
`27` Single matting, page 31

Double-sided tape
`42` Double-sided tape, page 44

Rub-down title
`54` Rub-downs, page 52

Small cropped photograph
`26` Cropping, page 30

⅜-in (1-cm) wide blue gingham ribbon; four cream and pale yellow buttons; matching embroidery floss; sewing needle; sharp scissors
`73` Buttons, page 68

Selection of different blue-and-yellow patterned papers

Journaling printed in gray on print-quality acetate (this must NOT be done in advance); clear embossing powder; heat gun
`51` Journaling, page 50
`50` Printing, page 50
`14` Embossing with powder, page 20

Fine-tip, black permanent pen

Eyelet punch; hammer; tapestry needle

1

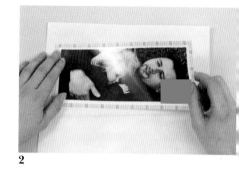
2

3

4

5

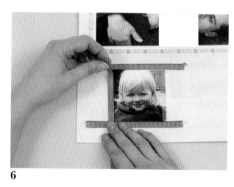
6

1 Soak the tea bag and squeeze it out well. Rub it over the background with short strokes, building up a variegated-color page. Allow it to dry.

2 Using double-sided tape, stick the matted photograph onto the page, positioning it 1½ in (4 cm) from the top edge and centered between the side edges.

3 Following the manufacturer's instructions, rub down the title above the photograph.

4 Using double-sided tape, stick the cropped photograph onto the page, positioning it 2⅜ in (6 cm) from the left-hand edge and centered in the space below the matted photograph.

5 Stick lengths of double-sided tape along the edges of the cropped photograph, making sure the corners are neat.

6 Stick a length of ribbon to the tape across the top of the photograph, leaving the ends too long. Repeat the process across the bottom and side edges of the photograph, allowing the ends to cross at the top and bottom corners.

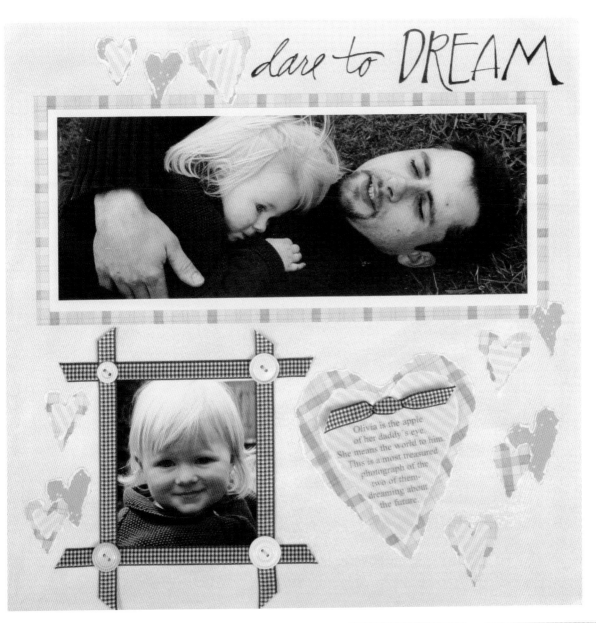

dare to DREAM

◁ *Assess the qualities of your subject matter to help you select appropriate materials and compose a sympathetic layout. Here, the contrast in hair color between the father and the child, and the light skin tones against the dark clothing, provide direction. All the background materials have been kept soft to emphasize the images and balance the dark colors. The title is strong against the background, and the irregular lettering balances the formal shapes of the photographs.*

Olivia is the apple of her daddy's eye. She means the world to him. This is a most treasured photograph of the two of them— dreaming about the future.

7

8

Choosing the pictures

The unusual angle the larger picture was taken from shows just how an eye for composing a photograph can turn something fairly ordinary into something special. Ideally, take a variety of shots of your subject from different angles to see which one of them works best. Interesting cropping can also help strengthen an image.

7 Sew on a button in each corner where the ribbons cross: one at a time, position the buttons. Using the needle, pierce holes in the ribbon and the page, through the buttonholes. Thread the needle with embroidery floss. From the back, stitch through the holes in each button. Turn the page over and knot the ends on the back.

8 Using the scissors, diagonally trim the ends of the ribbon, cutting the ends of each length so they slant in opposite directions.

9 Tear a number of different-sized hearts out of the patterned papers, tearing with the paper faceup and toward you to create a narrow white edge. Tear one heart that is large enough to accommodate your journaling.

10 Arrange the hearts on the page, overlapping some of them on the mat of the larger photograph. Position the large heart beside the cropped photograph. When you are happy with the arrangement, stick the hearts in place with tacky glue.

11 Print out the journaling onto the acetate. Lay the acetate on a piece of scrap paper and, while the ink is still wet, sprinkle clear embossing powder over it. Pick the acetate up and tip off the excess powder onto the scrap paper, then flick the back of the acetate to remove any stray flecks. Using the heat gun, heat the powder until it melts and fuses, being careful not to buckle the acetate.

12 Lay the acetate on the large heart, centering the journaling. Draw around the edge of the heart using the black pen.

13 Using scissors, cut out the acetate heart, just inside the drawn line.

14 Position the journaling on the heart. Using the eyelet punch and hammer, punch two holes through all of the layers at the top of the heart.

15 Thread the tapestry needle with ribbon. From the front, push the needle through the right-hand hole, then up through the left-hand hole and pull a length of ribbon through.

16 Repeat the process, stitching through the same holes and gently pull the ribbon tight.

17 Diagonally trim the ribbon ends so they slant in the same direction.

9

10

11

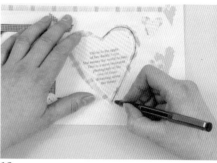
12

13

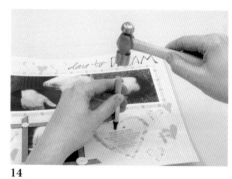
14

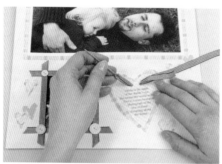
15

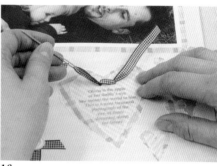
16

17

a day in my life

To create a scrapbook that illustrates a rounded view of family life, it's important to record everyday happenings as well as special occasions and life-changing events. The usual daily activities can provide many opportunities and present a fuller portrait of the subject through pictures and journaling.

MATERIALS AND TECHNIQUES

12-in (30.5-cm) square of red background card stock; 12 x 5¼ in (30.5 x 13.5 cm) piece of multicolored, polka-dot background paper
7 Colored backgrounds, page 16

Spray adhesive; brayer
39 Spray adhesive, page 43

Pencil; craft knife; steel ruler; cutting mat

Brightly colored variegated yarn; crewel needle
24 Hand stitching, page 28

Three different-size photographs, single matted onto different-colored papers and pinked around the edges
27 Single matting, page 31
19 Cutting, page 25

Double-sided tape
42 Double-sided tape, page 44

Four sets of brads, to match each color of photograph matting paper
47 Brads, page 47

Letter stickers to match each color of photograph matting paper
53 Letter stickers, page 52

Photograph in a white pearlescent paper window mat measuring 7½ x 4 in (19 x 10 cm), with an opening ¾ in (2 cm) from the bottom and side edges and colored blue edges
29 Window matting, page 32
21 Coloring, page 26

Vellum circle stickers
68 Stickers, page 63

4-in (10-cm) square each of multicolored, polka-dot paper and self-adhesive mount board
30 Relief matting, page 34

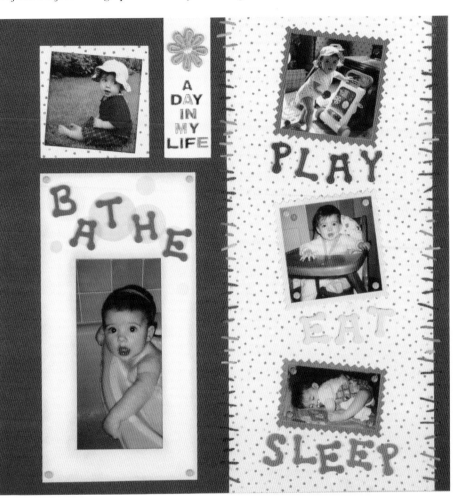

Cropped photograph measuring 3-in (8-cm) square
26 Cropping, page 30
29 Window matting, page 32

3½ x 1¼ in (9 x 3 cm) piece of white pearlescent paper relief-matted onto self-adhesive mount board
30 Relief matting, page 34

Multicolored letter stickers; purchased flower motif; mini adhesive dots
53 Letter stickers, page 52
40 Adhesive dots, page 43

△ *Though this page is very informal with its angled pictures and uneven text, the careful grouping of colors gives it a sense of order. Without this it could look very messy.*

Choosing the pictures

A page of this type allows you to effectively tie together a series of random images and give them meaning. It's a good way of using images that are not strong enough to stand alone on a page.

1 Using spray adhesive, stick the rectangle of polka-dot paper to the background, aligning the top and bottom edges, and positioning it ½ in (1 cm) from the right-hand edge. Roll over it with the brayer to ensure it is completely flat and firmly stuck down.

2 On the red section of the background, mark a 2¾-in (7-cm) square opening, positioning it ¾ in (2 cm) from the top edge and 1¼ in (3 cm) from the left-hand edge. Using the craft knife and steel ruler on the cutting mat, cut it out.

3 Thread the crewel needle with the yarn and knot the end. From the back, push the needle up through the red paper, just outside one side edge of the polka-dot paper, then push the needle down through the polka-dot paper to make a short, straight stitch.

4 From the front, use the needle to pierce a hole in the red background where you want the next stitch to start. From the back, push the needle up through the pierced hole, then down through the polka-dot paper to make a second stitch.

5 Repeat the process, making the stitches different lengths and setting them at different angles, until you have stitched down one edge of the polka-dot paper. Repeat the process on the opposite edge.

6 Arrange the three single-matted photographs on the polka-dot paper, positioning them at jaunty angles. Using the double-sided tape, stick them into position. Using just the tip of the craft knife, cut a tiny slot just inside the corner of each photograph. Push a matching brad through each slot and open out the arms against the back.

7 Use the matching letter stickers to make a title for each photograph.

8 Using the double-sided tape, stick the window-matted photograph onto the red background, below the opening, aligning the left-hand edge of the window mat with the left-hand edge of the opening.

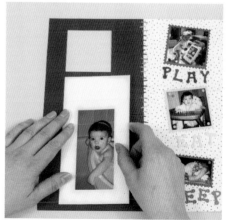

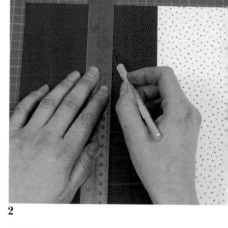

9 Stick some vellum circles to the top border of the window mat. Using matching letter stickers to make a title, stick them onto the circles.

10 As in Step 6, cut a slot in each corner of the mat and fix a brad in place.

11 Peel the backing off the square of mount board. Aligning the edges, stick the square of polka-dot paper to it.

12 Mark a 2⅜-in (6-cm) square opening on the back of the mount board, keeping the opening square, but setting it at an angle. Using the craft knife and steel ruler on the cutting mat, cut out the opening.

13 On the back of the mount board, stick double-sided tape around the edges of the opening. Orienting the photograph to the edges of the opening, not the edges of the mount board, stick it on.

14 On the back of the page, stick double-sided tape around the edges of the opening. Stick the window-matted photograph behind the opening, keeping the inner edges of the background and the outer edges of the mat parallel.

15 Using the multi-colored letter stickers, make a title on the relief-matted white paper, sticking down the last word first and working up the paper. You may find it easiest to use a craft knife to lift and position the stickers.

16 Using the double-sided tape, stick the title paper onto the page, aligning the top edge with the top edge of the page and centering it between the opening and the polka-dot strip. Using a small adhesive dot, stick on the flower motif.

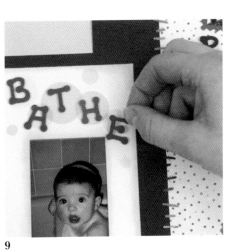

9

10

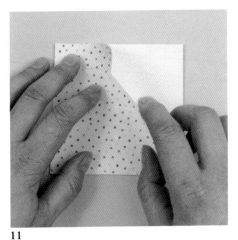

11

12

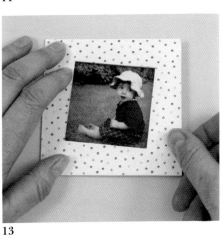

13

14

15

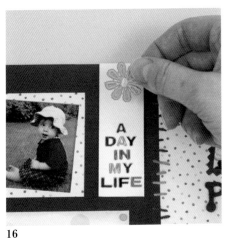

16

little toes

Get your child into scrapbooking at an early age! Footprints and handprints are a lovely way to make the introduction. The child with these footprints is a little too young to actively participate, but older children do enjoy being involved. Don't just make them a subject of your book, let them become a part of it by encouraging them to help you create it. Ask them to look out for memorabilia and found objects when you are on vacations or trips, get them to help choose locations for photographs, and start to teach them simple techniques for displaying their finds. Keep safety in mind, however, and never let children work with, or within reach of, sharp items or dangerous substances.

MATERIALS AND TECHNIQUES

11 x 7¼ in (28 x 18.5 cm) piece of brown, thin card stock
7 Colored backgrounds, page 16

11 x 8 in (28 x 20.5 cm) piece of vellum with the words "pitter patter" printed in pale pink ink in a continuous line along the top and bottom edges
50 Printing, page 50

Adhesive tape
41 Adhesive tape, page 44

11 x 8½ in (28 x 21.5 cm) piece of ivory watercolor paper

Print of Baby's footprints in pink ink, window matted in dull pink paper measuring 5 x 4½ in (13 x 11 cm)
29 Window matting, page 32

Photograph of the sole of Baby's foot single matted onto dull pink paper measuring 5 x 4½ in (13 x 11 cm) and with a pink eyelet at each corner
27 Single matting, page 31
46 Eyelets, page 47

Double-sided tape
42 Double-sided tape, page 44

Eyelet kit; two pink eyelets
46 Eyelets, page 47

24 in (61 cm) of pink fluffy decorative fiber; metal title charm

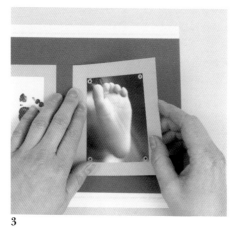

1

2

3

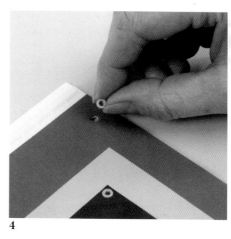

4

1 Using the adhesive tape, stick the brown card stock background to the vellum, aligning the side edges and centering it between the top and bottom.

2 Using the adhesive tape, stick the vellum to the watercolor paper, aligning the side edges and centering it between the top and bottom.

3 Using the double-sided tape, stick the matted pictures onto the brown background, positioning them ¾ in (2 cm) from the bottom edge and ¾ in (2 cm) from the side edges.

4 Using the eyelet kit, punch a hole in each top corner of the brown background, positioning it ⅝ in (1.5 cm) from the top edge and ½ in (1 cm) from the side edges, then set the eyelets in place.

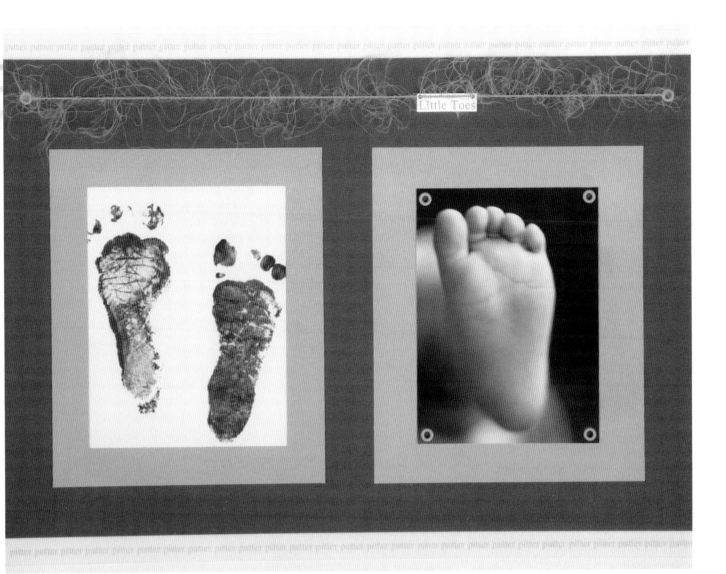

Little Toes

△ *Don't forget to take footprints and handprints as a child grows. It can be fun to compare them when the child is bigger to see how small they once were. It is easiest to apply the paint to the hand or foot with a paintbrush. It might tickle a bit, but you will get a good print.*

Choosing the pictures

If you have prints of your baby's feet, but not in the right color, they can be scanned and the color altered on a computer before being printed out.

5

5 Thread the title charm onto the fluffy fiber (you may need to use a needle).

6

6 Push one end of the fluffy fiber through each eyelet in the brown background. Gently pull it taut, turn the page over and knot the ends together on the back, then trim them short.

childhood memories

Making a scrapbook doesn't need to be a solitary pursuit, children can provide the focus of the page and they can also help to create it. They usually enjoy having their photographs taken and are quite uninhibited when it comes to talking about themselves. It's nice to capture their versions of events, so encourage them to record their thoughts and ideas, likes and dislikes, and so on. They can write them down as bullet points or in a list format if they tire quickly (see *Things I love*, page 106). With some supervision a child can be involved in plenty of techniques such as the decorated background in *Trick or treat*, page 101. Make the production of your scrapbook an activity that the whole family can enjoy.

a walk in the country

A whole page made up of transparent fabric pockets is a wonderful way to display a mixture of memorabilia in a book. The pockets can be used to hold not only three-dimensional items, such as feathers or shells, but also photographs and blocks of journaling.

MATERIALS AND TECHNIQUES

Template on page 139; enough items to fill the spaces in the template
31 Page template, page 35
51 Journaling, page 50
26 Cropping, page 30
66 Botanicals, page 62

Pencil; steel ruler

14-in (35-cm) square each of canvas and organza; pins; sewing machine; cream thread
23 Machine stitching, page 27

Rotary cutter

Sheet of cream, thin card stock measuring at least 12½ x 2¾ in (32 x 7 cm)
20 Tearing, page 25

Bone folder

Scissors

1

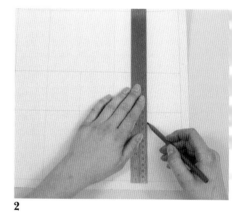

2

3

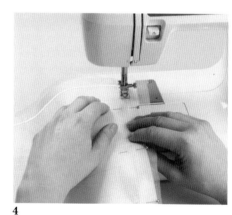

4

1 Enlarge the template onto a sheet of paper so it measures 12-in (30.5-cm) square. Arrange the items in the spaces, cropping them to fit if necessary.

2 Following the template measurements carefully, transfer the template onto the square of canvas, centering it.

3 Pin the square of organza to the canvas, aligning all of the edges.

4 Thread the sewing machine with the cream thread and set it to wide satin stitch. Stitch around the top, right-hand and bottom edges of the organza, along the outer lines of the template.

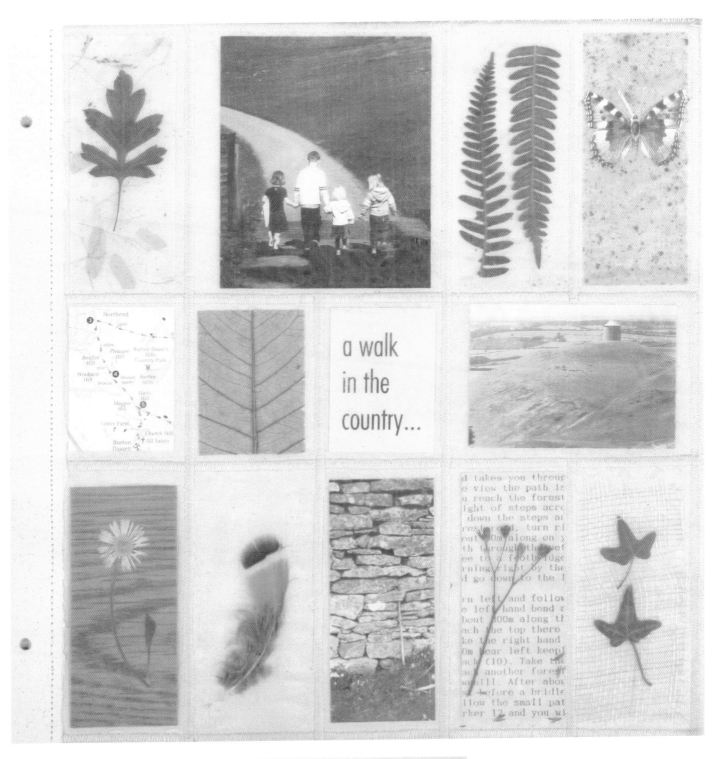

△ You can make your own template to accommodate your memorabilia, if you prefer. Make a full-size plan on layout paper first. It helps to start with a regular grid and remove the dividing lines between the spaces where necessary. This will give the page uniformity and maintain straight runs of stitching.

5 Position the elements you want to display in the top row, sliding them in between the canvas and the organza. Pin along the lines on the canvas to hold the items in place.

5

Choosing the pictures
On any outing, keep a sharp eye out for interesting found objects, and encourage others to do the same. You can sort the objects later, at home, when you get your photographs printed.

6 Stitch right along the horizontal line below the top row of items, starting at the right-hand stitched edge of the page, and ending below the end of the stitching line at the top of the page.

7 Position the center row of items and stitch below it, as in Steps 5 and 6.

8 Finally, position the bottom row of items. You will have only a narrow opening to slide them through, so work carefully to avoid damaging items.

9 Pin, then stitch along the vertical lines between the items, where possible, stitching from the stitching line at the top over the horizontal lines to the stitching line at the bottom. Shorter vertical lines of stitching should end on one of the horizontal lines. If you are going to keep the page in a plastic sleeve, stitch along the line on the left-hand side. Use the steel ruler and the rotary cutter to neatly trim the outer edges of both fabrics close to the stitching all around. If you want to bind the page into an album, stitch the left-hand line with straight stitch, then trim the top, bottom and right-hand edges, as above, but not the left-hand side.

10 To make a stiff edge for binding the page into an album, tear a 12½ x 2 in (32 x 5 cm) strip of cream card stock.

11 Using the bone folder and steel ruler, score a line down the middle of the strip, then fold the strip along the scored line.

12 Slide the strip over the fabrics on the left-hand side so the torn edge of the strip just covers the line of straight stitching. If necessary, trim the fabric so the strip lies flat in the correct position. Aligning the edge of the presser foot with the torn edge, stitch on the strip using straight stitch.

13 Using scissors, trim the ends of the paper even with the edges of the fabrics.

6

7

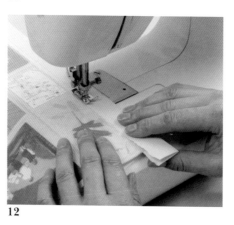
8

9

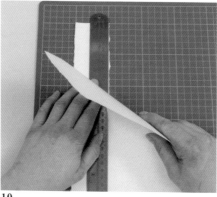
10

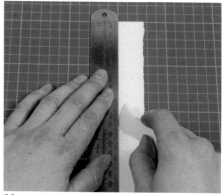
11

12

13

trick or treat

Evie and Jasmine really enjoyed Halloween this year. They spent a happy afternoon making some decorations, including the balloons with funny faces. Evie's gappy grin matched that on her balloon. They both dressed up as fairies for the party that followed, and had fun posing for some photographs.

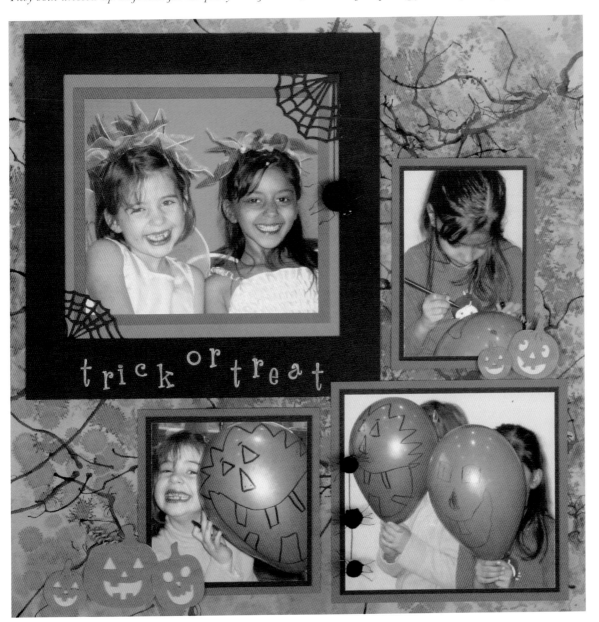

◁ *The largest photograph combines single matting and a dressed-up version of window matting. Experiment with combining different matting techniques to make the most of your images.*

Choosing the pictures

You can lose the spontaneity of a situation while trying to capture the right image, especially where children are concerned. Better results are likely if you stand back and let them get on with it; most young children enjoy having their photographs taken, and will be quite obliging. A digital camera makes the whole process much easier; you can see right away if you have captured the moment. If you just enjoy the process of snapping away, there is every chance that you will end up with some great, natural images.

MATERIALS AND TECHNIQUES

12-in (30.5-cm) square of light orange background card stock
7 Colored backgrounds, page 16

Foam brush; water; fine-tip artist's paintbrush burnt sienna ink; black ink; drinking straw

7-in (18-cm) square of black card, with "trick or treat" stamped in white along the bottom edge
55 Letter stamps, page 53

Adhesive tape
41 Adhesive tape, page 44

Double-sided tape
42 Double-sided tape, page 44

7-in (18-cm) square of darker orange card stock

Photograph single-matted onto 5-in (13-cm) square of bright orange card stock
27 Single matting, page 31

Three smaller photographs of varying sizes multimatted on black and bright orange
28 Multimatting, page 32

Spiderweb, spider and pumpkin stickers; scissors
68 Stickers, page 63

1 Protect your work surface with a plastic sheet. Using the foam brush, brush water onto the light orange background.

2 Dip the paintbrush into the burnt sienna ink and tap the handle behind the bristles to spatter ink onto the wet paper. Continue dipping and spattering until the paper is evenly covered. Allow it to dry.

3 Spatter black ink onto the dry paper.

4 Using a drinking straw, blow the ink drops across the paper to create randomly branching lines.

5 The finished background should look something like this.

6 Cut an opening in the black card stock leaving a ¾ in (2 cm) border around the top and side edges and a 1¼ in (3 cm) border across the printed bottom.

7 Using adhesive tape, stick the black mat to the darker orange card stock, aligning all outer edges.

8 Using adhesive tape, stick the single-matted photograph onto the center of the darker orange square.

1

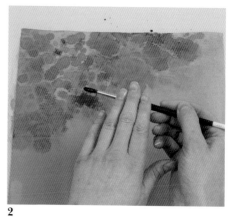

2

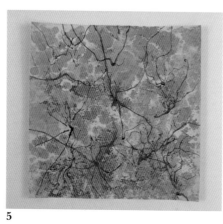

3

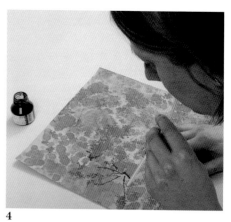

4

5

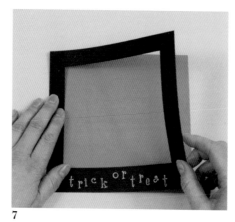

6

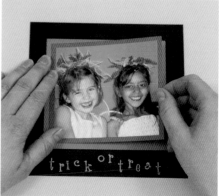

7

8

9 Using double-sided tape, stick the matted photograph onto the decorated background, positioning it in the top left-hand corner and ensuring that the top and left-hand side borders are equal.

10 Using double-sided tape, stick one multimatted photograph onto the background, positioning it diagonally opposite to the first photograph and slightly overlapping it.

11 Stick the second multimatted photograph onto the background, positioning it above the first multimatted photograph and equidistant from the adjacent mats.

12 Stick the third multimatted photograph onto the background, positioning it to the left of the first multimatted photograph and equidistant from the adjacent mats.

13 Using scissors, cut the spiderweb sticker into right-angled pieces.

14 Stick one piece of web onto two opposite corners of the window-matted photograph. Randomly stick on some spiders, too.

15 Add the pumpkin stickers to the page for more decoration.

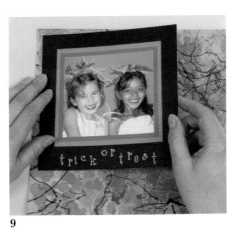

9

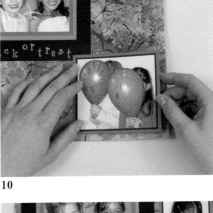

10

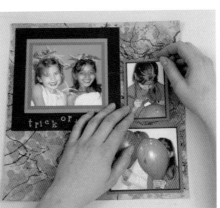

11

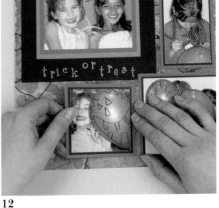

12

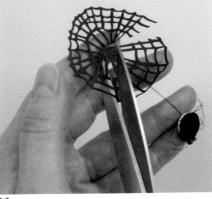

13

14

15

4th July

Holiday traditions always make interesting subjects, and every family has their own customs. Ritual, familiarity, comfort and a sense of place are some of the benefits that being part of a family brings. Celebrate your family by recording your own traditions.

▷ *Here, a smaller shot of the whole image shows the setting and relates directly to the journaling.*

MATERIALS AND TECHNIQUES

12 x 8¾ in (30.5 x 22 cm) of red checked background card stock; 5½ x 4 in (14 x 10 cm) piece of blue star-patterned paper
8 Patterned backgrounds, page 17

Double-sided tape
42 Double-sided tape, page 44

Cropped photograph
26 Cropping, page 30

Photograph suitable for cut-out focal-point matting; vellum printed with journaling; pencil; craft knife; cutting mat; steel ruler
33 Cut-out focal-point matting, page 37
51 Journaling, page 50

Scraps of paper; paper clips

Blue variegated embroidery floss; embroidery needle
24 Hand stitching, page 28

String of calico pennants; country-style heart and star stickers
62 Fabric pennants, page 58

Two buttons
73 Buttons, page 68

1

2

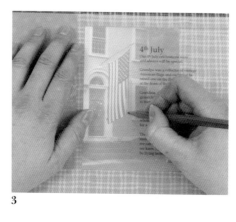

3

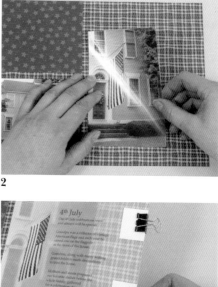

4

1 Using double-sided tape, stick the blue paper onto the top left-hand corner of the red background, aligning the top and left-hand edges. Using double-sided tape, stick the cropped photograph onto the background below the blue square, aligning the right-hand edges of the blue square and the cropped photograph.

2 Using double-sided tape, stick the second photograph onto the background, positioning it to the right of the blue square and aligning the bottom edge with the bottom edge of the cropped photograph.

3 Lay the sheet of vellum over the second photograph, with the journaling to the right of the focal point. Using a pencil, draw a line along the top, bottom and left-hand edges of the photograph and along the edge of the page, to the right of the journaling. Then draw a line along the edges of the focal point of the photograph; in this case the flag. Lay the vellum on the cutting mat and, using the craft knife and steel ruler, cut along the outer edges, then cut out the focal point.

4 Position the vellum on the photograph and hold it in place with the paper clips (slide scraps of paper under the clips to avoid marking the background and vellum).

Choosing the pictures

Using a primary and secondary image in a project is a good idea. Each can play a different role on the page, and each will strengthen the other.

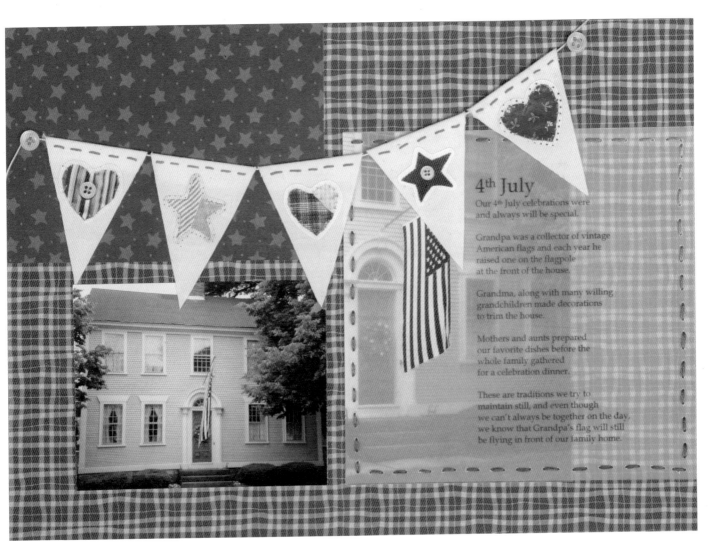

5 Thread the needle with the embroidery floss and knot the end. Stitch the vellum to the page, stitching through all layers using running stitches and piercing holes as you work (don't worry about keeping the stitches perfectly even — a homespun look will complement the page.

6 Decorate each pennant with a sticker.

7 Arrange the string of pennants across the page, positioning it to complement your composition. Position a button at each end of the string and mark its position with a tiny pencil mark.

8 Remove the string of pennants and, using the embroidery floss and needle, stitch on the buttons. Wind one end of the string around each button.

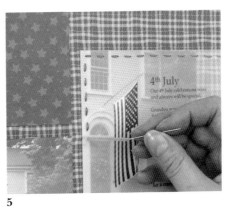

5

6

7

8

things I love

This is an ideal project to involve a child in, and would make a rewarding rainy-day activity. Children enjoy the opportunity to learn about themselves and their family. We had a lot of fun choosing the elements to go with the photographs and working together on the journaling.

MATERIALS AND TECHNIQUES

Sheet of cream background card stock; sheet of striped tissue paper
8 Patterned backgrounds, page 17

Spray adhesive; brayer
39 Spray adhesive, page 43

Craft knife; steel ruler; cutting mat

Sheet of paper striped with markers

Photograph single-matted onto polka-dot card
27 Single matting, page 31

Eyelet kit; white flower eyelets
46 Eyelets, page 47
75 Paper pockets, page 71

Rounded-corner photograph matted on two colors and decorated with stickers
36 Punching shapes, page 40
68 Stickers, page 63

Journaled vellum tag; embroidery floss; needle; scissors
51 Journaling, page 50

Double-sided tape
42 Double-sided tape, page 44

Multimatted photograph with journaling
28 Multimatting, page 32

Dog and bone buttons
73 Buttons, page 68

Self-adhesive diamanté hearts and rhinestones
68 Stickers, page 63

Double window-matted photograph with journaled frame
29 Window matting, page 32
51 Journaling, page 50

Shoe charm hanging from a ribbon bow; small adhesive dots
40 Adhesive dots, page 43

Flower gift wrap; white paper; small, sharp scissors

Journaling on a circle of white paper
51 Journaling, page 50

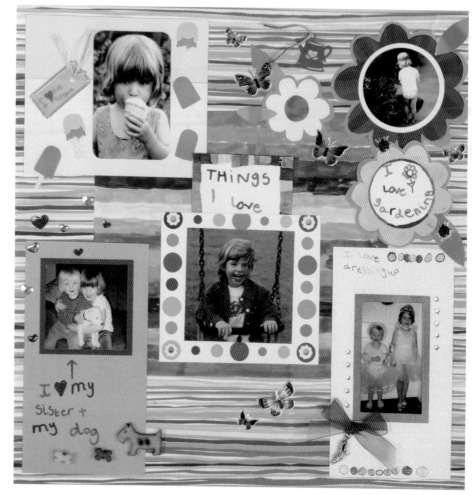

Paper adhesive
38 Adhesives, page 42

Punched circular photograph single-matted onto a white circle
36 Punching shapes, page 40
27 Single matting, page 31

Gardening theme charm

Ladybug and butterfly stickers
68 Stickers, page 63

List of "things I love" handwritten on paper
51 Journaling, page 50

△ *Although the overall effect is busy, the different loves are contained within designated areas of the page, making it easy to interpret the visual messages.*

Choosing the pictures
This is a good project for snapshots that you and your child like which are not strong enough to stand alone on a page. The opportunity for tight cropping allows you to choose pictures in which the child is quite small in the background.

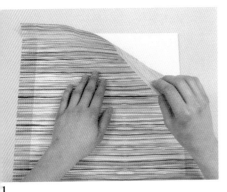

1

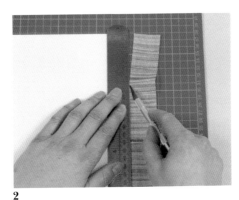

2

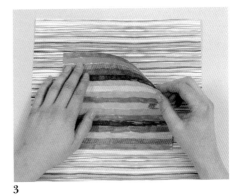

3

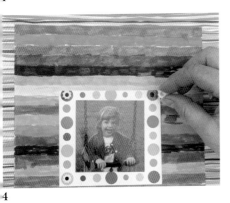

4

5

6

7

8

9

1 Lightly spray adhesive onto the back of the tissue paper, carefully stick it to the background card and smooth it down. Using a brayer, roll over it to ensure that it is completely flat and firmly stuck down.

2 Lay the background tissue-side down and, using the craft knife and steel ruler on the cutting mat, trim the tissue paper even with the edges.

3 Using spray adhesive, stick the sheet of marker-striped paper onto the middle of the background.

4 Lay the single-matted photograph on the marker paper, positioning it near the

bottom and centered between the side edges. Using the eyelet kit, punch a hole in each corner of the mat, punching through all layers. Set a flower eyelet into each hole so the matted photograph serves as a paper pocket.

5 Attach the journaled tag to the mat of the rounded-corner photograph. Thread the needle with embroidery floss and make a single stitch down through the hole in the tag and the mat and up through the mat again, then knot the ends.

6 Using the double-sided tape, stick the rounded-corner photograph onto the

top left-hand corner of the page, positioning it so that the top and left-hand side borders are equal.

7 Using the double-sided tape, stick the multi-matted photograph onto the bottom left-hand corner of the page, leaving the same small border at the left-hand and bottom edges.

8 Starting from the back, stitch the buttons to the mat as in Step 5, but knotting the ends on the back.

9 Decorate the mat and the nearby paper with the self-adhesive hearts.

10 Using double sided tape, stick the window-matted photograph onto the bottom right-hand corner of the background, leaving the same small border at the right-hand and bottom edges.

11 Using a small adhesive dot, attach the bow of the shoe charm to the mat. Decorate the mat with the self-adhesive rhinestones.

12 Using the scissors, roughly cut out three different-sized flowers from the gift wrap. Using spray adhesive, stick them onto white paper to stiffen them, then neatly trim them.

13 Using paper adhesive, stick the circle of journaling onto the center of one flower, then stick the matted circular photograph onto the center of another flower.

14 Using double-sided tape, stick the three flowers onto the top right-hand corner of the page.

15 Starting from the front, stitch the gardening charm to the background, as in Step 5.

16 Embellish this section of the page with the self-adhesive ladybugs and butterflies.

17 Slide the list of "things I love" into the polka-dot pocket created in Step 4.

10

11

12

13

14

15

16

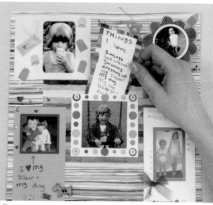
17

make a wish

Olivia looked so captivating in her party dress — it was a photographic opportunity that was too good to miss. She loved wearing her dress so much that she didn't want bedtime to come, and she was carried upstairs half-asleep before we could put her pyjamas on.

MATERIALS AND TECHNIQUES

Multimatted photograph measuring 5¾ x 3¾ in (14.5 x 9.5 cm)
28 Multi-matting, page 32

Piece of purple card stock 10 x 4½ in (25 x 11.5 cm), with machined feather stitches sewn down each side in silver thread
23 Machine stitching, page 27

Letter stamps; purple pigment ink pad; crystal sparkle embossing powder; heat gun
55 Letter stamps, page 53
14 Embossing with powder, page 20

Rub-down word "wish"; tiny self-adhesive rhinestone
54 Rub-downs, page 52
68 Stickers, page 63

Craft knife; steel ruler; cutting mat

Masking tape

Tacky glue; lavender glitter

Double-sided tape
42 Double-sided tape, page 44

Sheet of thin black card stock measuring 10¼ x 6¼ in (26 x 16 cm); star stamp; interference stamping medium; interference powder in violet and blue; artist's paintbrush
15 Making a simple stamp, page 21
13 Stamping, page 20

Baking parchment; glitterati filaments; iron

Sheet of purple card stock measuring 11 x 8½ in (28 x 21.5 cm), with sequinned and beaded wire decoration ¾ in (2 cm) from the left-hand edge
7 Colored backgrounds, page 16
72 Wire, page 67

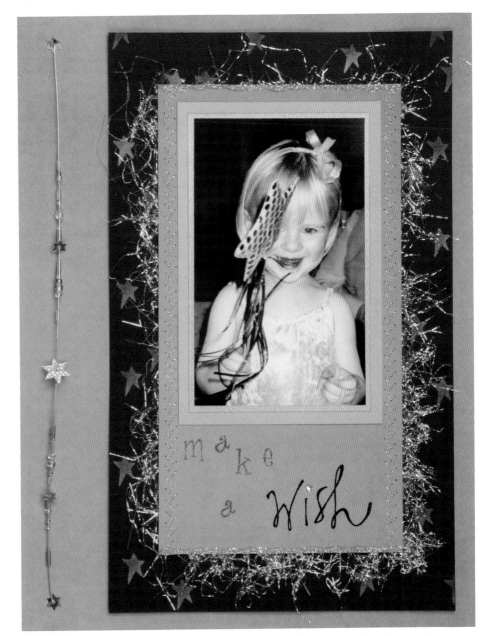

△ *Choose the colors of mats and embellishments to reflect and enhance the colors in the photograph. Every paper and detail color used on this page has a complement in the picture of the little girl in her fairy dress.*

1 Position the photograph on the strip of purple card, centered between the stitching and ⅜ in (1 cm) from the top edge (do not stick it down). Using the letter stamps and purple ink pad, stamp the words "make a" just below the photograph.

2 Remove the photograph. While the ink is still wet, sprinkle embossing powder over the letters and brush off any excess. Using the heat gun, heat the powder until it melts and fuses.

3 Following the manufacturer's instructions, rub down the word "wish" to complete the title.

4 Stick the self-adhesive rhinestone over the "i" in "wish."

5 If you have printed a piece of card stock that is longer than you need, you will want to prevent the stitching from unravelling when you cut the card stock (see *Getting it right*). Stick a length of masking tape right across the back of the card approximately 8¼ in (21 cm) from the top (make sure that your printing is correctly positioned on the front). Using the craft knife and steel ruler on the cutting mat, cut through the tape.

6 On the front, spread a line of tacky glue along the top and bottom edges.

7 Sprinkle glitter over the glue, then tip off the excess. Allow it to dry.

8 Using double-sided tape, stick the multimatted photograph into position on the decorated mat.

Getting it right

If you are stamping a title, print a piece of paper larger than you need and only use it if you are happy with the stamping. Position the image, but don't stick it down. Do the stamping then stick on the image and trim the paper to size. This way you will get the title in exactly the right place.

1

2

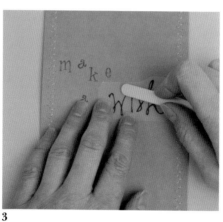

3

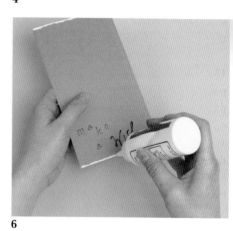

4

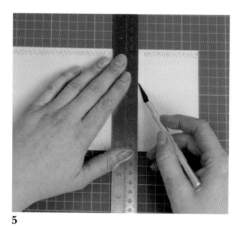

5

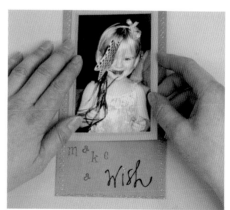

6

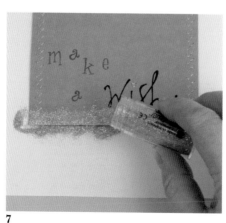

7

8

9 Using the star stamp inked with interference medium, randomly stamp around the edges of the black card stock.

10 Using the paintbrush, brush violet interference powder over the top section of each star and blue powder over the bottom section.

11 Brush off the excess powder.

12 Lay the glitterati filaments on the baking parchment, spreading them out to cover approximately 9½ x 5½ in (24 x 14 cm).

13 Fold the parchment over the filaments and, following the manufacturer's instructions, iron the parchment to fuse the filaments into a single sheet (make the sheet a little larger than you need; it is easy to resize it by pulling filaments away from the edges).

14 Stick lengths of the double-sided tape down the back of the printed purple card stock. Peel off the backing, then center the sheet of fused filaments on the tape.

15 Using the double-sided tape, stick the purple card to the stamped sheet of black paper, centering it.

16 Using the double-sided tape, stick the decorated mat onto the wire-trimmed background, positioning it so the top, bottom and right-hand borders are equal.

9

10

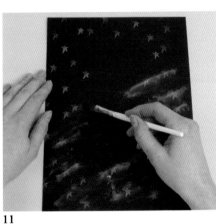
11

12

13

14

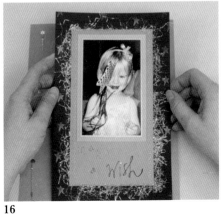
15

16

romantic memories

A wedding day will furnish us with some of our most treasured memories. Carefully planned and orchestrated in celebration of love, a wedding is bound to provide a wealth of material worth preserving. Wedding preparations start months before the event, so record the planning as well; it does contribute, after all, toward the fun and smooth running of the occasion itself. In addition, include pictures and information on people who helped to make the day special; try to combine the unexpected with the more conventional to achieve a well-rounded and interesting outcome. This chapter features contemporary weddings, an idea to commemorate an engagement and an example of how a vintage wedding photograph can be displayed.

forever

A wedding is always a good excuse to make a scrapbook, recording the occasion and the events leading up to it. Don't forget to include an invitation, acceptance cards, the seating plan, the menu and other memorabilia in the album, along with the photographs.

MATERIALS AND TECHNIQUES

Sheet of ivory, thin card stock with the names of the bride and groom printed reversed-out of green-gray and positioned along the top edge
50 Printing, page 50

Steel ruler

Adhesive tape
41 Adhesive tape, page 44

6 x 4 in (15 x 10 cm) cropped photograph
26 Cropping, page 30

Cutting mat

White boxed-letter stickers
53 Letter stickers, page 52

White rub-down "forever" motto
54 Rub-downs, page 52

Tracing paper jacket
1 Paper jacket, page 9

White ink pad; heart stamp; clear embossing powder; heat gun
14 Embossing with powder, page 20

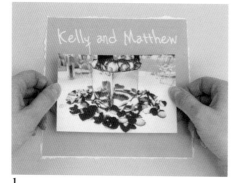

1

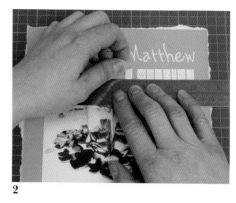

2

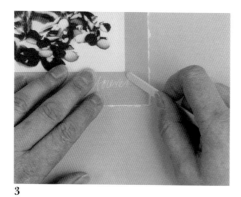

3

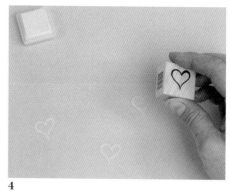

4

1 Tear the card stock against the steel ruler so it measures 7½-in (19-cm) square, tearing toward you so the edge is ivory. Using the adhesive tape, stick the photograph onto the card stock, 1¼ in (3 cm) up from the bottom and centering it between the side edges.

2 Using the grid on the cutting mat as a guide and positioning the steel ruler as

the baseline, make the words "the wedding" with the white letter stickers on the printed card stock above the photograph.

3 Following the manufacturer's instructions, rub down "forever" onto the printed card stock below the photograph.

4 Working on small sections at a time, stamp hearts onto the tracing paper jacket.

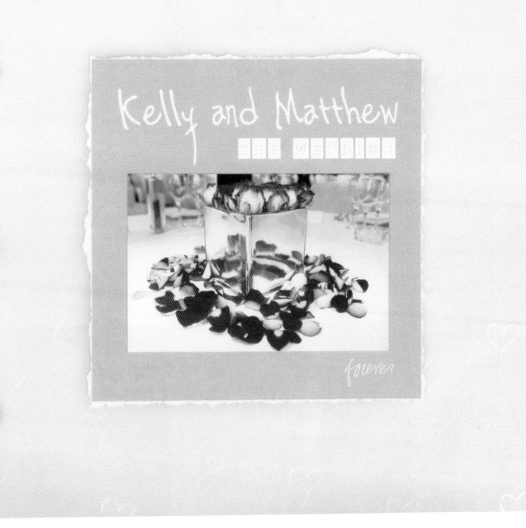

5

6

Getting it right

Allow stamps to overlap the cut edges of the tracing paper, but not the folds (the printed motifs may crack when the jacket is wrapped around the album).

Choosing the pictures

Although a photograph of the bride and groom might have been the obvious choice for the jacket, their photographs were saved for inside the album. Look for more unusual ways to set the scene for the subject matter in an album.

5 While the ink is still wet, sprinkle the embossing powder onto the hearts.

6 Tip off the excess powder. Using the heat gun, heat the remaining powder until it melts and fuses.

7 Wrap the jacket back around the album. Using the adhesive tape, stick the title panel onto the front, centering it.

7

ellie and kelly

The special relationship between Ellie and Kelly — as bridesmaid and bride and as niece and aunt — is beautifully captured in this image; they complement one another so well. Delicate and subtle page decorations enhance the feminine theme.

MATERIALS AND TECHNIQUES

Ivory feathers; adhesive tape

41 Adhesive tape, page 44

6-in (15-cm) square of pale mushroom card stock; text printed on 2⅞-in (7-cm) square of vellum; 3⅜-in (8.5-cm) square of ivory organza; sewing machine; ivory thread; 6-in (15-cm) square of cream card stock; 3⅜-in (8.5-cm) square of cream net; dried red rose petals; red heart sequins

58 Fabric pockets, page 55

50 Printing, page 50

Steel ruler; cutting mat

Piece of vellum measuring 12 x 5½ in (30.5 x 14 cm), with the names printed in dove gray 2⅜ in (6 cm) from the bottom edge and a punched border down both long sides

50 Printing, page 50

18 Punching, page 24

Piece of pale-mushroom colored card stock the same size as the vellum and with identical punched borders

³⁄₁₆-in (0.4-cm) wide cream silk ribbon; tapestry needle

65 Ribbon, page 61

Scissors; double-sided tape

42 Double-sided tape, page 44

12-in (30.5-cm) square of cream background card stock

7 Colored backgrounds, page 16

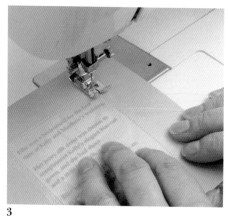

1

2

3

4

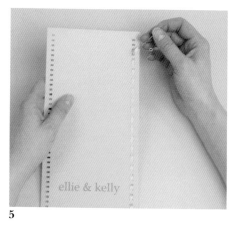

5

1 Using short lengths of adhesive tape, stick a feather to the middle of the square mushroom card stock.

2 Center the square of printed vellum on the feather, then center the organza on the vellum.

3 Thread the sewing machine with ivory thread and set it to straight stitch. Stitch around the edges of the organza, close to the edges of the vellum.

4 Using the steel ruler and the grid on the cutting mat as a guide, tear the edges of the mushroom card stock to make a 4-in (10-cm) square matted fabric pocket. Make another pocket using the cream card stock and the net, but fill it with some dried rose petals and sequins before stitching it closed.

5 Hold the vellum on the card stock, aligning the edges and the punched holes. Thread the needle with the ribbon and weave it through one border.

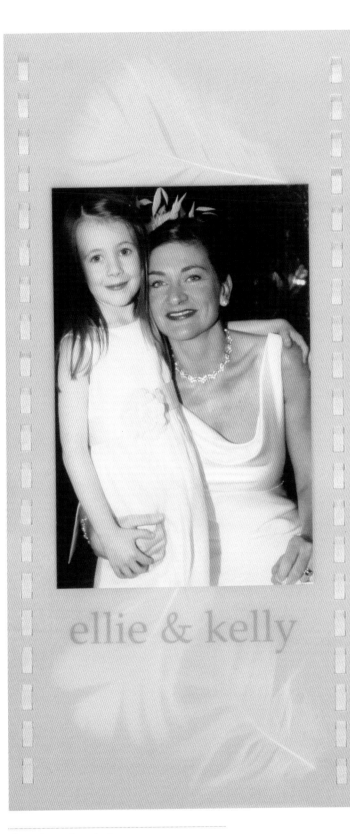

ellie & kelly

Ellie was a bridesmaid for the first
time at Kelly and Matthew's wedding.

Her ivory silk dress was chosen to
complement Kelly's elegant bias-cut
gown, and she had shoes
and a stole to match.

Ellie was so proud to take such an
important role in the day's events
and played her part beautifully.

Getting it right
Lay the vellum over the card stock, aligning the edges, then punch the borders through both layers so they are identical.

△ *Whenever possible, use techniques and materials that relate directly to the subject. Here, silk ribbon and feathers have been used to mirror the materials used in the bride's gown and headdress. The strong red accent color of the sequins was used in the wedding's color scheme.*

6 Without creasing it, carefully lift up the other edge of the vellum. Arrange three feathers underneath, remembering the position of the printed names and the eventual position of the photograph. When you are happy with the arrangement, stick the feathers in place with short lengths of the adhesive tape. Spread out the feathers to create strong shapes and texture. Smooth down the vellum and weave ribbon through the remaining border as in Step 5.

7 Using the scissors, cut off one side of a few feathers, close to their quills.

8 Stick one length of the adhesive tape onto the back of the card stock just inside the woven border on each long edge. Stick the cut feathers onto the tape, positioning each one vertically with the quill on the tape and the remaining side extending beyond the edge of the card stock. Spread out the sides of the feathers.

9 Stick a length of double-sided tape over the feathers and adhesive tape, inside each border.

10 Using the double-sided tape, stick the photograph onto the vellum, centering it between the borders, just above the names.

11 Peel off the backing from the tape on the back of the card stock and stick it onto the cream background, aligning the top and bottom edges and positioning it ¾ in (2 cm) from the left-hand edge.

12 Using the double-sided tape, stick the fabric pockets onto the background, positioning them to the right of the vellum and leaving the same cream border at both side edges.

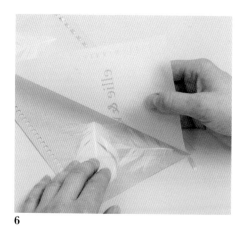

6

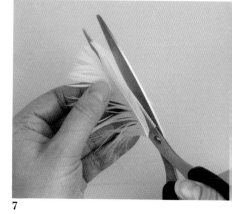

7

8

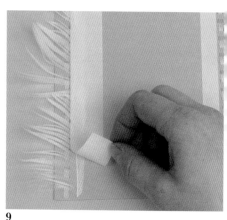

9

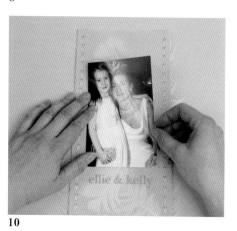

10

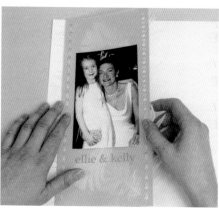

11

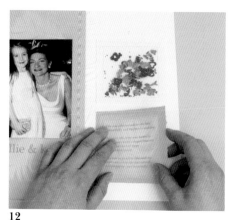

12

happily ever after

Reminiscent of icing on a wedding cake, the decorative touches on this page marry perfectly with the traditional style of my parents' 1960s wedding. Their sapphire wedding anniversary is on the horizon, so the sentiment seems most appropriate. It's surprising how timeless formal wedding photographs appear.

MATERIALS AND TECHNIQUES

12¹/₂ x 9¹/₂ in (32 x 24 cm) sheet of ivory watercolor paper

Pencil; craft knife; steel ruler; cutting mat

Sewing machine
22 Perforating, page 27

Bone folder

Sheet of mother-of-pearl effect white inclusion paper measuring 11⁵/₈ x 8¹/₂ in (29.5 x 21 cm), cut and punched into a trellis; sheet of powder-blue background paper measuring 11⁵/₈ x 8¹/₂ in (29.5 x 21 cm)
16 Paper cutting, page 22

Spray adhesive
39 Spray adhesive, page 43

Piece of mother-of-pearl effect white inclusion paper measuring 6 x 4³/₈ in (15 x 11 cm); oval cutter; bow template on page 139; tracing paper; piercing tool; foam mat
12 Piercing, page 19

Rub-down "happily ever after" motto
54 Rub-downs, page 52

Double-sided tape
42 Double-sided tape, page 44

8 in (20 cm) of ³/₈-in (1-cm) wide white satin ribbon

Scissors

Photograph

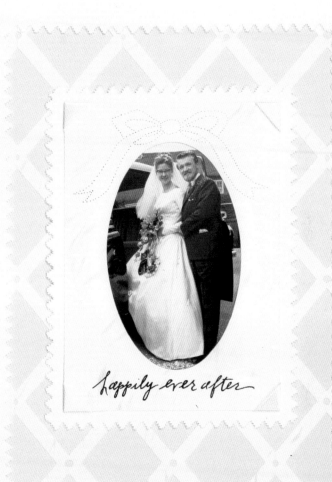

△ *Position an image carefully in a shaped opening, making sure the subject is framed sensitively. Black-and-white prints make a nice change from color ones: Try printing some contemporary images in black-and-white, too.*

1 Draw a border around the sheet of ivory watercolor paper, positioning it 1¾ in (4.5 cm) from the top and bottom edges and 1¼ in (3.5 cm) from the side edges.

2 Set the sewing machine to zigzag stitch. Keeping the right-hand edge of the presser foot aligned with the drawn border, sew perforations along the lines (negotiate the corners in the zigzag pattern if possible).

3 Using the point of the bone folder, press down the paper, just inside the perforated line, to start tearing off the frame.

4 Gently continue tearing with your fingers (don't damage either the frame or the center of the paper; you will need both for your page). Tear all the way around to create a frame with an inner perforated edge and a rectangle with a perforated edge.

5 Spray adhesive onto the back of the trellis and stick it onto the powder-blue background.

6 Using double-sided tape, stick the perforated frame onto the trellis background, positioning the frame so the trellis is symmetrical.

7 Using the oval cutter, cut a centered oval opening in the small piece of mother-of-pearl effect paper to make an oval mat.

8 Enlarge the bow template to the appropriate size on tracing paper. Lay the top half of the oval mat on the foam mat. Center the template on the top edge of the oval mat. Holding the template in place, pierce along the outlines of the bow.

1

2

3

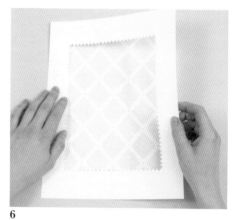

4

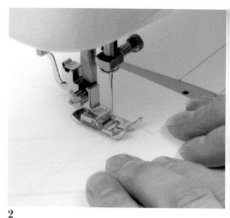

5

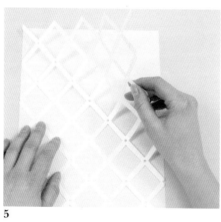

6

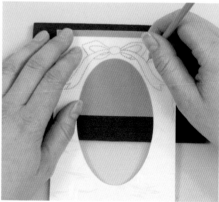

7

8

9 Rub down the motto onto the oval mat, centering it below the opening.

10 Lay the oval mat facedown, then stick a triangle of double-sided tape onto each corner.

11 Lay a short length of the ribbon under one corner. Peel the backing off the tape, then fold one end of the ribbon to the back and press it down onto the tape.

12 Repeat the process to stick down the remaining end. Using the scissors, trim the ribbon ends close to the tape. Repeat the process at every corner to create faux ribbon photo corners on the front of the oval mat.

13 Stick lengths of double-sided tape around the inner edge of the opening. Peel off the backing and stick the mat onto the photograph.

14 Draw a line across the rectangle of perforated cream paper saved from Step 4, positioning it 5 in (13 cm) from the points of the perforations on one long side. Using the sewing machine, zigzag stitch along this line, then carefully tear off and keep the larger piece.

15 Using the double-sided tape, stick the oval-matted photograph onto the rectangle of perforated-edge paper.

16 Using the double-sided tape, stick the photograph panel to the background, centering it.

9

10

11

12

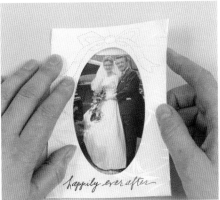

13

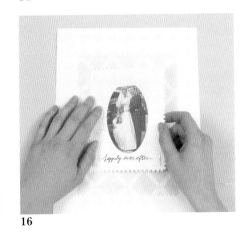

14

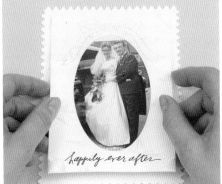

15

16

three good friends

Matthew looked great in his wedding suit; the strong colors were complemented perfectly by the velvet suit of his best man, Mark. Even Olive looked the part in her velvet-and-silk coat; she couldn't be left out of the fun and almost stole the show.

MATERIALS AND TECHNIQUES

Sheet of burgundy background card stock measuring 11 x 8½ in (28 x 21.5 cm)
7 Colored backgrounds, page 16

Four corks from wine bottles, four colors of acrylic paint; plate

4¾ x 2¼ in (12 x 5.5 cm) rectangle of coordinating printed striped paper with the title printed down the short left-hand side
50 Printing, page 50

Double-sided tape
42 Double-sided tape, page 44

Rectangle of rust card stock measuring 11 x 2¾ in (28 x 7 cm)

Photograph matted onto frayed fabric measuring 7½ x 4½ in (19 x 11.5 cm)
60 Woven fabric, page 56

Rivet kit, two rivets

1 Keeping them separate, pour a small amount of each color paint onto the plate. Using a clean cork for each color, dip one end of the cork into the paint, then stamp onto the background, stamping in vertical rows and using random colors.

2 Stamp from the right-hand edge across two-thirds of the background.

3 Fold the striped paper in half so the short sides are even.

4 Using the double-sided tape on the untitled half, stick the folded striped paper onto the long right-hand edge of the rust rectangle, positioning it ⅝ in (1.5 cm) from the bottom edge and leaving 1½ in (4 cm) protruding.

5 Stick a length of double-sided tape onto the back of the rust rectangle, along the edges. Peel off the backing.

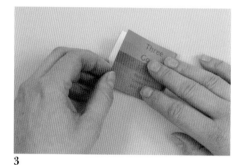
1

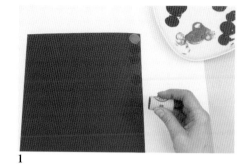
4

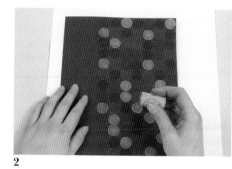
3

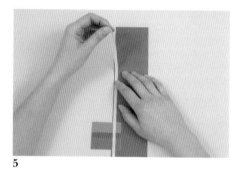
6

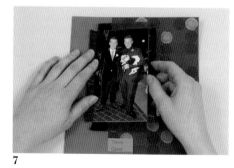
5

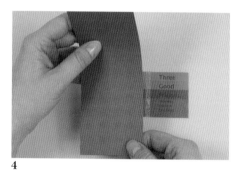
7

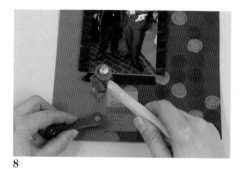
2

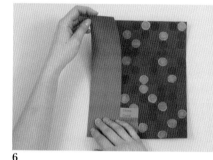
8

6 Stick the rust rectangle onto the background, aligning the left-hand and top and bottom edges.

7 Using the double-sided tape, stick the mounted photograph onto the background, positioning it 1¼ in (3 cm)

from the left-hand edge and ⅜ in (1 cm) above the folded title.

8 Using the rivet kit and following the manufacturer's instructions, fix two rivets through all layers, on the rust rectangle to the left of the title.

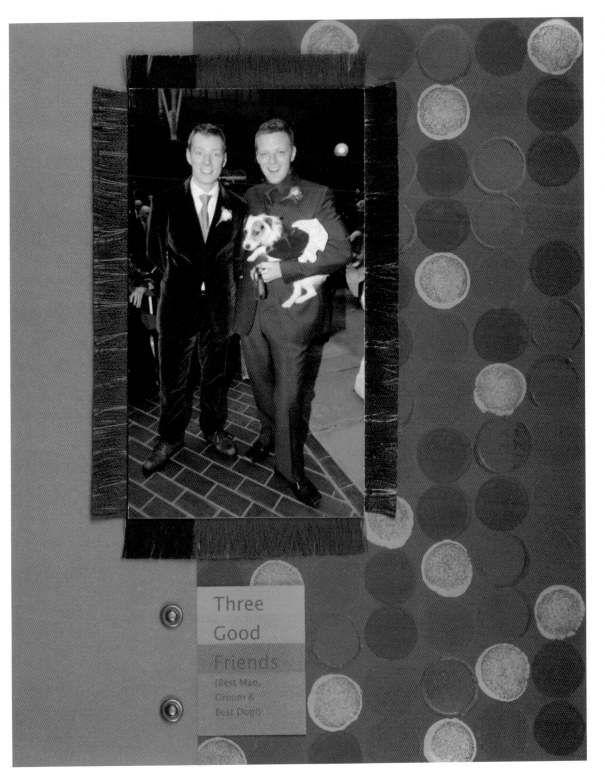

Three
Good
Friends
(Best Man,
Groom &
Best Dog)

◁ *Here, corks have been used to print a simple motif and create a background paper with a modern look. Although I didn't go so far as to collect the corks from the wedding day, they did seem somehow appropriate! Colors have been selected to pick up those in the photograph.*

Choosing the pictures

This informal photograph was taken just before the ceremony. These candid shots can make a great contrast to the more formal wedding-party photographs that will also be at home in a wedding album.

true love

Celebrate love and commitment with a page of their own. Here, the sentiment is obvious, but not too hackneyed. Although traditional motifs and materials are incorporated, the chosen techniques interpret the theme in a fresh and contemporary way. Lavender particles make a lovely, scented frame for the small photograph.

MATERIALS AND TECHNIQUES

7¾ x 5 in (19.5 x 13 cm) cropped photograph
26 Cropping, page 30

12-in (30.5-cm) square of soft blue card stock sprayed with lace pattern in cream
17 Spraying, page 23

Lilac vellum tag; rub-down motto "kiss"
54 Rub-downs, page 52

Heart charm; ⅝-in (1.5-cm) wide lilac organza ribbon; scissors

Found letters to make title, with one word on a card with colored edges which is glued into an envelope
56 Found letters, page 54
21 Coloring, page 26

Small adhesive dots
40 Adhesive dots, page 43

Spray adhesive; brayer
39 Spray adhesive, page 43

⅛-in (0.25-cm) wide double-sided tape; tweezers; lavender particles
42 Double-sided tape, page 44
66 Botanicals, page 62

3¾ x 2½ in (9.5 x 6.5 cm) photograph centered and relief-matted onto a 5 x 3¾ in (12.5 x 9.5 cm) rectangle of lilac card stock
30 Relief-matting, page 34

Choosing the pictures

The main photograph is strong enough to sit directly on a page without being matted. A background was chosen that would not compete for attention. The image should always be the focal point, with the other items complementing and enhancing it.

1

2

3

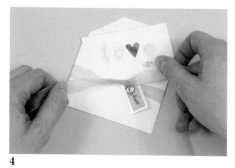

4

5

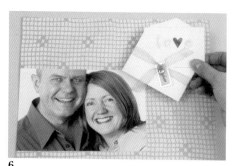

6

7

1 Using spray adhesive, carefully stick the cropped photograph onto the sprayed background, centering it between the top and bottom edges and aligning the left-hand edges. Roll over it with a brayer to ensure it is firmly stuck down.

2 Rub down the word "kiss" onto the tag.

3 Thread the tag and the heart charm onto the ribbon.

4 Tie the ribbon around the envelope and knot the ends.

5 Using the scissors, diagonally trim the ribbon ends.

6 Using the adhesive dots, stick the envelope onto the top right of the background, slightly overlapping the photograph.

7 Using spray adhesive, stick the remainder of the title letters onto the sprayed background.

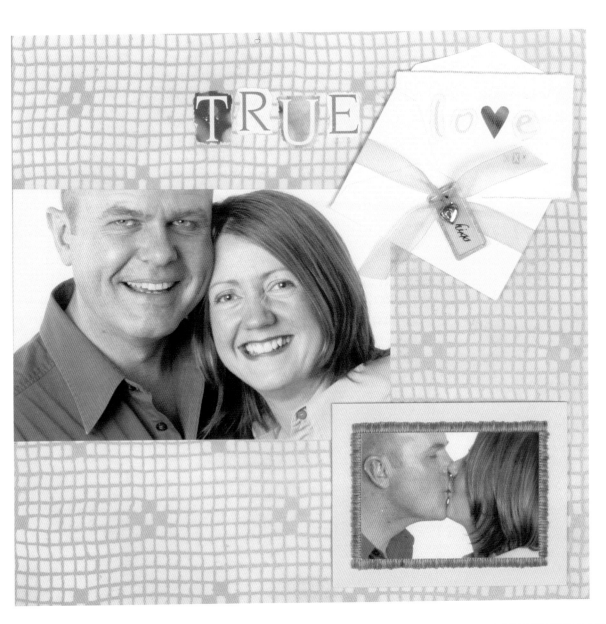

TRUE love

◁ *This project is another example of how using a primary and secondary image can make a page work well, see also* **4th July**, *page 104.*

8

9

10

8 Stick lengths of the double-sided tape along the edges of the matted photograph.

9 Peel back a short length of the backing on the bottom edge. Using the tweezers, pick up and press lavender particles side by side across the tape, with the green

ends toward the photograph. Butt the particles against one another to hide the tape and make a continuous scented strip. Peel off a little more backing and continue the process until the whole edge is covered. Repeat the process until all the edges are covered.

10 Using the adhesive dots, stick the matted photograph onto the bottom right corner of the background, slightly overlapping a corner of the large photograph.

family memories

Creating a scrapbook is an opportunity to look back and remember special people, times and places and to find interesting ways to record their lives and commemorate them. A scrapbook created with love and care preserves history and provides a lasting document for the future. Your scrapbook may well come to be a family treasure and heirloom.

Look through family photograph albums, then collect and copy special photographs so you can make your pages but keep the family albums intact. Not all heritage subjects demand photographs from days of old; there are projects included here that incorporate contemporary images. You are, after all, creating history today.

family album

Here, fabric and thread represent the different strands in the rich tapestry of life that is evident in my album. A fabric cover was a natural choice to symbolize my family heritage and makes a jacket that will be treasured for years to come.

MATERIALS AND TECHNIQUES

Fabric jacket in calico
2 Fabric jacket, page 10

Selection of family photographs transferred onto calico and linen, some with frayed edges
61 Image transfer, page 57
60 Woven fabric, page 56

Large button carrying a photograph
73 Buttons, page 68

Embroidered title on punched felt background
3 Embroidering a title, page 11
59 Felt, page 56

Pins

Selection of buttons
73 Buttons, page 68

Selection of embroidery floss; embroidery needle
24 Hand stitching, page 28

"Antique" letter tag stickers
53 Letter stickers, page 52

Two tassels
64 Tassels, page 60

Two lengths of twisted cord
63 Cords, page 59

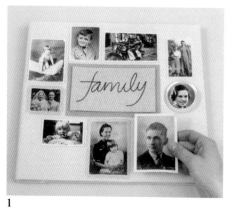

1

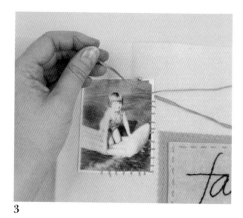

2

3

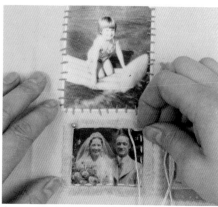

4

1 Arrange the elements on the front of the calico jacket. They can be placed anywhere, but the large button carrying the photograph must be 2 in (5 cm) from the leading front edge and centered between the top and bottom edges. When you are happy with the arrangement, make a sketch noting measurements so you will be able to recreate it, then remove the elements.

2 Using the embroidery floss and needle and running stitches, sew the title onto the jacket, stitching just inside the edge of the title and being careful not to catch the inside flap with your stitching.

3 Using straight stitches, sew straight-sided pictures to the jacket, making the stitch lengths and spacing uneven to add a naive quality.

4 Using running stitches, sew frayed-edge pictures to the jacket, stitching just inside the fraying.

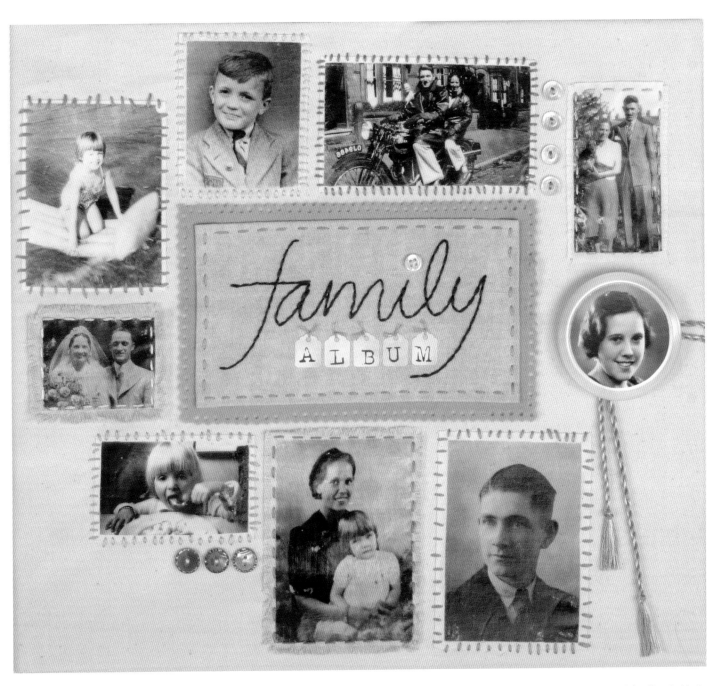

5 Continue stitching until all of the fabric pictures are attached.

△ *Muted tones and subtle materials reflect the black-and-white and sepia tones of the photographs and are perfect for the nostalgic mood of the project.*

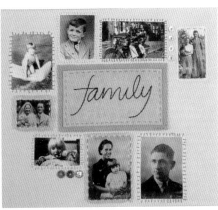

Choosing the pictures

Go through your family albums and select a range of photographs covering different generations. Even if the original pictures look very different, the process of photocopying them in black-and-white and transferring them onto fabric will help to lend them a similar look.

5

6 Sew on the large button, being careful not to stitch through the flap.

7 Sew on some decorative buttons: A medium-sized button onto the spine, for example, and dot the "i" in "family" with a tiny button.

8 One at a time, thread embroidery floss through the hole in each tag sticker, knot the ends and trim them short.

9 Stick the word "album" onto the fabric under "family."

10 Stitch a button onto the back of the jacket, positioning it 1 in (2.5 cm) from the leading edge and centered between the top and bottom edges.

11 Wrap the jacket around the album and gently ease the flaps over the front and back covers.

12 Tie one of the cords around the button on the back of the jacket. To close the album, wind the cord ends around the large button on the front.

13 Join one of the tassels to each end of the remaining cord by unravelling a short length at the end and tying the unravelled section through the head of the tassel. Loop the cord around the button on the spine and tie it so the tassels hang at different heights.

6

7

8

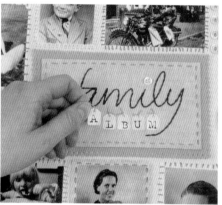
9

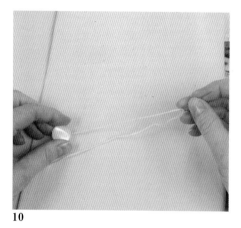
10

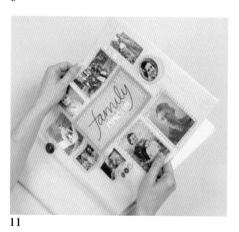
11

12

13

meet the family

This project was an attempt to produce a nontraditional style of family tree that is, for me, more representative of families today. The sophisticated use of color, the lack of fussy detailing and the clean contemporary lines have just the effect I was hoping for.

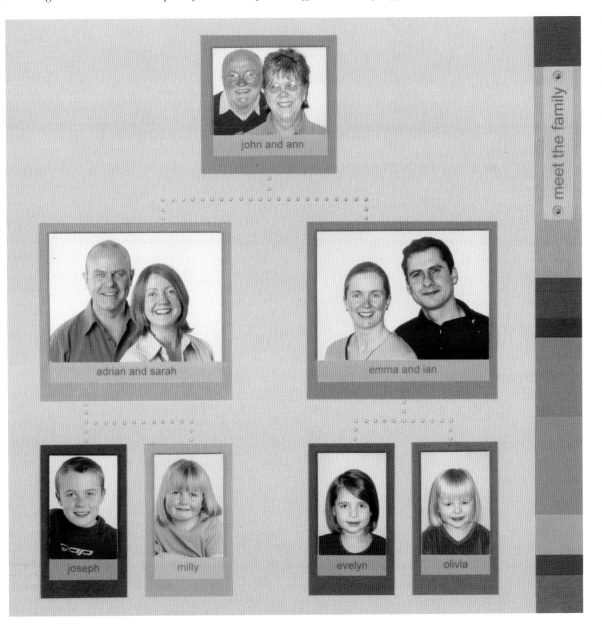

◁ *Though this project looks straightforward, it demands very careful planning and execution. The selection of the colors, and the positioning of the various elements are important, as is the level of finish. The eye will be immediately drawn to poorly trimmed edges and lines that are out of true.*

MATERIALS AND TECHNIQUES

Different-colored papers, one for each photograph

Craft knife; steel ruler; cutting mat

Vellum with the individual names printed far enough apart to accommodate the photographs
50 Printing, page 50

Double-sided tape
42 Double-sided tape, page 44

Relief-matted photograph of each family member or couple
30 Relief-matting, page 34

12-in (30.5-cm) square of pale gray background card stock
7 Colored backgrounds, page 16

Pencil; eraser

Masking tape

Scraps of the different-colored papers

Eyelet kit; two mauve eyelets
46 Eyelets, page 47

Title printed on vellum
50 Printing, page 50

1 Using the craft knife and steel ruler on the cutting mat, cut a mat of colored paper for each photograph. Each mat should be ¼ in (0.5 cm) larger than the photograph at the top and each side edge and ¾ in (2 cm) larger at the bottom.

2 Cut a piece of the printed vellum that is the same width but ⅜ in (1 cm) longer than each photograph and has the printed name centered within this ⅜ in (1 cm) along the bottom edge.

3 Using the double-sided tape, stick each photograph onto the appropriate piece of vellum, aligning the top and side edges.

4 Using the double-sided tape, stick each piece of vellum to a colored mat, positioning it so the top and side borders are equal.

5 Leaving a 1 in (2.5 cm) border free on the right-hand side, arrange the matted pictures on the background to make a family tree. The photographs can be arranged formally or more casually, but allow space for the punched lines in the correct places (see Step 13). Using the pencil, lightly draw the lines on the page.

6 Using the double-sided tape, stick the photographs into position.

7 Cut 16 in (40 cm) length of double-sided tape. Lay it sticky-side up on the cutting mat and tape it down at each end with a small piece of masking tape.

8 Cut random-size rectangles of the different colored papers, ensuring that the edges are perpendicular, and that each strip is wider than the tape. One rectangle must be large enough to accommodate the title (see Step 14). Arrange the strips on the cutting mat next to the tape. One at a time, stick each strip to the tape, ensuring that it overlaps both edges of the tape and butts neatly against the preceding strip.

1

2

3

4

5

6

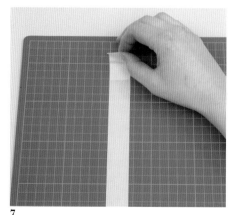
7

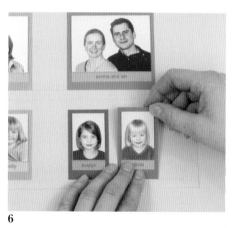
8

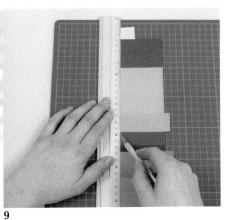

9

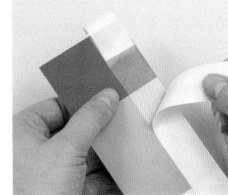

10

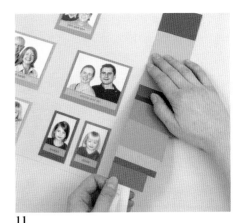

11

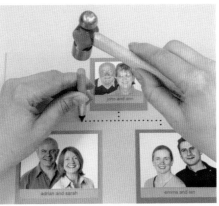

12

13

14

9 Lay the ruler on the strips, aligning it exactly with the left-hand edge of the tape. Using the craft knife, cut off the excess paper.

10 Lift the joined strips off the cutting mat and peel off the backing.

11 Stick the joined strips along the right-hand side of the background, positioning the straight left-hand edge of the tape exactly 1 in (2.5 cm) from the right-hand edge of the page.

12 Lay the page facedown. Using the craft knife and the steel ruler on the cutting mat, cut the joined strip even with the edge of the page.

13 Using the eyelet kit, punch holes along the pencil lines connecting the members of the family. Erase any remaining pencil lines.

14 Center the title on the chosen stripe. Using the eyelet kit, punch a hole in each end, then set an eyelet in each hole to attach the title.

Choosing the pictures

It is fairly unlikely that you will be photographing all the subjects at the same time or even in the same location, but it is important that you try to have continuity in the images. Do what you can to ensure this. Choose a plain neutral background that can be replicated in different locations and will suit everyone. Give some thought to the clothes the sitters will wear; ask them to choose garments with simple necklines and, in the case of the couples, colors that coordinate. Try to get the head sizes similar and in scale where you can, at least along each row.

cherish

My maternal grandmother, Russie, entrusted her photograph collection to me some years before she died. We went through it together, identifying the people and places. This photograph of her at a dance with my grandfather is among my favorites. It dates from before they were married. So does the envelope, which is addressed to my grandmother's maiden name.

MATERIALS AND TECHNIQUES

Corner punch; piece of moss-green thin card stock measuring 7¾ x 5¼ in (19.5 x 13.5 cm); dark moss-green ink pad; makeup sponge; piece of pale brown thin card stock measuring 7¼ x 4¾ in (18.5 x 12.5 cm); mid-brown ink pad

21 Coloring, page 26

Sepia-tinted photocopy measuring 6¾ x 4⅜ in (17 x 11 cm); "antique" gold photo corners

25 Sepia tinting, page 29

48 Photo corners, page 48

Double-sided tape

42 Double-sided tape, page 44

12-in (30.5-cm) square of brown background card stock

7 Colored backgrounds, page 16

Piece of background paper measuring 10½ x 8 in (26.5 x 20 cm), with torn edges and lines of printed handwriting

8 Patterned backgrounds, page 17

20 Tearing, page 25

Original hand-addressed envelope

Small adhesive dots

40 Adhesive dots, page 43

Two cutout Victorian-style bird and flower motifs; spray adhesive

39 Spray adhesive, page 43

Rectangle of pale brown card stock measuring 3½ x 1½ in (9 x 3.5 cm); printed title on cream paper measuring 3 x 1 in (8 x 2.5 cm)

50 Printing, page 50

Piece of antique ribbon; mother-of-pearl buckle; masking tape

Large adhesive dots

40 Adhesive dots, page 43

Heart charm

1

2

3

4

5

6

1 Shape the corners of the green card stock with the punch. Using the green ink pad and sponge, color the edges and around the punched corners. Repeat with the brown card stock and brown ink pad.

2 Using the double-sided tape, center, then stick the brown card stock to the green card stock. Using the photo corners, stick the photograph onto the double mat, centering it.

3 Using the double-sided tape, stick the printed paper onto the background so the top, bottom and left-hand side borders are equal. Using the small

adhesive dots, stick on the envelope so the top and right-hand borders are equal.

4 Using the small adhesive dots, stick the double-matted photograph onto the background, positioning it ⅜ in (1 cm) from the bottom and 1¾ in (4.5 cm) from the left-hand edge.

5 Spray adhesive onto the backs of the cutouts. Stick them onto the page, overlapping different elements.

6 Color the edge of the rectangle of brown card stock as in Step 1. Using the double-sided tape, stick the title onto it.

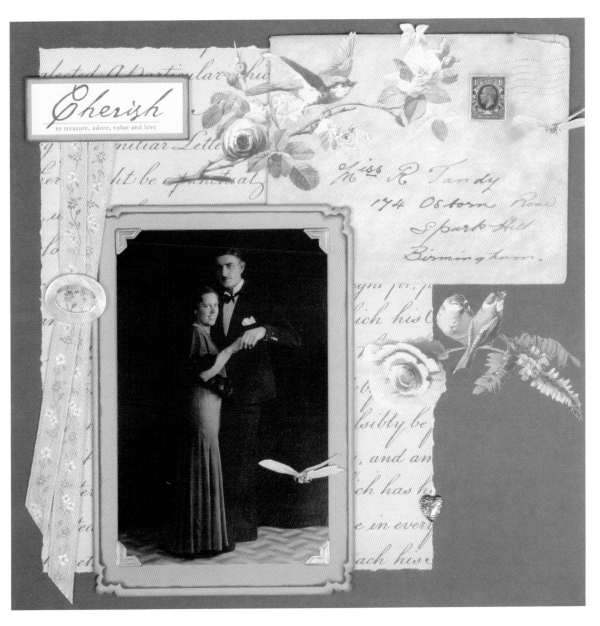

◁ *It's surprising how quickly information is lost and forgotten. Always record details of your own photographs. If you have a family collection, make sure you go through it with your older relatives so that the younger ones will benefit.*

7 Fold the ribbon in half and slide the ends through the buckle, then push the buckle about halfway up. With the ribbon ends down, center the fold on the back of the brown card stock. Attach it with masking tape. Diagonally trim the ribbon ends to they slant in the same direction.

8 Using the large adhesive dots, stick the title onto the page, positioning it so the ribbons hang down to the left of the photograph.

9 Using a large adhesive dot, stick the heart charm onto the torn right-hand edge of the printed paper.

7

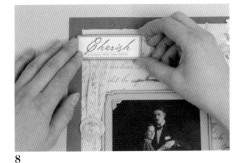

8

9

home sweet home

A lovely home and a home full of love; home is certainly where my heart is. The photograph is a recent one, printed in sepia, and, along with the muted materials and the style of presentation, was chosen to reflect the period of the property.

MATERIALS AND TECHNIQUES

13-in (36-cm) square each of tartan fabric and lightweight fusible webbing (or double-sided interfacing); iron; 12-in (30.5-cm) square of cream background card stock
8 Patterned backgrounds, page 17

Pencil; craft knife; steel ruler; cutting mat

7⅞ x 6¾ in (20 x 17 cm) rectangle of blue-gray thin card stock with a 5½ x 4⅜ in (14 x 11 cm) central opening
29 Window matting page 32

6¾ x 5 in (17 x 13 cm) photograph printed in sepia tones

Double-sided tape
42 Double-sided tape, page 44

7¾ x 6½ in (19.5 x 16.5 cm) rectangle of copper embossing foil; embossing tool; dressmaker's tracing wheel

5½ x 1½ in (14 x 4 cm) strip of thin white card stock; slot border punch
18 Punching, page 24

Brown and green antiquing waxes; cotton batting

Four copper brads
47 Brads, page 47

Fine brass craft wire

Three copper foil tags with the title embossed on them, two of the tags with a hole punched in both ends and one tag with a hole in one end and a length of linen tape looped through and tied
57 Embossing foil, page 54

Copper key and heart charms

Eyelet kit, two copper eyelets
46 Eyelets, page 47

Foam pads
44 Foam pads, page 46

Adhesive dots
40 Adhesive dots, page 43

House number printed in reverse; cellulose thinners; spoon; 1¼-in (3-cm) square of cream paper; brown ink pad; makeup sponge
52 Transferring text, page 51
21 Coloring, page 26

1⅜-in (3.5-cm) square of copper embossing foil

Copper-colored letter stickers
53 Letter stickers, page 52

Piece of blue-gray paper

1 Following the manufacturer's instructions, iron the fusible webbing (or interfacing) onto the wrong side of the tartan fabric.

2 Peel off the backing, then lay the tartan fabric facedown. Lay the background card on the webbing. Iron the card to bond the fabric firmly onto the background. Lay the page fabric-side down and, using the craft knife and steel ruler on the cutting mat, cut the fabric even with the background around the edges.

3 Using the craft knife and steel ruler on the cutting mat, cut a 6¼ x 5 in (16 x 13 cm) opening in the page, positioning it 2 in (5 cm) from the top and right-hand side edges.

4 Using the double-sided tape, stick the blue-gray window mat over the photograph.

5 Using the double-sided tape, stick the page onto the matted photograph, centering the mat in the opening.

1

2

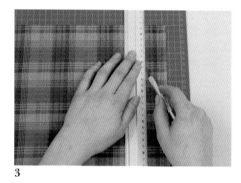

3

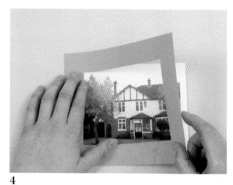

4

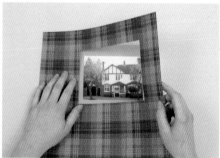

5

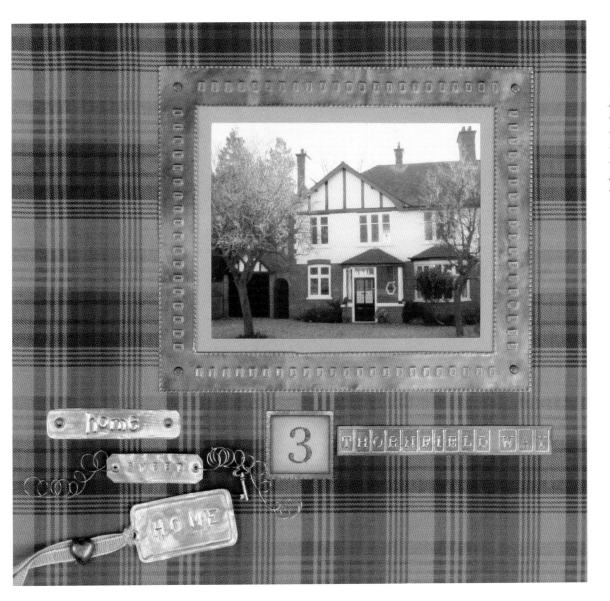

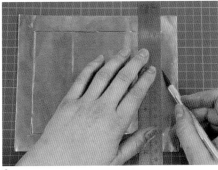

6

7

8

6 Using the craft knife and steel ruler on the cutting mat, carefully cut a 6⅛ x 4⅞-in (15½ x 12½-cm) opening in the rectangle of copper embossing foil to make a frame. (This will blunt the knife blade, so change it before cutting any paper.)

7 Fold the strip of white card stock in half lengthwise.

8 Using the slot border punch, punch a continuous border through both layers of the folded strip.

9

10

11

12

13

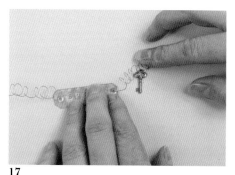

14

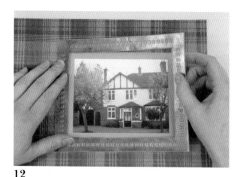

15

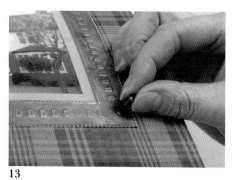

16

17

9 Slide the punched strip over the edge of the copper frame, with the fold against the outer edge. Using the embossing tool and the same technique used for embossing paper, emboss the copper through each punched hole. When necessary move the strip along, realign the pattern and repeat the process until you have embossed around the frame.

10 Lay the steel ruler close to the outer edge of the frame, leaving just a tiny strip of copper beyond the edge of the ruler. Roll the tracing wheel along the edge of the ruler, firmly pushing down to emboss a dotted line along the edge of the frame. Repeat the process on each outer and inner edge.

11 Dab a wad of cotton batting into the brown wax, then rub it over the surface of the copper, thoroughly rubbing it in. Repeat the process with the green wax to create an antique effect.

12 Using the double-sided tape, stick the copper frame over the edges of the opening in the page, centering it.

13 Using just the tip of the craft knife, cut a tiny slot in each corner of the frame. Rub the head of each brad with a little wax. Push the arms of one brad through each slot and open them out against the back.

14 Leaving the brass wire on the spool, wind the free end eight times around the pencil.

15 Approximately 6 in (15 cm) from the coil, cut the wire. From the front, thread the straight end of the wire down through a hole in the second of the copper title tags, then thread it up through the other hole.

16 Slip the coil of wire off the pencil. Wind the straight end of the wire around the pencil four times, then thread on the key charm. Continue winding the wire around the pencil six more times. Slip the coil of wire off the pencil.

17 Pressing with your fingers, flatten both coils of wire.

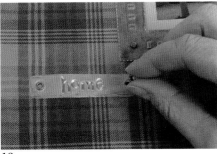

18

19

18 Using one of the copper eyelets fixed through the hole at each end, attach the first title tag to the background. Position it on the left-hand side, just below the framed photograph.

19 Using the foam pads, stick the wired tag onto the background, just below the first tag.

20

21

20 Using the foam pads, stick the last title tag onto the background, just below the first two tags. Using the adhesive dots, stick the linen tape onto the background halfway along its length from the tag. Using more adhesive dots, stick the heart charm onto the attached tape.

21 Using the thinners, transfer the house number onto the square of cream paper.

22

23

22 Using the makeup sponge and the brown ink pad, color the edges of the number square.

23 Using the steel ruler and the tracing wheel, emboss the edges of the copper square as in Step 10, then antique it with the waxes as in Step 11.

24

25

24 Using the double-sided tape, stick the square of paper onto the square of copper, centering it.

25 Using the double-sided tape, stick the copper square onto the background, positioning it below the photograph and aligning it with the first title tag.

26

27

26 Using the letter stickers, make up the street name on the blue-gray paper. Trim the paper, leaving a narrow border around the name. Rub it with a little of the brown wax.

27 Using the double-sided tape, stick the name onto the background to the right of the house number.

faithful friends

When I was a child our family always had a dog. I now have a dog of my own and wouldn't be without one. This page commemorates all of our faithful friends so far, but I need to make a new page now to celebrate the arrival of a puppy, Phoebe Ethel!

MATERIALS AND TECHNIQUES

Page template, on page 141; collection of themed photographs, journaling and memorabilia; colored paper for matting photographs (the main photograph should have a mat large enough to accommodate a title and journaling)

31 Page template, page 35

27 Single-matting, page 31

12-in (30.5-cm) square of soft green background card stock; pin

7 Colored backgrounds, page 16

Double-sided tape

42 Double-sided tape, page 44

Letter stamps; paw-print stamp; brown ink pad; tan paper; green paper

55 Letter stamps, page 53

13 Stamping, page 20

Craft knife, steel ruler; cutting mat

Faux metal tags stamped with the dogs' names (some should be whole names on a single tag, others single letters on separate tags that can be hung together to make a name)

71 Faux metal tags, page 66

Metal jump rings; needle-nose pliers

Lightweight silver chain

Pencil

Two large silver brads

47 Brads, page 47

Choosing the pictures

Although your pictures will have been taken at different times and in different places, try to select ones with a common color scheme. Careful cropping can help to blend together photographs that clash.

1

2

3

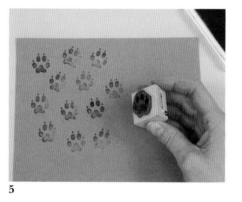
1

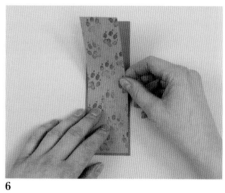
5

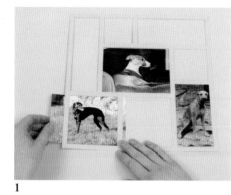
6

1 Arrange the photographs to fit the spaces in the template, then transfer the template onto the background by piercing a pin hole in the corner of each space.

2 Using the letter stamps and brown ink pad, print the title onto the mat below where the photograph will be, centering it.

3 Using the double-sided tape, stick a piece of journaling onto the right-hand side of the mat, above the title (the journaling must be the same height as the photograph).

4 Using the double-sided tape, stick the photograph onto the left-hand side of the mat, just overlapping the edge of the journaling.

5 Using the brown ink pad, stamp paw prints all over the tan paper. Cut the stamped paper a little smaller than one of the spaces in the template.

6 Mat the paw-stamped paper onto the green paper so it fits the space.

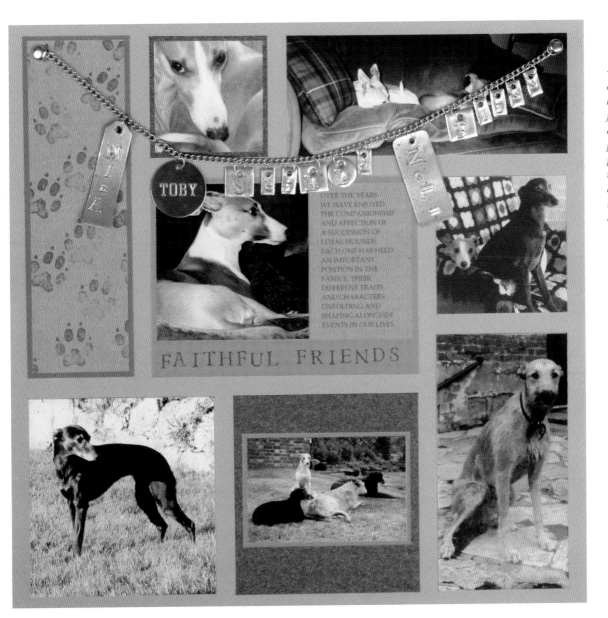

◁ This page shows how a template can be used to incorporate journaling blocks and other decorative panels among the photographs. The grid will always work if you ensure that the various items are cut to the correct size.

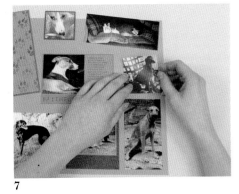

7

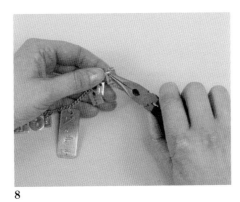

8

9

7 Using the double-sided tape, stick the photographs and printed sections onto the background, using the pin holes as guides.

8 Using the pliers, open a jump ring and thread a name tag onto it. Thread the

ring through an appropriate link in the chain and close it with the pliers. Repeat the process until all the tags are hung.

9 Drape the chain across the page and, using the pencil, mark an anchor point at each end. Cut the chain if necessary and

fasten a jump ring onto each end. Using just the tip of the craft knife, cut a tiny slot at each anchor point. Push the arms of a brad through each jump ring, then through the corresponding slot and open them out against the back.

templates

On the following pages you will find templates for some of the projects featured in this book.

Enlarge the template by the stated amount and use it to create your own scrapbook page.

fabric jacket, page 10

measure your album following the instructions below

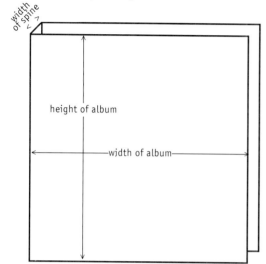

The height of the fabric must be the height of the album, plus 2½ in (6 cm) for the seam allowances. The width of the fabric must be the width of the front cover, plus half that measurement again; added to the width of the spine; added to the width of the back cover, plus half that measurement again. The half-measurements are folded in to make the front and back flaps.

in the snow, page 78

enlarge by 300 percent

in the snow, page 78

enlarge by 200 percent

a walk in the country, page 98
enlarge by 300 percent

4th july, page 104
use at size given

happily ever after, page 117
use at size given

family album, page 124
use at size given

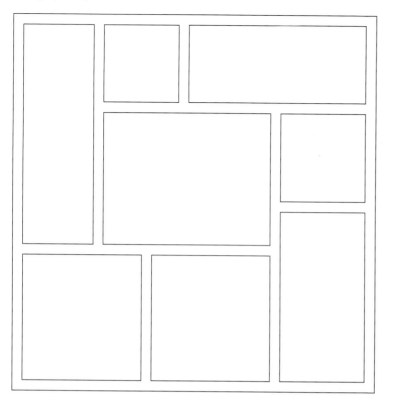

motifs

Here is a selection of popular outline motifs that you can use in various ways on your pages. Enlarge them to the appropriate size and use them to make shaped photo mats, see page 37; emboss a title motif, see page 12; pierce a decoration, see page 19; or cut them out and spray over them, see page 23.

mottoes

There are literally millions of mottoes, proverbs, quotations and poems you can incorporate into your pages if you don't want to use your own words. Look in speciality books and on the Internet and choose something that relates closely to your pictures. Here are some interesting mottoes suitable for different pages.

I think that I shall never see, a poem as lovely as a tree.

One generation plants the trees, another gets the shade.

Family is our link to the past, our bridge to the future.

There is no old age.
There is, as there always was, just you.

I came but for friendship, and took away love.

If flowers were friends, I'd pick you.

Life's a voyage that's homeward bound.

You're never too old to become younger.

Time spent with cats is never wasted.

A successful marriage means falling in love many times, always with the same person.

It's not the years in your life that count, it's the life in your years.

The moon belongs to everyone, the best things in life are free; the stars belong to everyone, they gleam there for you and me.

Every day, in every way, I am getting better and better.

A pound of pluck is worth a ton of luck.

There is no remedy for love but to love more.

The most wasted of all days is one without laughter.

In all things of nature, there is something of the marvellous.

Travel the world in search of what you need, return home to find it.

Home is not just a place, it's people, too.

The palest ink is better than the best memory.

suppliers

USA & CANADA

Creating Keepsakes Magazine
14901 Heritagecrest Way
Bluffdale, UT 84065
Toll-Free Tel: (888) 247-5282
Web: www.creatingkeepsakes.com
Visit the website to subscribe to the magazine, learn about scrapbooking conventions and find products, projects and readers' tips.

Creative Paper Crafts
Angela's Craft Centre
37 King Street East
Dundas, ON L9H 1B7
Toll-Free Tel: (877) 627-9905
Web: www.creativepapercrafts.com
Shop in person or online for specialty scrapbook products.

Great Impressions
Sierra Enterprises
P.O. Box 5325
Petaluma, CA 94955
Toll-Free Tel: (888) 765-6051
Web: www.sierra-enterprises.com
Shop online for rubber stamps and accessories such as ink pads, embossing powders and heat guns.

Keeping Memories Alive Scrapbooks.com
260 North Main
Spanish Fork, UT 84660
Toll-Free Tel: (800) 419-4949
Web: www.scrapbooks.com
Visit the website to order a catalogue and shop online.

Loomis Art Store
254 St. Catherine Street East
Montreal, QC H2X 1L4
Toll-Free Tel: (800) 363-0318
Web: www.loomisartstore.com
Art and specialty scrapbook supplies. Visit the website to find products, projects and the store nearest you. Shop in person or by phone.

Michaels
8000 Bent Branch Drive
Irving, TX 75063
Toll-Free Tel: (800) 642-4235
Web: www.michaels.com/art/online/home
A wide range of art, craft and specialty scrapbook supplies. Visit the website to find products and projects, as well as an online gallery of customers' scrapbooking.

Scrapbook.com Superstore
116 North Lindsay Road No. 3
Mesa, AZ 85213
Toll-Free Tel: (800) 727-2726
Devoted to scrapbooking supplies and accessories. Visit the website to browse the catalogue and see the layout gallery. Shop online only.

Scrapbooking With Love
13956 West Hillsborough Avenue
Tampa, FL 33635
Tel: (813) 814-5892
Web: www.scrapbookingwithlove.com
Visit the website to find a comprehensive range of specialty scrapbook products and projects, learn about events and expos, and share messages with other scrapbookers. Shop in person at the Tampa store or online.

We Love Scrapbooking.com
Web: www.welovescrapbooking.com
Visit this website to find a comprehensive directory of Canadian scrapbook supply stores, scrapbooking events and fellow scrapbookers in your area.

UK

Sarah Beaman produces a range of card making kits; more information can be found at www.sarahbeaman.com

Hobbycraft
Tel: 0800 027 2387 for your nearest branch.
Web: www.hobbycraft.co.uk
Arts and crafts superstore.

Stampeezee
2 Cedars Avenue
Coventry
West Midlands CV6 1DR
Tel: 024 7659 1901
Email: stampeezee@hotmail.com
A wide range of papercraft products and specialty scrapbook supplies.

Artbase
88 North Street, Hornchurch
Essex RM11 1SR
Tel: 01708 457948
Web: www.artbasehornchurch.com
A good selection of scrapbook products available online.

Scrapbook Memories
Unit 3, Stanley Lane Industrial Estate
Bridgnorth
Shropshire WV16 4SF
Tel: 01746 769777
Web: www.scrapbookmemories.co.uk
Visit the website to shop online.

The Paper Trail Scrapbook Co. Ltd
123 The Promenade
Bridlington
East Yorkshire YO15 2QN
Tel: 01262 601770
Web: www.thepapertrailcompany.com
Shop in person or online for specialty scrapbook products.

The Scrapbook House
Unit 9 Cromwell Business Park
Chipping Norton
Oxon OX7 5SR
Tel: 01608 643332
Web: www.thescrapbookhouse.com
A wide selection of scrapbook supplies available online.

acknowledgements

Thanks to Marie Clayton at Collins & Brown for another valued opportunity to share my ideas. Much admiration and respect to Kate Haxell for the hours spent on what was a very complex book to plan and edit. Thanks to photographer Dan Towers for combining professionalism with humour, and to the OnEdition team for making the studio days easy and enjoyable. Many thanks to designer Roger Daniels for giving the book a sense of order and clarity, while squeezing as much into it as possible. Thanks to John at Clairefontaine for supplying a selection of paper. A big thank you to Judith at Woodware Craft Collection for helping me out of a fix one day. Finally, special thanks to family and friends who gave me the freedom to use photographs of them and so made the book possible. This includes members of the families Beaman, Price, Penrose, Dickens, Haxell, Orrill, Surana, Ashbolt, Barry and Lane. Shine on…

index